Almodóvar on Almodóvar

Edited by Frédéric Strauss
Translated by Yves Baignères
Additional material translated by Sam Richard

faber and faber

First published in France in 1994
by Cahiers du Cinéma, Editions de l'Etoile

First published in Great Britain in 1996
by Faber and Faber Limited
3 Queen Square London WC1N 3AU
This revised edition published in 2006

Published in the United States by Faber and Faber Inc.
an affiliate of Farrar, Strauss and Giroux LLC, New York

Typeset by RefineCatch Limited, Bungay, Suffolk
Printed in England by Mackays of Chatham, plc

© Cahiers du Cinéma, Editions de l'Etoile, 1994
English translation © Yves Baignères, 1996
English translation of additional material © Sam Richard, 2006

The right of Frédéric Strauss to be identified as author of this work has been asserted in
accordance with Section 77 of the Copyright, Designs and Patents Act 1988

A CIP record for this book
is available from the British Library

ISBN 978-0-571-23192-8
ISBN 0-571-23192-6

Contents

Pedro Almodóvar

Sense and Sensation

I was left with two overriding memories of the many hours I spent with Pedro Almodóvar. The first was that of having been captivated by the impassioned and rational story of a life dedicated to film. The second was of my hope of having helped in the telling of another story, that of the emotion each film of his extraordinary career engenders.

For my part, that story began on Monday 15 June 1987 when I first saw *What Have I Done to Deserve This?* at the Trois Luxembourg Cinema, rue Monsieur-le-Prince in Paris. My first glimpse into Almodóvar's universe. Carmen Maura's raw expressiveness, Chus Lampreave's discreet yet hilarious presence, Veronica Forqué's staccato, musical delivery, all bowled me over. And left me speechless. I had been writing for Cahiers du Cinéma for only a few months and, eager to affirm my standing as a serious critic, found myself mistrusting my own emotions as if my very objectivity were under threat. What's more, Pedro Almodóvar was already well known. His sulphurous reputation as the leading light of the Madrid movida, a quasi-mythical and unbridled movement of liberation, epicentre of the new Spain of the early 1980s, went before him. *What Have I Done to Deserve This?*, completed three years earlier, was the first of his films to be commercially distributed in France. Doubtless, nothing aroused my suspicions more than a director who not only possessed such attractive, if admittedly flashy, credentials, but could also touch my emotions. I was clearly in danger of being manipulated. It was therefore with some reserve that I communicated in a brief review to the readers of the Cahiers my affection for *What Have I Done to Deserve This?* I showed the same enthusiasm in March 1988 for *Law of Desire*, a film which contained several scenes which had moved me so much I subsequently watched them again and again.

Almodóvar the manipulator? The idea is not inaccurate, not if it describes the work of a director who fashions everything, from the smallest prop to the performances of the actors, as his desire dictates. The rigour and coherence of his work is such that hardly ever during these interviews did my questions take Almodóvar by surprise.

His total control over his work, however, does not denote a desire to manipulate an audience, an audience which the film-maker himself says he cannot conceive of except in the abstract, an audience he even risked losing with the slow and discursive *High Heels* and most of all with the fast and

furious *Kika*. His goal, through a consciously elaborated *mise en scène*, is intensity: a saturation of colour and passion which releases pure, visual, physical and visceral emotion. Though profoundly crafted, this emotion is, in the final analysis, neither artificial nor intellectual, but delivers itself rawly on to the screen, leaving the audience the choice either of accepting or rejecting it.

This movement from sense to sensation imprinted its logic on these conversations with Almodóvar. They were conducted in the knowledge that to succeed in hammering out the sense of an image, the ideas and intentions it contains, could never justify its real value, that it would be impossible for us to exhaust its sensation. How can I explain why seeing the little girl in *Law of Desire* singing 'Ne me quitte pas' in playback was for me so heart-rending? Why I found Loles León's dance in *Tie Me Up! Tie Me Down!*, Miguel Bosé's drag act in *High Heels* and the title sequence of *Women on the Verge of a Nervous Breakdown* so totally exhilarating? Why in *Dark Habits* Julieta Serrano's scream and the sight of Carmen Maura as a nun standing next to a huge tiger should awaken in me similar feelings? To explain all this by aesthetic analysis would never do full justice to a creativity fuelled by a formal power which thwarts all formal analysis.

Visual pleasure is only one aspect of the sensual stimulation Almodóvar's films embody. They are films of the flesh, of immaterial feelings made flesh by the actors, the first of these feelings being desire. The most elegant form becomes an echo chamber of emotions. To this end all contrivances and variations are possible. If the frozen images of the famous title sequence of *Women on the Verge . . .* touch me to the quick, the reason lies in the staggering song performed by the Mexican Lola Beltrán which accompanies them. It is in the grain of the voice and, occasionally, in the texture of the skin.

To describe what I experience witnessing certain scenes and certain shots in Almodóvar's films would entail describing my innermost emotions and impressions. That was the limit of our conversations. More than once, it became clear our dialogue could not progress unless one of us – and it was more often Pedro than I – referred directly to his private life. This was certainly not our intention and we would quickly move on to another subject. Certain answers and certain questions – and there were no doubt other reasons for this too – have been held in abeyance. Almost by default, I consider this communicates one of the essential aspects of Almodóvar's films. They are films in which the most intense, yet for all that, chaste emotions are spectacularly displayed; emotions both untrammelled and unforced, significant and unsignified, explicit and unexplained, emotions which the director offers without forcing them on us, thereby preserving

their quintessential violence as well as their playfulness. That is perhaps the secret of these films' vibrant energy. They know how to retain their innocence; they delight in strong, simple images, full of complete and primordial feelings (love, pain) which, bathed in primary colours, also know how to be simply beautiful. Yet these films are also mature, as one must be to trust one's own emotions and accept being touched by their images.

Before the idea for this book came to mind, I discovered these qualities in Almodóvar himself, when we first met in 1990 at the Berlin Film Festival (where he was promoting *Tie Me Up! Tie Me Down!*) and later on the set of *High Heels*. Just as naturally as in his films, there exists within Almodóvar two spirits. The one is frank, innocently candid, passionate and rebellious – this he uses to get under the characters' skins in order to play them or to tell their stories to the cast during rehearsals; the other is serene, judicious, stubborn, exacting and constantly at work. Again, sense and sensation, intelligence and expressiveness. In a way, it was through the film-maker himself I came to understand what I liked in his films. However, this does not solve the problem Almodóvar admits he himself is confronted with at the end of this book; namely, that he has become – or has remained – more famous than his own films, stealing the limelight from those actors and technicians who helped make them.

His mastery of communication, which first led him into becoming a creature of the stage singing with McNamara, coupled with the joyous sense of celebration, of sheer entertainment in all its forms that his films delight in, have made him the most lionized, not to say media-friendly of contemporary directors. Fertile ground indeed for the seeds of provocation and excess. Until *High Heels*, his biography as contained in press releases read as follows: 'Pedro Almodóvar was born in La Mancha in the 1950s. It was the age of the Cold War, of mambo, of Balenciaga, of the Korean War, of the Hungarian revolution, of the death of Stalin etc. But none of these events had any affect on Cazalda de Calatrava, the small town where he was born. Almodóvar cast his eye around him and did not like what he saw. He felt like an astronaut at the court of King Arthur.' The facts are true, but already they are being manipulated by their subject in a style hardly typical of such sober publications. In the press book for *Kika*, Almodóvar's likes and dislikes were listed: 'He detests famous drug addicts who having ruined both their health and their careers with all kinds of drug abuse, go into detox and then start writing books on the subject ... He hates epaulettes and uniforms of all kinds including those for sport ... He hates the idea someone may write his biography either before or after his death. This is one of the reasons he would like never to die. However, if he should die, he cannot bear the idea of

not being present at his own funeral. Surgical operations: removal of appendix, tonsils and a polyp on a vocal chord . . . He takes sleeping pills. His constitution is paradoxical. He suffers both agoraphobia and claustrophobia.' This list, both serious and eccentric, where self-celebration and self-derision are inextricably entwined, represents an ongoing attempt to raise the film-maker to the level of a character, in other words an original being who revels both in futility and sagacity, who is by nature intriguing and, like Andy Warhol (another artist who was even more skilful in manipulating the media), is also deeply phobic.

Such a cult of the original cannot escape caricature. Avoiding the Almodóvar character was therefore also one of the rules of these conversations. This was an easy rule to respect: if Almodóvar looks after his image, he himself rarely plays it, especially when he works – and he works a great deal.

Our journey through his career was planned chronologically and conducted over a year of meetings in Madrid. In spite of its obviousness, this method seemed to me the only one capable of bringing out, through a detailed analysis of each film from original idea to public release, the working method of the film-maker and to give an overview of a career in itself difficult to describe. After his first publicly released feature, *Pepi, Luci, Bom*, shot with no money and little technical know-how, Almodóvar made *Labyrinth of Passion*, a film of greater visual and sound quality but whose narrative was more chaotic. This was followed by *Dark Habits*, whose nuns confused those who saw in Almodóvar merely the director of the modern Spanish generation. With the realism of *What Have I Done to Deserve This?*, the abstract precision of *Matador*, the sensual vigour of *Law of Desire*, the brilliant comic ballet of *Woman on the Verge . . .*, the virulent acidity of *Tie Me Up! Tie Me Down!*, the Hollywood sophistication of *High Heels* and, finally, with the dazzling, explosive puzzle that is *Kika*, Almodóvar, faithful to his obsessions, and not to the image they give of him, has never ceased to wrongfoot both his critics and his admirers.

Such freedom was bound to make a happy mess of our sage chronological approach. As you will see, the films speak to each other, interweave, come and go as their heroes do in the romantic labyrinths erected by their creator. Such meanderings are the weakness which make up the strength of Almodóvar's films; incapable of giving his scripts a rigid structure, of curtailing his imagination, his limitless inventiveness, he allows each story, each character, major or minor, to live to the full; in other words, sometimes anarchically. And when, for *Matador*, he worked for the first and only time with another writer who helped channel his inspiration, Jesus Ferrero, the result was

hardly his best film. It's in diversions and complex entanglements that Almodóvar's *mise en scène* finds its fullest expression. His labyrinths are channels of communication using all forms of expression: advertisements, photo-stories, comic strips, television, music and song. The result is a heterodox aesthetic where classicism, the avant garde, films of all genres find their place; a baroque cinema bringing together in one gesture all the great artistic adventures of the century. That is what makes them so fascinating.

But there is one thing missing from this book – the voice of Almodóvar himself, its colourful, animated intonations bringing to life the smallest anecdote, capable of transforming it almost into an epic. A sensation which gave these conversations all their sense.

Frédéric Strauss

Pepi, Luci, Bom

Super 8

Solitude

Photo-stories

Pop

Andy Warhol

FRÉDÉRIC STRAUSS: *Your first commercially released film in Spain was* Pepi, Luci, Bom *(Pepi, Luci, Bom y otras chicas del montón). What had you been doing before 1980?*

PEDRO ALMODÓVAR: From 1972 onwards, before making *Pepi, Luci, Bom*, I'd shot a great deal of very short Super 8 movies. In 1978, I also made my first full length film, *Folle . . . Folle . . . Folleme . . . Tim*. I'd moved to Madrid in 1968. But only after three years of living in a city I didn't know (and working for Telefonica, the national telephone company) did I save up enough to buy a Super 8 camera, get together a group of friends and feel ready to take my first steps in movie-making. At the time, the underground scene in Madrid and Barcelona was much richer and more dynamic than it is today – if it's survived at all. Lots of people, grouped together in clubs and associations, were making films and organizing their own Super 8 festivals. Barcelona was much more the centre of this creativity than Madrid. Influenced by American culture and counter-culture, this creativity expressed itself not only through films but also through comic strips, fashion and, most of all, through a certain lifestyle. Oddly enough, it was ten years later in Madrid, at the end of the Seventies, that the movement developed and came into its own. By that time, Catalan separatism had effectively isolated Barcelona from the rest of Spain.

During the Seventies I often went to Barcelona to show my Super 8 films at festivals and I became rather well-known as a director of Super 8 movies. People enjoyed watching my films so they went down rather well. However,

because my films were narratives, Super 8 specialists, directors and theorists, didn't consider me a true practitioner of the art. Super 8 at the time was heavily influenced by underground movements such as Fluxus, one of whose members was Yoko Ono. It was essentially a conceptual cinema, the kind of cinema where nothing happens. I remember one film, for example, which consisted entirely of shots of a country house. It was rather long. My films, on the other hand, always told a story. This had been my strongest desire ever since I'd first picked up a camera. But for the members of the Super 8 movement telling a story was something very old-fashioned, like a film of the 1940s. I ended up feeling left out of a movement I naturally belonged to.

I attempted all genres in my films. Quite a few of them were influenced by the Cecil B. De Mille biblical epics. We shot them in natural light without any professional equipment at all. The shoots always turned into a party. People used to plunder their sister's or mother's wardrobes for costumes. Eventually, I started imitating the programme of a real cinema; I'd make fake newsreels, fake adverts, then the main feature. The programmes were successful because they became a kind of Happening. Since all the films were silent – sound recording for Super 8 is difficult and the results always unsatisfactory – I'd stand next to the projector and do the voice of each character. I'd also provide a running commentary and sometimes criticize the actors' performances. And I'd also sing. I had a little tape recorder and would insert songs in the films. These were live shows and the audiences loved them. The screenings were held at friends' houses but I'd organize them as if they were eagerly awaited world premières. They were a big party. And they became more and more successful. Soon, I was screening my programmes in bars and discos, then in the private film schools which had just been set up in Madrid, in art galleries and finally – and this was the high point of this period – at the Madrid Film Institute.

Had you seen many films before making your own?
Yes, I'd started going to the cinema when I was about ten. Until then, it was rather difficult to see any films at all in the village where I lived. In the Sixties, at Cáceres where I was at school, we'd see American comedies, films by Frank Tashlin, Blake Edwards or Billy Wilder. I very much liked Stanley Donen's *Two for the Road*. I also saw the first films of the French Nouvelle Vague, *Les 400 Coups, A Bout de Souffle*, and the great Italian neo-realist films, the first Pasolinis, films by Visconti and Antonioni which will stay with me forever. They touched me profoundly. None of these films spoke about my life, yet I felt strangely close to the world they described. I was bowled over by *L'Avventura*. I'd say to myself 'This film speaks to me.' Which was

rather an exaggeration since I was still a child and had no idea what the bourgeoisie was about. But the film was about *ennui* and, stuck as I was in my provincial backwater, I knew all about that. I felt exactly like Monica Vitti does in the film. I could say, just as she does: 'I don't know what to do. All right, let's go to a nightclub . . . I think I've an idea . . . but I've forgotten it . . .'

L'Avventura: 'This film speaks to me.'

In retrospect, my reaction seems rather kitsch, maybe it has something to do with my gay sensibility, but it was sincere, I felt the same. I also remember Françoise Sagan's *Bonjour Tristesse* and feeling totally nihilistic when I'd finished reading it. By then I'd already rejected religious education. From the start, I knew the priests had nothing to say to me. I recognized myself with equal conviction, in *Cat on a Hot Tin Roof*, a film the church considered the apotheosis of sin. I'd say to myself: 'I belong to the world of sin, of degeneracy.' I was twelve years old and if someone asked me 'What are you?' I'd reply: 'A nihilist.'

Cat on a Hot Tin Roof: 'I recognized myself.'

Did you know what it meant?
A little. The lack of any meaning anywhere. Since my life had no meaning it seemed rather obvious. I felt like an extraterrestrial, close to the Nihilists and very far from God. That was the message I received from films. I saw the great classics ten years later at the Madrid Film Institute at the end of the Sixties. I'd go every day: westerns, which bored me as a child, the great American comedies of the Thirties and Forties. I loved them most of all: Lubitsch, Preston Sturges, Mitchell Leisen. Until then, I didn't even know these directors existed. It was also my first experience of the German expressionists. Their films left me speechless as if I'd seen miracles.

Did you read a lot?
All the time. I must have been nine when I bought my first book. No one told me what I should read so I discovered everything for myself. I started with the obvious. Living as we did in a small village, my mother and my sisters used to order things from Corte Inglés, a mail order catalogue, which for me was a kind of museum full of beautiful photographs. They were my first experience of art. My sisters bought things for the house and I bought books. I had no idea whether they were good or bad, they were simply the books in the catalogue, mostly the bestsellers of the time: Lahos Zilahi's *Devil's Advocate*, Mika Wattari's *The Egyptian*, Morris West, Walter Scott. But there was also *Steppenwolf* by Hermann Hesse and the famous *Bonjour Tristesse* which made me cry out, 'My God, there are people like me! I'm not alone!' I only started reading Spanish literature when I was twenty. I especially liked the late nineteenth-century realists. Rimbaud or Genet were hardly mentioned at school, but I knew they'd interest me and I read them as well as some of the decadent poets. From then on, literature, French literature most of all, became a passion. In 1968, by the time I arrived in Madrid where books were much more readily available, Latin American writers had exploded on to the world. I read them avidly.

You were a very mature twelve year old.
I don't know whether I was mature or not. But I realize that what interests me now already interested me then. I had no need of education to discover such things. They came to me very early.

You were also very lonely.
Terribly lonely! I remember being ten and telling my friends about Bergman's *The Virgin Spring*. It had made a vast impression on me. They looked at me almost with terror. But they were also fascinated because it was something

totally alien to them. I had no one I could speak to at school. We simply weren't interested in the same things. I encountered the things I liked in the most absolute solitude. I only realized when I arrived in Madrid that there were people who shared the same interests.

So until that time you lived in a kind of parallel world?
Absolutely.

It must have worried your parents.
Yes, I remember my mother looking at me, hands on hips, saying: 'Where did you learn that?' She was quite disconcerted.

Was it a struggle to impose your personality?
Children develop great strength in solitude; they can also become very neurotic. Luckily, that wasn't the case with me. I'm sure of that because I was a

Pedro Almodóvar aged five with his sister, Maria Antonia, and his father, Antonio.

very good observer of other people's lives, and a happy one, pleased with what I saw. But always an observer, never a participant.

Your solitude was therefore never of an autistic nature?
No. Luckily, I had a strong character and I must say I found my predicament rather amusing. My childhood was made up of monologues. Often people would listen to them most attentively. Later, when I acted at school and, much later, when I presented my films at screenings, I understood that the solitude I felt on stage was the same as that which I had felt as a child when I spoke of what I liked. It probably explains why I'm so at ease on stage, why I'm so successful at it. I've never suffered from stage fright. I'm as relaxed there as I am in my kitchen.

Almodóvar aged eight with a mandolin: A long-held desire to perform on stage.

When you sang with McNamara, as you did in Labyrinth of Passion, *was it the realization of a long-held desire to perform on stage?*
Yes, it was. But it was a playful desire, devoid of pretention. Being on stage is a very intense experience. I recommend it to everyone. I don't mean it's important to do something on stage in order for other people to see it but that it's interesting to have a dialogue with an audience rather than with just the one person.

The concerts with McNamara were very provocative.
Yes, they were. They seem even more so today. We live in more conservative times.

When you speak of your childhood you give an impression of great freedom. One would have assumed such a rural upbringing would be very moralist and reactionary?
It was far worse! From the earliest age, I was surrounded in my village by all the things I didn't want to do, the kind of things I would fight against in the future. It was very important for me to understand this early. But this understanding was the result of enormous tension, and to arrive at it was not pleasant. My childhood was neither sad nor happy. I already felt the disapproval as a child I would later feel as an adult. Although my elders didn't know what they disapproved of, their judgement of me had been made. I don't want it to sound dramatic but it was hard. Luckily, I wasn't traumatized by it because I have a very positive personality. I also escaped into books and films and this gave me enormous pleasure. But I did feel rejected and despised. The strength I possess, I found it within myself. Strangely enough, I was always very aware of what was happening around me. I had to be patient and wait several years until the outside world fitted the universe I inhabited.

Did you continue your studies in Madrid?
No. I'd passed the equivalent of the Baccalauréat and I thought I'd go to university and study film at the same time. But I didn't have enough money to go to university and Franco had closed down the film school. I told myself life in all its aspects would be my education. I went to the Film Institute, read, bought myself a Super 8 camera and lived a great deal. I also had a job. That also was part of my apprenticeship. My very presence at Telefonica was rather scandalous: I had long hair and didn't dress like anyone else. I led a kind of double life. From nine to five, I worked as an administrator and in the evenings I was something else entirely. But the years I spent at Telefonica

8

were very important. I learnt a great deal about the urban bourgeoisie which I could never have learnt otherwise. This discovery had a great influence on my films. Until then, all I knew about was the rural poor.

You waited until 'the outside world fitted the universe you inhabited', but you also contributed in creating this outside world. You became one of the key figures of the Madrid movida.
I didn't create that world. Various creative currents met at the same time. But by arriving in Madrid I also found freedom in spite of Franco's dictatorship. Madrid was a centre of clandestine activity. Such a life was quite normal as far as I was concerned.

You haven't mentioned the actors of the films you saw in your adolescence. Did certain actors, and especially actresses, make an impression?
The actresses who sit in my private pantheon are the great actresses of the Forties and Fifties. In the spontaneity of certain actresses who've worked for me, I see Carole Lombard, the early Shirley Maclaine or Katharine Hepburn. That somewhat idealized image of women was very influential.

There's a photo taken in the Seventies of you and your brother Agustín standing in front of a poster of Marilyn Monroe. But you haven't mentioned her.
Kika's character owes a little to Giulietta Masina, the working-class woman

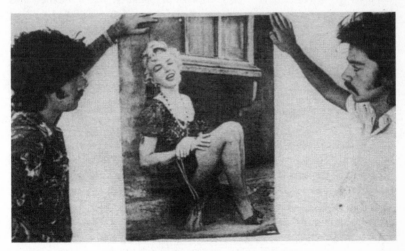

Pedro and Agustín Almodóvar, enshrining Marilyn Monroe.

9

in *Nights of Cabiria*, a little to Holly Golightly in *Breakfast at Tiffany's*, but also a great deal to Monroe's innocence, along with her sensuality and spontaneity. For me, Marilyn was an excellent actress, totally out of the ordinary. Her last film, John Huston's *The Misfits*, is one of the most moving films I've ever seen. What impresses me most about Marilyn – like James Dean, she's become a kind of icon – is not her glamour but her very personal, unschooled acting style. Like Kika, she also possesses a kind of wounded innocence.

The Misfits: 'One of the most moving films I've ever seen.'

I discovered Marilyn when I was about twelve but only fully understood her talent, her exceptional character, later on. The photograph you mentioned was taken when Agustín was helping me make a very conceptual short, the idea for which – a shrine dedicated to Marilyn – I reprised in *Law of Desire*. A picture of Marilyn dominates the shrine. On the steps leading up to it are various books with cover photographs of her. All the pictures of the saints on the altar are pictures of Marilyn lit by candles. There are shrines everywhere in Spain, especially in the villages, and they always put

pictures on the altars which are believed to have a beneficial influence, ease one's solitude and strengthen one's faith in the future. For my mother, the picture would be of Mary of Carmel, and for me, Marilyn. Their function is identical. My rural education was very important in this way. Even though I didn't as a child take part in the world around me, there came a time when, in my own way, I made it my own. Witnessing the outside world was also part of my education.

Getting back to Pepi, Luci, Bom, *how did this full-length film come into being after the success of your Super 8 programmes?*
I was still working for the phone company, making movies in the evening and on weekends, when I encountered an independent theatre company, Los Goliardos, who, as well as performing their own shows, were starting to take part in more professional productions. During this last period of shooting Super 8 I therefore had the chance to work with genuinely talented and experienced underground performers such as Carmen Maura, whom I both directed and acted with in Los Goliardos.

I was still very attached to Barcelona where I maintained a close relationship with a group of artists, many of them cartoonists such as Mariscal, who were all associated with *La Vibora* (*The Viper*), one of the best Spanish cartoon magazines of the last twenty years. I'd written stories for the cartoons in the magazine and also created a kind of photo-story which had gone down very well. I was asked to do another one. It had to be punky, very aggressive, dirty and funny. That was very fashionable then. I wrote it and called it *General Erections*.

At the same time, I was also acting with Carmen in a play which had something to do with filth: *Dirty Hands* by Jean-Paul Sartre. I had a small part, the communist who is about to commit a crime, while Carmen, who'd already become a famous actress, was the star of the show. Our relationship would have been ideal melodramatic material for an American musical of the Thirties. Carmen was the star and I was the *meritorio*, the new boy, the one who works for next to nothing and who has to prove himself capable of being a true professional. We were therefore at opposite ends of the ladder. Carmen, however, was fascinated by me and we'd spend hours together in her dressing room. I'd watch her preparing for the show, a ritual which always fascinates me. And while she brushed her hair and made up, I'd tell her the stories I was writing and, in those days, I was writing a great deal.

One day, I told her about *General Erections*. She loved the story and told me I should turn it into a film. So I took the photo-story and turned it into a script. The result pleased me. I found it very funny. I thought of shooting it

in Super 8 but Carmen and some friends of hers, members of Los Goliardos, decided it was time to stop working in Super 8 and move up to 16mm. The film was renamed *Pepi, Luci, Bom y otras chicas del montón* and Carmen decided to find the money. She was helped by Felix Rotaeta, who plays the policeman in the film, and who became a director himself a few years later. Carmen and Felix called all their friends and asked them for money. Some gave five thousand pesetas, others twenty thousand and, thanks to hundreds of friends, we amassed half a million pesetas. That was our budget.

Pepi, Luci, Bom: The general erections scene.

We shot the film with a crew of almost all first-timers. The cameramen cut off some heads, mine above all during the general erection competition. The shoot was very chaotic and lasted a year and a half, starting in 1979 and ending in 1980. We could only work weekends and when he had money. We constantly had to adapt the schedule to our material circumstances – which changed constantly. One day, when we'd completely run out of money and we weren't even sure we could finish the film, I remember thinking I'd appear on screen myself and tell the audience how the film ended. After all, telling a story was what interested me most.

Pepi, Luci, Bom is formally my most imperfect film but it gives a clear and precise indication of my vocation as a director. It was a fantastic education for me. The way we had to shoot also gave me a certain independence from the narrative rules of film-making. Under such conditions, continuity, for example, is no longer a problem. The lack of funds provides the kind of creative freedom which it's much more difficult and sometimes impossible to attain on a normal shoot. It's a film full of flaws but when a film has only one or two flaws it's merely imperfect; when the flaws are as numerous as they are in *Pepi, Luci, Bom* they constitute a style. I used to say this as a joke when I promoted the film, but I think it's rather true.

The criteria for the original commission of the photo-story, the original source of Pepi, Luci, Bom, *seem to permeate the film. It's both provocative and even somewhat vulgar. Later, the language and the way you tackled such scabrous material was much less crude.*

Yes, it's true, the vulgarity arose from the terms of the initial commission. The film's origins lie not only in photo-stories, but also in comic strips. I make the influence quite clear by using cards between various scenes which describe the action in a dramatic and condensed manner. As compared to film-based material, the fact that *Pepi, Luci, Bom* was first a comic strip – and a vulgar punky one at that – affected the development of the characters. The characters are very clear archetypes, instantly recognizable and typical of the medium they came from: the modern girl, the nasty cop. There is no need for psychological development.

Do you mean Pepi, Luci, Bom *was a kind of stylistic exercise mixing the codes of the comic strip with those of cinema?*

Not at all. For me, the style of the film corresponded to the kind of cinema I was spontaneously drawn to both as director and spectator. Although instinctively attracted to the punk attitude which was one of the conditions of the original commission, I was also more naturally influenced by the American underground, Paul Morrissey's first films, and most of all John Waters' *Pink Flamingos*. The films I'd been making were less documentary and sociological than Morrissey's. I was more interested in fiction. But my sensibility was as amoral and playful as his. *Pepi, Luci, Bom* helped express in concrete form my relationship to pop, a style I'd always felt close to – in this case, the hard, corrosive pop of the late Seventies. I tackled the pop of the Sixties in *Labyrinth of Passion*. It's a much lighter, tamer style, exemplified by Richard Lester's first films and Frank Tashlin's comedies featuring the kind of American housewife Doris Day played so well.

Were you aware of these references when you were making these films?
I don't know whether they were clear to me then or whether they became clearer later on. Most of the time, I'm only aware of what I wanted to do after I've finished a film. I discover what I want to do while I'm shooting. No doubt, this was even truer then. One inevitably gains greater awareness with hindsight.

In Pepi, Luci, Bom, *Pepi considers making a film with her friends which, like Andy Warhol's movies, would be inspired by their own lives. Was your intention similar to Pepi's, and therefore Warhol's, when you made the film?*
My desire was no doubt similar to Pepi's, but different from Warhol's. Actually, Pepi explains this in the film: when you want to shoot a kind of documentary about people you know and present them as characters, the very nature of the project implies a certain manipulation of your friends, of their true personalities. Pepi tells Luci that her natural presence isn't enough to bring out her truth on screen. She must play herself, not just be herself. She tells her cinema rain is fake because real rain doesn't register on screen.

This is exactly what interests me in cinema: cinema speaks of reality, of things which are true, but must become a representation of reality in order to be recognizable. There's a very important difference between me and Morrissey or Warhol. They simply stuck their camera in front of the 'characters' and captured everything that happened. It's very powerful cinema, but I'm not patient enough to wait for something to happen in front of my camera. I love the artifice which is a part of a director's work. And artifice is precisely what communicates a film-maker's intentions. When Morrissey and Warhol were working, their films were violently new compared to the American cinema of that time. They completely rejected what one considered to be the normal rhythm of film, the lighting which creates the atmosphere of a scene. Even if it wasn't their intention, their films are genuine sociological analyses of their country. It's both very interesting and surprising to see how Warhol, who was a master of the art of frivolity and the banal, became one of America's greatest sociologists. His book, *My Philosophy from A to B*, is one of the most serious works ever written about American society.

Did you really meet Warhol the way Patty Diphusa, the character you created for your chronicles in the magazine La Luna *and who featured in some photo-stories at the beginning of the Eighties, describes it?*
Yes. But it didn't happen quite the way I tell it as Patty. It probably happened in 1983/1984. A Spanish millionaire who, by chance, became the producer of *Dark Habits* and *What Have I Done to Deserve This?* had bought several

of Warhol's pictures. They were composed of crosses, guns and a third element, I can't remember what. He exhibited them for the first time in public in his house in Madrid. Warhol came over for the occasion and every night there was a party in his honour. And every night I was invited and introduced to him. It became a bit of a bore because each time I was introduced to him as the Spanish Andy Warhol. By the fifth or sixth time, Warhol asked me why. I told him it was probably because there were a lot of transvestites in my films. He took lots of pictures of me – he was always taking pictures at parties – but what really interested him was meeting the Spanish aristocrats who might commission work from him. He didn't have much luck with them and he didn't paint my portrait either because I wasn't famous enough yet.

Was it an emotional meeting for you?
Not especially, because I'm not an idolater. In the last few years, I've had the chance to meet many very important and famous people, some of whom I'd admired for ages. But, oddly enough, when I like an artist, I have no desire to meet him because quite often, when one does, the person one meets is very different from the person one knows through his work. On the other hand, it is possible to be interested in an artist and for his personality to be appealing quite independently from his genius as a creator. For example, I remember meeting Billy Wilder who, I'm sure, would have fascinated me even if he hadn't had such a formidable body of work behind him. I met him two or three times in Los Angeles in 1988 when I was promoting *Women on the Verge of a Nervous Breakdown*. He saw very few people at the time but he agreed to see me because he very much liked my film. He told me he'd asked all his friends to vote for it at the Oscars. He also gave me one piece of advice: never give in to the temptation of working in Hollywood.

Is it a piece of advice you'll follow?
I don't know. For me, a film always depends on its script. So it all depends on the kind of story Hollywood might offer me. But if there's a possibility of working there, it's still a distant one. I'm not against shooting a film in English. I even think it might happen quite soon. But for the moment I wouldn't want to make this English-language film in Hollywood. I'm very clear about that. Often, when I see American films directed by Europeans, such as Stephen Frears' *Hero*, I tell myself it's exactly what one shouldn't do, that those directors fell into every trap lying in wait for them. It's a very dangerous enterprise.

Pepi, Luci, Bom *is your only film which, in the end, most firmly rejects the*

idea of disparity. Luci is abandoned by her two friends because they cannot accept and cannot bear her very ordinary, not to say reactionary, idea of happiness – a life dominated by a tyrannical husband. Nothing can save Luci. She is disqualified. In retrospect, her exclusion is very surprising. It's the exception which proves the most immutable and most natural rule in your work: your affection for your characters and your desire to give all of them, even the most unsympathetic, such as the selfish mother in High Heels, *a chance to be liked by the audience.*

One must also make clear that what one perceives as normality can no doubt include the most perverse things. Bom experiences a great deal more perverse pleasure as a housewife than as a bohemian, a creature of the night. She comes home disappointed, convinced that her true nature belongs in the kitchen and the dining-room. This was the first film where I dealt a little with the particular difficulties of being a couple. As in *Tie Me Up! Tie Me Down!*, every couple is different and has their own rules. For me, the moral of *Pepi, Luci, Bom* is that modern women are alone. Pepi and Luci abandon Bom who is not alone, while they are deeply so. Free, but alone.

I was very interested in this vague, vagabond-like aspect of the female character. Anything can happen to a solitary person who has no defined aim, who is always on the edge of a crisis. Such a character is the perfect vehicle for telling a story. I don't mean people who are genuinely lost, without any kind of social connections, who through their very abnormality are capable of waiting for anything to happen, but rather someone such as the heroine of William Boyd's *Brazzaville Beach*, a novel I recently strongly considered adapting. She is erratic, not because she doesn't know what to do with her life, but because at a certain point – the point where the writer enters the story – she is searching for something she is only vaguely aware of. For me, the end of *Pepi, Luci, Bom* reflects that feeling.

It's also a little bit about the triumph of feeling over modernity. Bom, who represents the modern Madrid singer, starts to suffer, and that feeling allows her to discover another kind of music, the *bolero*, which is the most emotional type of singing, although it's never really been fashionable and certainly isn't modern.

The female characters in Pepi, Luci, Bom *are echoed in nearly all your later films. Their independence, their energy, their seductiveness as well as their emotional confusion are the primary elements of their descendants. On the other hand, the character of the policeman was never developed later. He's a cipher and doesn't seem to have interested you much.*

True. I wasn't pleased with him either. Policemen appear in my films only to

16

Luci (Eva Siva) and Pepi (Carmen Maura): 'Modern women are alone.'

facilitate the development of the story or the female characters. I try to escape from them or cut them out because they're never as good as the characters around them. But since there are always crimes in my films, or things that can be interpreted as crimes, it's very difficult not to include them. I managed to find a better way of dealing with the problem in *High Heels*, where Judge Dominguez, played by Miguel Bosé, is a genuine presence, both mysterious and seductive; the elements, therefore, of a proper character. But it's precisely because he presents various faces, those of Femme Letal and Hugo, because he isn't only a judge, that he became interesting as a character.

This rather thin image of the policeman also suggests – and this seems to me very interesting – that there is no real representation of the law in your films. In Pepi, Luci, Bom *the fact that Luci's husband is a policeman is hardly used. In* Tie Me Up! Tie Me Down!, *the transgressive behaviour of the character played by Antonio Banderas is never seen in relation to the law. It exists in a world of excess, including an excess of vitality. It needs no rules to define itself against.*

The law: Miguel Bosé in *High Heels*.

There are so many links between transgression and the law that I try to negate the existence of the law. I'm constantly struggling to exclude the law from my films. In the case of *Tie Me Up! Tie Me Down!*, Antonio Banderas's character isn't particularly transgressive. He's even someone trying desperately to be normal, whose every excess arises from his desire to correspond to his image of what is a socially acceptable person. He apes normality. It's an infantile desire and he's very much a child. Personally, transgression isn't my aim, for it implies the kind of respect and acceptance of the law I'm incapable of. This may explain why my films were never anti-Franco. I simply didn't even recognize his existence. In a way, it's my revenge against Francoism. I want there to be no shadow or memory of him. Transgression is a moral word and my intention is not to break the rules but simply to impose my characters and their behaviour on the audience. It's one of the rights and also one of the powers a film-maker possesses.

I very much liked Alaska, who plays Bom and whom you never used again. Was she originally an actress or a singer?
Alaska was a singer and continued to be one. Nowadays, she has more success in the hotel trade than in music. By that I mean that there is much

The transgresser: Antonio Banderas in *Tie Me Up! Tie Me Down!*

less of a spirit of musical adventure in Madrid nowadays than when we made *Pepi, Luci, Bom*. Many performers of the time are now business people, hoteliers. It gives some idea of how this city has changed. Alaska was one of the key figures of the pop movement; what, in the past fifteen years in Spain, became known as the *movida*. But at the time of *Pepi, Luci, Bom* she hadn't yet made a record. She was fourteen and played the guitar. I was the first to make her sing. She never acted again on film. I hadn't found her a particularly gifted actress but her character, her nature, interested me a lot. Most of all she had the guts to agree to being in the film. I like her a lot.

Cristina S. Pascual and Cecilia Roth play small parts in the film. They were to star in two later films, which I find surprising. In my opinion, they aren't your best actresses.
No, they're not. Cecilia was a friend of mine and I gave her a small part because her character was totally in keeping with the role. But, as I said earlier, she had to act this character for the film and she didn't perform it very well. As for Cristina S. Pascual, she always took part in my films for other reasons. Before becoming the heroine of *Dark Habits*, she'd done several small film parts and had managed very well. But *Dark Habits* was produced by her husband, hence her starring role.

In Labyrinth of Passion *we see you directing a photo-story starring McNa-
mara, the actor and singer you recorded with several times. And we can see
that, even for a photo-story, your directions are very precise. But the words
you use are keywords, orders, formulas defining strong ideas. It isn't really a
dialogue with the nuances one expects. Passing for the first time, with* Pepi,
Luci, Bom, *from photo-story to film, from stills to moving pictures and
sound, how did your work with actors develop?*

For me, directing actors is like a game. It's what I always did with the
greatest ease and was always the most immediately satisfying aspect of my
Super 8 films. I had no idea what a director had to do technically. I consider
myself fundamentally clumsy, technically. Learning technique was what I
found most difficult. The sound on *Pepi, Luci, Bom* is bad, but we kept it
live. We didn't work on it particularly, due to lack of funds.

Making the film didn't really change my way of working with actors. I've
always communicated through them to the audience, even in my silent Super
8 films. I did develop, of course, but more importantly I must say there's no
such thing as directing actors in the broad sense of the term. Each actor is
directed differently. One tailors one's work according to the actor. The way I
directed McNamara has nothing to do with the work I accomplished with
other actors. McNamara has a strong, very undisciplined personality and
limited or, at best, highly personal faculties of comprehension. This is due
both to his own character and to the fact that, while we were making *Laby-
rinth of Passion*, he was constantly on drugs. I therefore directed him – and I
don't mean this at all pejoratively – as I would have an animal: very clearly,
authoritatively, directly and violently. At the same time, I left him much
more freedom than the other actors because what I wanted from him was the
expression of his own character, what he was in life. So I tried to provoke
him into being most like what he was outside the film. In fact, I hadn't
planned to be in that scene at all but his lack of attention and his indiscipline
were such – he was incapable of keeping to his marks and was always
leaving the shot – I couldn't direct him from behind the camera. I therefore
had to be in the scene in order to direct him. I was almost holding him on a
leash.

My aim is to lead the actors to express what I desire and what I have a very
precise idea about. Any means are justified in order to arrive at this, even
revealing one's working method which, in this case, was rather unique and
particular.

Labyrinth of Passion

Screwball comedy

Gossip columns

Madrid *movida*

Bad mothers

Little girls

FRÉDÉRIC STRAUSS: *Did the fact of having shot* Pepi, Luci, Bom *in 16mm help you enter the world of cinema proper and make your second film?*
PEDRO ALMODÓVAR: Not really. *Pepi, Luci, Bom* quickly became a cult movie. They'd show it at two in the morning in independent cinemas such as the Alphaville in Madrid. It took me nearly two years to make *Labyrinth of Passion*; I was still working at the phone company and found it very difficult to find a producer. It was the Alphaville, who'd never produced a film before, who decided to finance my second film. It was shot in much better conditions than *Pepi, Luci, Bom*. It was still a lowly and precarious undertaking, though. The budget was 20 million pesetas which, taking into account the numerous characters, scenes and nearly forty locations, was very little even for those days. *Pepi, Luci, Bom* was a cooperative production; no one was paid a salary. For *Labyrinth of Passion*, I was able to work with a professional lighting cameraman. However, it was a film shot in the same 'underground' spirit as its predecessor. I remember I had to paint the set for Cecilia's room.

The dramatic structure of Labyrinth of Passion *is clearly more ambitious than that of* Pepi, Luci, Bom. *The script is much more elaborate and presents a universe of greater romantic complexity. How did you make such progress in writing?*
In spite of its complexity the film wasn't difficult to write. Shooting it was much harder. I was a beginner. I'd only made Super 8 films, apart from *Pepi,*

Luci, Bom, which to all intents and purposes was one as well. Making a screwball comedy such as *Labyrinth of Passion* wasn't easy. One needs great technical mastery to make an illogical, headlong, *'disparatada'* comedy. The action is fast and taken up by several characters at once. The narrative rhythm must be perfectly sustained and be evident both in the overall organization of the film and within each scene. One needs a great deal of experience to succeed in putting across this sense of rhythm. I don't think I was ready at the time to make such a film but the end result appeals to me even if, with hindsight, *Labyrinth of Passion* strikes me as a film which could have been better made technically. I don't mean the technical aspect should be spectacular; with this kind of film one should never be aware of the camera. But a certain facility and know-how is vital in the telling of a story where many things happen at once.

Pepi, Luci, Bom was a freewheeling, pop comedy. Labyrinth of Passion, however, is already the type of comedy which conforms to certain conventions. How would you define these conventions and how did they influence the story of the film?
The film belongs to the genre of the screwball comedy, a genre which always appealed to me and to which I always felt a close affinity. I'm thinking, for example, of *Easy Living*, a film written by Preston Sturges and directed by Mitchell Leisen at the end of the Thirties. It's the very epitome of the kind of screwball comedy I adore. When I was writing the script of *Labyrinth of Passion*, my intention was to present Madrid as the world's most important city, a city everyone came to and where anything could happen. One draft of the script had Dalí and the Pope meeting and falling passionately in love. That story was eventually cut, but it summed up the general idea. It was an ironical idea, of course, but one which many people, who started promoting Madrid as if it really was the world's most important city, took very seriously.

At the time, I loved reading women's magazines. I'd always find something which appealed to my sense of humour: women who wrote in because they bit their nails or because they'd put on weight and were asking advice. Those are the kind of women in my film. I also had in mind kitschy historical films such as *Empress Sissi*, but from the point of view of those sensationalist and absurd newspapers obsessed with royalty. The film was particularly inspired by the Shah of Iran, who at the time was still in power and the last living emperor. So I imagined the son of the Shah of Iran coming to Madrid and used another key figure in the gossip columns, Princess Soraya, who became Toraya in the film. Through them I wanted to tell the story of a

Easy Living: 'The epitome of the kind of screwball comedy I adore.'

couple who have difficulties developing their relationship. These difficulties stem from the fact that the man and the woman share the same sexual behaviour.

I took up this theme again later and treated it in quite a different way in *Matador*. There the man and woman are destined for each other because they belong to the same species; they are totally different from other human beings. This fictional motif is, in a certain way, related to the relationship Nastassia Kinski has with her brother (played by Malcolm McDowell) in the remake of *Cat People* directed by Paul Shrader. At one point he tells her: 'You cannot fall in love with another man because you're not like him. You're destined to love me because I'm the same as you.' The character of the brother doesn't exist in Jacques Tourneur's original *Cat People* and I loved the kind of relationship Shrader created.

In *Labyrinth of Passion*, the relationship is much less complex and much less serious. Their similarity lies in the simple fact they both like men. Hence the first scene of the film: the girl only has eyes for men's crotches and tries to guess their assets. The boy is the same. I was trying to talk in an ironic

manner about the kind of pure relations lovers take no part in so as to differentiate themselves from others. Since both the girl and the man in *Labyrinth of Passion* have slept with so many men, their true love must be founded on something else entirely.

Formally, Labyrinth of Passion *is still rather free. But certain ideas in the script and some of the characters recur in later films right up to* High Heels: *the mother who sings, whom her daughter tries to imitate; the woman who suffers from a traumatic childhood; the terrorists who meet at the end of the film at the airport as in* Women on the Verge of a Nervous Breakdown. *Your ideas were already well advanced.*

The film contains almost all of the romantic themes I developed in later films. But it also corresponded much more closely to contemporary life. *Labyrinth of Passion* was made during the golden age of the Madrid *movida*, between 1977 and 1983, and almost all the key figures of the movement – painters, musicians – are in the film. They enter the film almost by the side door and, leaving aside all cinematic considerations, it gives the film a certain topical interest. For this reason, however, the film retains an emblematic power in Spain. It was also in this film that two of our most famous actors, Antonio Banderas and Imanol Arias, played their first parts.

To take up an adjective you used to describe Warhol, Labyrinth of Passion *is also your most 'sociological' film. You weave a highly complex fiction while painting a very realistic portrait of the life of a city.*

The story is pure fiction, even science fiction. But in some respects it did correspond to a certain image of contemporary Madrid. I believe this is one of the things that characterizes all my work. My scripts are pure invention, but the greater their unreality the more I try to treat them in a true and realistic manner. My basic tools are the dialogue and the actors' performances. For example, one could remake *Barbarella* in such a way that, even though the character is totally imaginary, the film would no longer be science fiction. One could remake *Barbarella* very realistically and still tell the story of an extra-terrestrial girl. It's one of the most wonderful aspects of cinema; you can make something unbelievable believable.

A director who would want to make Barbarella *in such a way would therefore keep the story and the character but shoot it in a literal style, without referring to the genre the film belongs to. Is that what you mean?*

It's more subtle than that. It means telling a story which belongs to one genre

in the style of another. One must therefore remain aware of the original genre in order to be unfaithful to it.

In fact Labyrinth of Passion *is a mixture of several genres: pure comedy, action films, musicals, realist, romantic films . . .*
Such radical eclecticism is characteristic of all my films. It's not an intellectual position, though I'm convinced such eclecticism is a very *fin de siècle* way of telling a story. Nowadays, people can easily look back, choose the stories the century has provided and mix them together according to their taste. This eclecticism is evident nowadays in music, literature, even fashion. At the end of a century one tends to take stock; it's not a time for inventing new genres, but rather for reflecting on what has occurred, a time where all styles are possible. My films reflect this purely coincidentally. Their eclecticism is natural, instinctive. No doubt because I never had an academic education, because I never went to film school, I've always remained undisciplined and free. I don't mean I'm more original; I'm simply less orthodox.

One of the funniest characters in Labyrinth of Passion *is the psychoanalyst. She has nothing to say about the psychology of the characters she sees. She comes across as a purely comedic character. One feels you liked her for herself and not for one moment do you take her seriously.*
Yes, my use both of the character and psychoanalysis is strictly parodic. I wanted to do something which, in fact, I still haven't dared do: to make a parody of all those films – Hitchcock's included, which I like very much – where an elaborate flashback to the character's childhood attempts to explain the inexplicable. The two main characters of *Labyrinth of Passion* often speak of their nymphomania and I decided that they should do so to a psychoanalyst in order to show that this type of behaviour has no explanation. That's my opinion, in any case. For certain scenes I used music by Béla Bartók very similar to Bernard Herrmann's scores for Hitchcock. The flashbacks to childhood are some of my favourite parts of the film.

However, the flashback to Victoria Abril's childhood in High Heels *isn't parodic at all. In fact, it's one of the most moving moments of the film.*
Yes, I try to show that the woman is still the little girl she once was. I try to explain the true nature of the character. It's not parodic at all.

Does this mean your feelings about such devices have changed? That you

recognize the power of truth and sincerity such explanatory flashbacks can provide?
I'm simply getting older!

In general, the characters of your films are rather neurotic. If you had believed in psychoanalysis your way of telling a story would have been quite different. Your rejection of psychoanalysis determines the shape your stories take: all your characters, when confronted by emotional problems and crises of identity aim, not to solve them, but rather to live with them.
Absolutely. I believe that if characters have problems they should solve them between themselves. That is the adventure of their lives. A character lives with his problems and develops within them. This makes him a hero because these problems force him to do things which are out of the ordinary. I can't imagine how I'd tell a story without such unresolved and problematic elements. They're what make it so refreshing and interesting.

There is a very strange and minor character in Labyrinth of Passion *who recurs in several later films and who seems to have inspired Becky del Paramo, played by Marisa Paredes, in* High Heels: *the bad mother who doesn't love her child. She's the only character in your films incapable of love and, as such, an enigma.*
Yes, she does recur in my work. The character was born out of my observation of a certain type of Spanish mother. She is often frustrated and embittered because her husband has either disappointed her or left her and so she becomes cruel towards her child. Often in the street you see a child fall over and the mother, instead of helping him up, gives him a slap. It's a very Goyaesque, Spanish image, a negative maternal image which occurs circumstancially in the universe of my films yet corresponds to the nature of that universe. Since it's a character I don't like, I've never based a whole film around her. The mother in *High Heels* is selfish, a pleasure-seeker and a bad mother, but she has other traits too and, in the end, even expresses love.

It strikes me that what interests you most about this cruel mother is her little girl. The child in your films always is a little girl and in different guises she recurs in What Have I Done to Deserve This?, Law of Desire, Tie Me Up! Tie Me Down! *and* High Heels. *Even as minor characters these little girls, as personifications of childhood, are always very moving.*
It's something irrational which happened without me being conscious of it. I

Labyrinth of Passion: 'The child, already alone and different.'

haven't made a film about childhood *per se*, but it's true, all the little girls who appear in my films have traits in common. I suppose the image I have of them reflects my deepest feelings about childhood. These are little girls who will grow either into great artists or great neurotics. Or both. They are already alone and different and always seem to have been so. Even though I've never spoken directly about my own childhood, feelings of solitude and isolation evoke that time of my life.

Inspired by Brian De Palma's *Carrie*, I gave the child in *What Have I Done to Deserve This?* a highly cinematic destiny through the use of special effects representing supernatural forces. There's a Spanish proverb: to steal from a thief is not a sin. So to imitate an imitator doesn't strike me as dishonest and this trade of influences amuses me enormously. Stealing an idea from Brian De Palma seems perfectly legitimate because, even though he's a true creator, he himself has stolen lots of ideas from other film-makers. Children like Carrie live surrounded by such violence and incomprehension they are forced to develop certain defence mechanisms in order to survive. Such a situation, admittedly bad, can lead some children to understand themselves, to discover an inner strength well before other children do. The special effects in *What Did I Do to Deserve This?* are a metaphor for this inner understanding which can endow one with a secret, but definite, strength. I was myself isolated and misunderstood as a child and I remember coming to terms with my personal identity at a very early age. When I was eight, I knew exactly what I did not want. This allowed me to develop quickly, without wasting any time. Perhaps these little girls are a projection of my own childhood, but I've never analysed it.

How was Labyrinth of Passion *received publicly and commercially?*
It had a much greater success than *Pepi, Luci, Bom*, no doubt because it's a real comedy, not so hard and dirty. I remember attending one of the first public screenings and seeing the whole audience laughing from beginning to end. The film caught the spirit of liberation which then ruled in Madrid. People identified with it. It became a cult film like *Pepi, Luci, Bom* and even today it's on late night screenings at the Alphaville. Critically, the film fared very badly, much worse than *Pepi, Luci, Bom*. It was distributed in the States, Italy and France after *Women on the Verge of a Nervous Breakdown*. The critics abroad were kinder, no doubt because the film was by then eight years old and useful in providing a key to understanding what came later. I haven't seen *Labyrinth of Passion* for a long time now, but I like the film even if it could have been better made. The main problem is that the story of the two leads is much less interesting than the stories of all the secondary

characters. But precisely because there are so many secondary characters, there's a lot in the film I like.

Labyrinth of Passion: one of the secondary characters.

Dark Habits

Religion

The pure and the impure

Plastic art

Visual ideas

Insane love

FRÉDÉRIC STRAUSS: *Your next film was* Dark Habits. *For a non-conformist, wild, young director such as Almodóvar to tackle religious taboos seems a producer's idea. Was the film in fact a commission or a personal project?*
PEDRO ALMODÓVAR: The idea for the film was entirely mine but *Dark Habits* became a producer's film.

After making *Labyrinth of Passion*, I was approached by Hervé Hachuel, a multimillionaire who'd made his fortune in oil and real estate – also the man who'd bought the Warhols. He was living with Cristina S. Pascual at the time and she was threatening to leave him. He was madly in love with her and ready to grant her anything in order to keep her. She asked him to set up a production company which would finance films in which she could pursue her career as an actress. So, Hachuel set up Tesauro Productions and asked her who she'd like to work with. She replied: Berlanga, Zuluetta and Almodóvar.

Hachuel rang to ask whether I had a script ready. I immediately asked whether Cristina S. Pascual was to be the star. 'Of course not,' he replied. But by the way he said it I knew he meant the opposite. He said the same thing to Berlanga, who wrote a part for her. But the film was never made and neither was Zuluetta's. As for me, I tried to approach the commission in a positive way and explore all the possibilities. I therefore wrote a film with a female role all actresses would die for. The concept behind the commission became the concept for the style of the film. I came up with the story of a girl who drives both men and women wild, a girl who sings, drinks, takes drugs, occasionally goes through periods of abstinence and has the sort of

extraordinary experiences one would never have were one to live a hundred years.

This was the film I intended to make but, since Cristina S. Pascual wasn't capable of turning this dream into reality, I had to limit my ambitions and rewrite the script. While writing it I had in mind Marlene Dietrich's work with von Sternberg, especially *Blonde Venus*, where she plays a housewife who becomes a singer, spy and prostitute, who travels the world living a life

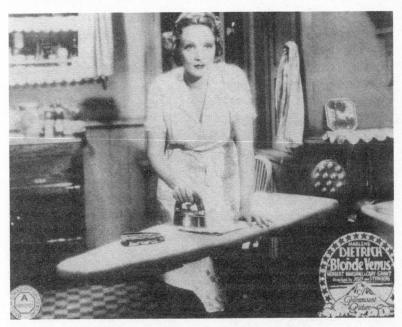

Blonde Venus: Marlene Dietrich as a housewife.

of never-ending adventure. That kind of character was the ideal for the film I wanted to make. However, the important thing for me is not the initial idea of a script but what comes out of it once I start working on it. And, as I was writing the script, I realized I was not only telling the story of this fabulous woman, but also the story of the nuns of the convent in which she finds refuge. Paradoxically, these nuns possess a much stronger personality and creativity than the people outside their convent. Their vocation is to save lost girls, but when the story begins there is a shortage of delinquent girls to save and, out of boredom and idleness, the nuns begin to develop their own freedom and independence.

Dark Habits is not, in my view, an anti-clerical film; that's a facile, superficial interpretation. I'm not a practising Catholic, but I know that the vocation of the nuns in my film is entirely Christian; they simply follow the words of Christ's apostolate. To save man, Christ became man and experienced man's weakness. In the same way, in order to save lost girls, the nuns must be close to them, to the point that one of them actually becomes a delinquent and is thereby capable of speaking to these girls as an equal. The Mother Superior represents something else again: the fascination with evil in

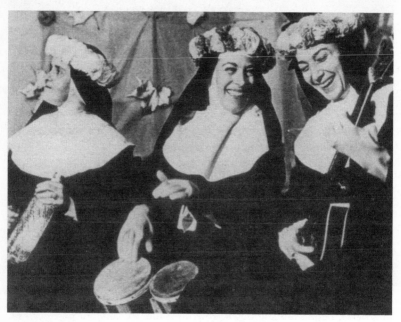

Dark Habits: 'The nuns possess a much stronger personality and creativity than the people outside their convent.'

the tradition of French writers such as Sartre in *Saint Genet*. This fascination, which is related to a certain conception of pity, is fundamentally religious. The Mother Superior has decorated her room with pictures of the greatest female sinners of her age – Brigitte Bardot, Ava Gardner, Gina Lollabrigida – because, as she says, Christ did not come to earth to save saints, but sinners. It's therefore to these poor sinners that we owe Christ's coming and the miracle of the Catholic Church. All this is much better explained in the film by the Mother Superior. *Dark Habits* was a turning

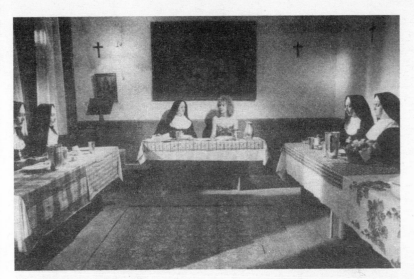

Dark Habits: 'In order to save lost girls, the nuns must get close to them.'

point for me. It was the first time I attempted to tell a story that was both very sentimental and highly melodramatic.

Watching the film, one feels your intention was to avoid caricaturing your own daring and avoid being systematically shocking, which would have been very easy in the circumstances. But to retain such innocence is rather difficult in a film where every scene seems intentionally provocative. And sometimes you seem ill at ease, as if you were stopping yourself from going too far in order to go too far.

In general, I don't think about whether my films are going to shock or not. And all interpretations seem to me interesting and acceptable. The different ways of reading a film arise out of the film itself and for this reason they are all valid and authentic, including those I least agree with. The fact I don't want to be provocative is therefore irrelevant; if someone is shocked by the film it's because of the film. A Catholic audience such as Spain's is bound to find *Dark Habits* scandalous because the nuns do forbidden things. It's the most predictable reaction and I tried to ignore it while I was writing and making the film because I wanted to develop a very personal idea. I'm not so naïve as to think I wouldn't provoke angry or negative reactions by showing nuns shooting up heroin. But I don't want that kind of instinctive reaction to stop me telling my story. For this reason, I worked on the script with the

utmost seriousness and created each character with the utmost care and tenderness. I was therefore highly prepared before making this film and very at ease shooting it.

Technically, the film marks a great step forward. There is a greater ampleness, harmony and variation in your mise en scène.

Making this film, I really began to come to grips with the cinematographic language. It was also the first film I made with sufficient funds. This afforded me fewer technical problems. With the right crew and equipment, it's possible to attempt different kinds of *mise en scène* without putting the whole film in peril.

It was while making *Dark Habits*, particularly while directing Julieta Serrano who plays the Mother Superior, that I realized the power of the close-up, a very simple image whose narrative content is highly complex and specific. The close-up is a kind of X-ray of the character and precludes all duplicity. It's technically difficult to set up. First, you must be very sure of what you want the character to express at that precise moment and, secondly, how the actor will interpret this, for there is nothing more frustrating and disappointing than a meaningless close-up. I'm insisting on the point because I hadn't realized it before this film and it was a very powerful experience for me. I had to conquer a kind of modesty. The close-up lays bare the character, the actor and the director. It therefore isn't just a technical matter, but also a moral one. In this particular case, the close-ups of Julieta Serrano were also my way of compensating for the fact that the character played by Cristina S. Pascual wasn't working and wasn't living up to its importance. By filming close-ups of Julieta Serrano, I was also filming the object of her love; the character of Cristina S. Pascual finds its full power in Julieta's eyes.

There is also a more practical reason for these close-ups. They allow us to differentiate between the actresses, who otherwise would seem identical on account of their nuns' habits.

Yes, of course. Only their faces are different.

Does costume in your other films constitute a form of characterization?

Costumes are very important not only for the characters but also to help define the aesthetic of a film. I like to choose a kind of uniform for the characters. This endows them with a mythical quality amd makes them almost more abstract and universal. For example, in *High Heels*, Victoria Abril only wears Chanel. Apart from the fact that this corresponds to her

character of a newsreader, it's also a way of giving her a uniform, as with Marisa Paredes, who in the film only wears Armani. For me, these uniforms express a feeling close to Greek tragedy. In *Dark Habits*, the nuns' habits also interested me because of the numerous high angles. High angles are commonly taken as representing the eyes of God, which in this case was perfect. The high angles nail the nuns to the ground like frightened animals. Their black habits are ideal; they become insects, closer to the underworld than to heaven. It's a little humiliating for them, but it's the look of God.

From Dark Habits *onwards, religion is present in all your films, if only through a minor character such as the mother in* Matador, *who belongs to* Opus Dei, *or the scene in* Law of Desire *where Carmen Maura goes to see the priest who educated her and is thrown out of the church because she was once a boy and is now a woman. There is also the opening image of* Tie Me Up! Tie Me Down!, *the picture of Christ and the Virgin. Did you film the image for its kitsch value or is it to be taken literally, for its religious significance?*

Kitsch exists in all my films and it's inseparable from religion. In all those examples, I used religion to comment on purely human feelings. What interests me, fascinates me and moves me most in religion is both its ability to

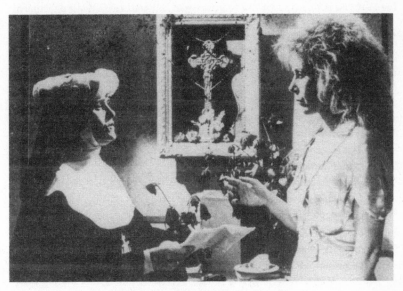

Dark Habits: 'Kitsch exists in all my films.'

create communication between people, even between two lovers and its theatricality. In the communion scene in *Dark Habits* communion for the Mother Superior becomes a way of expressing her love for Yolanda (Cristina S. Pascual). I discreetly change the traditional end of the ceremony by substituting Christ and the Virgin for another object of adoration. At the moment of communion, the doors of the church open and a heavenly light bathes in glory the person who enters: Yolanda. The Mother Superior steps forward at the same pace as Yolanda, the person she desires to commune with, communicate with, become at one with. I convert a religious language into a lover's language, something profoundly human.

In *Tie Me Up! Tie Me Down!*, the kitsch image which opens the film hangs above the bed where Antonio Banderas and Victoria Abril consummate their union. By starting the film with a religious image, I wanted to comment on the sacredness of marriage, sacred not because it's blessed by the church, but because for me the union of two people is by its very nature sacred. So, I show this picture of the flaming heart because we are going to see two people who love each other passionately. I use the sacred heart of Jesus in a way which is no longer entirely religious or purely aesthetic. I realize such a significance may seem obscure to an audience, but I don't particularly mind that. When I choose to show an image, or a shot, many interpretations are possible. I realize the reason why I want to show such an image may not entirely be grasped by everyone. All the more so because sometimes I myself am not totally aware of the significance of the choices I make when I make them.

In transforming a collective act of religious adoration into a personal act of love, you brave the forbidden. But you do so with great discretion, without seeming to blaspheme or wanting to fight against the established religious order.

I'm cleverer than that! I don't fight against religion, but take from it what interests me. It's a very personal habit but it corresponds to a very Spanish way of treating religion. For example, the Holy Week in Seville is a totally pagan event, pure idolatry. It's terribly human and sensual. Among the people watching the procession, you always hear girls utter a phrase which has since become part and parcel of the event, an expression which the ceremony almost seems to codify: 'Someone's feeling my bum!' The remark's almost run-of-the-mill – everyone pressing together and so on – and the girls who say it are neither shocked nor trying to shock. Sensuality plays a conscious part in the ceremony.

Let me tell you something I've never told anyone. Since this book is going to be published abroad it won't matter. I studied under Salesian priests; I

don't hide it because I hate the Salesians. One of their duties is to say a great many masses a week. The grand public mass was held just once a week, but to fulfil their duty the priests also held solitary masses. So, by the time the nine o'clock public mass was held, they had already said at least two others, one at six, the other at seven, at dawn. Each priest needed an acolyte to say these masses. I remember this very well because I was often 'chosen'. Clearly, the priests chose the boy they found most appealing. This mass therefore became for the priest a secret, intimate, nocturnal act. The child couldn't possibly realize this, but it would all happen as if the priest was saying to him, 'I'm celebrating this mass for you.' It's an example of the way religion, by slyly profiting from the intimacy of the mass, can be used for personal gratification, without making any open admissions. I find that disgusting.

I'll give you another example which I remember from my life with these priests. In fact, I made much use of this experience while writing *Dark Habits*. I loved to sing, I'd spend hours singing, I was a soloist and two choirs would accompany me. When it came to my solo, which was really a show in itself, I'd dedicate my song to my best friend. It was a deliberate, calculated act. I'd make a little sign to my friend, he'd show he'd understood, and I'd start singing for him. The mass became a personal ceremony. If one lives it consciously, it becomes pure; unconsciously, it becomes dirty.

Dark Habits *features the first appearance of one of my favourite actresses in your films, Chus Lampreave. How did you come to choose her and where did she come from?*
She's one of my favourites too. I'd told her of my interest in her before *Dark Habits*. She was totally unknown at the time. She'd started working in films out of friendship; she'd work with people she liked and who liked her, such as Berlanga, but she wasn't considered a professional actress. She'd first acted for Marco Ferreri when he was working in Spain at the end of the Fifties. She had small parts in *El Pisito* and in *El Cochecito*.

Chus is the kind of actress who makes a huge impression on me even if she only appears on screen for a few seconds. I wanted to work with her from the moment I started making Super 8 movies. I called her to offer her the part of Luci in *Pepi, Luci, Bom*. She seemed a little horrified by the script, but even her reservations were charming. She had problems with her sight at the time and an operation on her eye prevented her from acting in the film. I called her again for *Labyrinth of Passion*, but this time they were operating on her other eye. She was very struck by my tenacity because she didn't consider herself to be a proper actress.

When I called her again for *Dark Habits*, she told me she couldn't turn

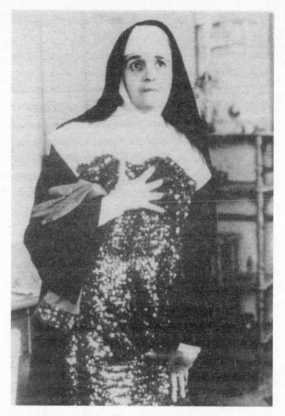

Dark Habits: Chus Lampreave.

down the part I was offering – a tiny part, that of Sister Illtreated – after so many refusals. The actress who was to play Sister Illtreated had dropped out at the last moment so I called Chus. Her reaction was not what one would have expected from an actress: she couldn't understand why I was offering her such an important part and felt incapable of playing it. Luckily, I persuaded her to accept and in Spain she became the great revelation of *Dark Habits*. Audiences hadn't noticed her in her small parts and the surprise was universal.

Ever since, Chus and I have had a very strong relationship. Out of all the actresses I've worked with, she's probably my favourite. She has qualities which make her unique, she's sort of a female Buster Keaton. She has an extremely expressive face, but her expressivity is due to a complete lack of acting – rather like certain Japanese actors whose expressionless faces release

enormous power. Chus belongs to the tradition of great film comics who express the maximum meaning with the minimum effort. Her talent is comparable to Toto's. What's more, Chus manages to retain an extraordinary naturalness in the most shocking and crazy situations. This gives her an almost surreal truth. She'll always create something true and credible out of the craziest parts. I very much like actresses who are atypical, like Chus. Their way of moving and speaking make them unclassifiable.

In order to get the kind of irresistibly funny performances she gives in your films do you have to rehearse her a lot or do you allow her a certain freedom?
Chus creates her own characters, enriches them, thinks about them a great deal. But she's one of the actresses I rehearse least. She's highly intuitive and over-rehearsing would ruin her spontaneity. I take what she brings from her characters, I direct her but leave her a great deal of freedom and initiative.

She isn't in Tie Me Up! Tie Me Down!, High Heels *or* Kika *and it's difficult to see which parts she could have played in them. Does this show a certain shift in your inspiration, that it's no longer open to the expressivity of a Chus Lampreave?*
I hope not. It's true there wasn't a part for her in any of those films, but I do want to work with her again. In a more general way, it's true I'd like to rediscover certain elements missing from those films. I've developed in an entirely instinctive and intuitive way and I can't tell what I'm going to do next. I would very much prefer if the type of character Chus Lampreave can play didn't disappear from my films. But that's all I can say for the moment.

One of the strongest images of Dark Habits *is that of the nun, played by Carmen Maura, feeding and caressing a tiger. The tiger doesn't really affect the story, it's almost an object, you seemed to have filmed it simply for its remarkable presence. There are images in your other films which seem to be present simply for their aesthetic appeal, images which audiences will remember and hence are used for promotional purposes such as the tiger in* Dark Habits, *the man in leather in* Tie Me Up! Tie Me Down! *and the green lizard in* What Have I Done to Deserve This? *What did you intend by using these images?*
The tiger in *Dark Habits* isn't simply an object. For me, it represents the irrational. The image of a tiger and a nun isn't simply an image which appeals to me as a visual effect, the tiger is also an essentially surreal device which helps explain certain characters, in particular Sister Perdition

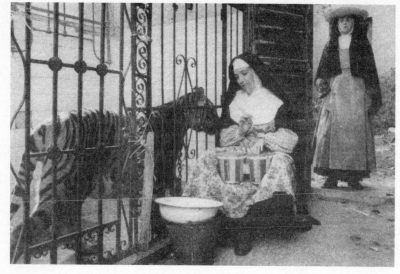

Dark Habits: Carmen Maura and the tiger.

(Carmen Maura). The tiger represents many things in the film. Firstly and most obviously, it's a masculine presence. Sister Perdition is a housewife, she looks after many animals and the tiger, whose size makes him seem clumsy and out of place, becomes her child. At the time I was making the film it was fashionable among certain people to keep big cats, snakes, even crocodiles, at home. The papers often reported there were mutant crocodiles abandoned by their owners and which had adapted themselves to city conditions living in the New York sewers – a bit like The Penguin in *Batman Returns*. That was partly the reason for the tiger. A lost girl had brought it to the convent while still a cub. Cured of her ills, the girl had gone and the tiger had grown into a wild animal. The tiger is a metaphor; he couldn't be stopped from growing, like the personalities of the nuns which grow wild and uncontrolled.

The masked man in leather in Tie Me Up! Tie Me Down! *makes a very brief appearance in the film-within-a-film. Was he more of a visual device to shock the audience, something you could use for its entertainment and publicity value?*
These images do have the capacity of promoting a film. They don't really represent the film, yet they give a strong visual idea of its content. But for me these images also have a meaning. In general, I prefer not to explain the

meanings contained in the images of my films. I prefer to suggest them. Let me find the script of *Tie Me Up! Tie Me Down!* then I'll be able to explain the role, the very concrete function the man in leather plays in it.

The film-within-a-film in *Tie Me Up! Tie Me Down!* is exaggeratedly artificial and baroque, an outrageous *Phantom of the Opera*. The film is simply an excuse for the director to get to know his actress. He wants to save her from death; in other words from her fate as an addict. The man in leather represents the threat of death. Through his film, the director offers his actress the opportunity to speak without danger to an image of death. I showed this in such a kitschy manner that the audience may well have missed the point. I chose to do so because it's such a powerful concept for me that I would have been embarrassed to communicate it seriously. Kitsch protects my modesty and so I'm very attached to it.

Presenting a scene where a girl speaks to her own death, something which both attracts and repels her, would have seemed to me unbearably pretentious. But the dialogue contains that meaning. Marina asks the monster, 'Where are you taking me?' and he replies, 'To a place of peace where no one knows us and where we can be happy' – a highly simplistic way of promising happiness. Marina goes on: 'But first take off your mask and show me your face' – thereby showing her irresistible curiosity for the forbidden. The dialogue continues: 'I have no face.' – 'But you must have something if you want to take me with you. I'd better get used to it now.' – 'Are you sure you want to see me?' – 'Yes.' – 'I can't. Look at my body. It's full of life. But I have the face of a dead man.' – 'You offer me only death which rarely brings happiness.' Marina's last lines express in an ordinary way what a psychiatrist would say to an addict: that the body brings pleasure, but beyond it there is only death. That is why the monster has such a spectacular body, but no face, no soul. It's a kind of a psychodrama, very theatrical and very kitsch.

Talking about my work in this manner, I feel I'm showing you my guts. I'm explaining all this in a very banal way, but that was my intention in the scene.

The way you subsequently use these meaningful images for promotional purposes is therefore hardly cynical. It's a natural extension of the spirit of the films, films which themselves often play with the idea of publicity.
Yes, it's spontaneous. In *Tie Me Up! Tie Me Down!*, everything that occurs around the film-within-a-film is dramatic and linked to the aesthetic of publicity. On the set, there are tests with false daggers and fake blood; I show the artifices of horror, but they're also a preparation for the real horror to come. The director saves Marina from the terrible situation which Ricky's arrival

creates. Ricky will endanger her life and she will have to dominate him, first physically, by going on top when they make love, then emotionally by tying him into her feelings for him. The essential difference between Ricky and Marina is that she is aware of the passion which unites them while he isn't.

Dark Habits *is a comedy, but the end of the film is sad and tragic, particularly for the Mother Superior, heartbroken and abandoned by the woman she loves just as her community falls apart. The serious tone is surprising, but I very much like this ending precisely because by staying closer to the character it doesn't conform to the comedic genre. It's very moving.*

The film was always seen as a costume situation comedy. But behind the comedy lies the story of the Mother Superior's insane passion for Yolanda. I sincerely felt the tragedy of that love. This may perhaps take the audience by surprise. But the ending of the film seemed to me logical. It is disturbing. I imagine this may have something to do with my outlook on life, my belief that there is always a moment when tragedy wins over comedy, also the fact that, as a director, I don't respect genres; even if I adore them I can't keep to them.

I did shoot another much funnier ending, more in keeping with the comical conventions of the film. The drug-dealing nun ends up in prison and Yolanda goes to live with the Marquise who has found her son in Africa where, brought up by apes, he's become a kind of Tarzan. He returns to the villa and in the last scene of the film Yolanda is seducing him while the Marquise dictates her memoirs to Chus Lampreave who intends turning them into a romantic novel. I edited the scene, but when I heard Julieta Serrano's cry of despair in what is now the final scene of the film I realized that was the true ending and there could be no other.

I very much like films whose endings are a kind of turnaround. *Barton Fink*, for example, starts off as an acid comedy on the life of a writer in Los Angeles and becomes a horror movie by the end. In retrospect, this explosion of horror illuminates the whole movement of the film. *Something Wild*, initially a sophisticated light comedy, reveals in the last quarter hour that one of the male characters is a seriously dangerous psychopath. I love that. Jonathan Demme told me he had enormous difficulty persuading the producers to accept this ending. They considered it uncommercial. I like the Coen Brothers as film-makers; they're also friends of mine. I showed *High Heels* to Joel. He told me it was precisely the changes in tone and genre, even within lines of dialogue, which he liked. But most audiences stay very attached to traditionally linear narratives and remain highly respectful of the genres they represent.

What Have I Done to Deserve This?

Neo-realism

The storyteller

Publicity fiction

Taboos

Social roots

FRÉDÉRIC STRAUSS: What Have I Done to Deserve This?, *which you made after* Dark Habits, *is also a pseudo-comedy, this time in its entirety. There are a lot of laughs, but Carmen Maura's character is tragic from beginning to end.*

PEDRO ALMODÓVAR: My films have a very ambiguous appearance, *What Have I Done to Deserve This?* most of all. It's not a love story; I recount the horrific life, the daily injustices of a housewife. She's a very serious character and Carmen Maura played her that way. When she saw the film she said, 'My God it's cruel! How can people laugh at such an unhappy character? She is doubly victimized; by life and by the audience laughing at her.' The story is pathetic, but there is also a great deal of humour in the film. Personally, I'm not at all bothered by people finding it funny. I noticed that, at the end of the film, when Carmen says goodbye to her little boy who's taking the bus back to his village, Spanish audiences were very moved as if suddenly aware of what they had laughed at before, of this woman's tragedy and the social conscience of the film. When Carmen goes home after leaving her son, she has nothing left to do, not even the housework or the cooking. Her life is completely empty, she's helpless. She walks over to the balcony to throw herself off. After one screening, some members of the audience told me they couldn't have stood her committing suicide. It was already bad enough as it was.

How would you describe the film in terms of genre? Did you intend to mix several narrative styles in the film?

43

What Have I Done to Deserve This? is a film where again one finds several cinematic genres. Most of all, it alludes to a form of narrative I'm particularly fond of: Italian neo-realism. For me, Italian neo-realism is a sub-genre of melodrama which specifically deals not just with emotions but also with social conscience. It's a genre which takes the artificiality out of melodrama, while retaining its essential elements. In *What Have I Done to Deserve This?* I replace most of the codes of melodrama with black humour. Therefore it isn't surprising that the audience first takes the film to be a comedy, although of course it's a very tragic, pathetic story.

This mixture of tragedy and humour is very Spanish; I do the same thing in *High Heels*. For the Spanish, humour is a weapon against suffering, anxiety and death. There is humour throughout the film, but I deliberately distance Carmen's character from the comedy. And she understood this perfectly. She constantly finds herself in very funny situations, but never lets her character slip nor changes her style of playing; she follows her own path. It's very tempting for an actor to be taken over by the general atmosphere, especially when all the actors around her are having fun. But Carmen kept to her sober way without falling under the influence of the others or, another danger, caricaturing the unhappiness of her character. You need a lot of talent to arrive at such an equilibrium. Carmen's character is very similar to those housewives played by Sophia Loren or Anna Magnani: unkempt, badly dressed, always screaming at their children, they face all kinds of problems. Carmen's performance recalls those great actresses.

You often refer to the avant-garde or classical cinema, very rarely to the moderns, apart from the neo-realists.
The first part of my career was highly influenced by the American underground, John Waters, Paul Morrissey, Russ Meyer, the Warhol factory and also English pop, Richard Lester and *Who are you, Polly Magoo?*, a wonderful film about fashion by William Klein. My education took place amid the pop culture of the seventies. Pop for me is Stanley Donen's *Funny Face*, a film I consider my encyclopedia. Among the modern Europeans, the neo-realists were the biggest influence. For some strange reason, the Nouvelle Vague influenced American directors most of all. I love the French cinema of that time. *A Bout de Souffle* inspired many films, as did Hitchcock's *Vertigo*, but I also liked, from the period before the Nouvelle Vague, Renoir, Jacques Becker, Georges Franju, Clouzot.

There are a great many things I like which oddly haven't had any influence over me. I love American *films noirs* and Westerns, but you can only see traces of them in my films: an extract from Nicholas Ray's *Johnny Guitar* in

Funny Face: Audrey Hepburn.

Women on the Verge of a Nervous Breakdown, one from Joseph Losey's *The Prowler* in *Kika*.

Cinema is always present in my films, but I'm not the kind of cinephile director who quotes other directors. Certain films play an active part in my scripts. When I insert an extract from a film, it isn't a homage but outright theft. It's part of the story I'm telling, and becomes an active presence rather than a homage, which is always something passive. I absorb the films I've seen into my own experience, which immediately becomes the experience of my characters.

It's the method of a novelist rather than a film-maker.
Yes, the method of a story-teller. I use cinema the way a story-teller would use a story he's read rather than just seen.

One of the funniest aspects of What Have I Done to Deserve This? *are the fake commercials. They create a mixture of fictional levels within the film and recall the programmes you created at the start of your career. This playing with artifice and the functions of advertising has become one of your specialities. It occurs in almost all your films and has become almost a cult feature of them, eagerly awaited by a part of your audience. How important are these fake commercials and how are they linked to the general way you see advertising?*
I have a very ambivalent attitude to advertising. It entertains and horrifies me at the same time. The idea of seeing adverts every day – not a single day goes past without seeing one in the newspapers or on TV, they're omnipresent like God and the Devil – appals me. That's why the only adverts I make are those in my films. I've always refused to make real ones. The advertising genre interests me solely cinematically. What interests me in a commercial is not the selling of a product but the story it tells and the way it tells it. I can perfectly understand why children love watching commercials; they're stories told in short films. Commercials are also, in principle, the genre most open to comic delirium, to humour and surrealism. That's why I always insert a commercial into my films. Also, my films are very urban. Commercials are like the furniture in town apartments. They're part of the interior decoration.

In a commercial a situation and a character are created in a very short time. It's a very effective and expressive form. Did this interest you in relation to the work you do on the characters in your films?
I don't know whether it helped or influenced me, but it's certain that, as I was saying for* Pepi, Luci, Bom, *commercials contain the same archetypes as my films. I use a lot of clichés and develop them in a way commercials don't. But the fact these characters are archetypes interests me a great deal.

In What Have I Done to Deserve This? *when Carmen Maura uses the oven, the washing machine or the fridge you systematically shoot her from inside the machines as they do in commercials. This creates a kind of distancing effect. It's both comical and disturbing. Did this commercial technique hide other intentions?*
Absolutely, because commercials have a greater significance in *What Have*

What Have I Done to Deserve This?: 'The film is specifically about a social victim (Carmen Maura).'

I Done to Deserve This? than in any of my other films. The housewife is the main target of the consumer society and of all advertising. Nowadays, she has, in a way, been replaced by the yuppy. Nevertheless, since the beginnings of advertising the housewife has been the most well-observed and studied target of the medium. The heroine of *What Have I Done to Deserve This?* is one such target. She is genuinely isolated, abandoned by everyone. Her only companions are her household appliances. They're the sole witnesses to her pain, her solitude and her anxieties. They're also the only witnesses of the murder she commits. That's partly the reason why I film her from within these machines as they do in commercials. I wanted to underline the fact that only these machines see her and watch her. The camera takes their point of view. Advertising – and this is linked to pop culture – is the only medium which makes these objects alive and even endows them with personalities. There is a huge number of commercials in which the main character is a yoghurt carton, directed as if it were a real character, lit by the cameraman as if it were a genuine star. I'm very interested by this aspect of advertising: the value it gives to objects and the way it turns them into characters.

The commercials contained in your films correspond to a certain advertising style which one could date quite easily – from the early Eighties. I imagine

that when you conceive the trailers of your films the form of communication isn't the same and obeys other rules?

I use other ideas in the trailers for my films. Advertising interests me for all the reasons I've mentioned, but I'm horrified when I see it on television. I'm very aware that what I do is a product which belongs in the marketplace. I respect the laws of the market and I use advertising as a basic promotional tool – which doesn't prevent me feeling I'm contradicting myself. Luckily, I believe I have a knack for advertising. When I'm working on the promotion of a film I try to make the publicity part of the film itself, part of the overall creative process. Otherwise I wouldn't want to get involved. For example, for the opening of *High Heels* in Spain, we organized a preview at the Gran Via cinema where the whole crew of the film turned up on trailers wearing shoes five metres high. These exaggeratedly high heels on the Gran Via, the Spanish equivalent of Broadway, was my way of creating a conceptual image; people got a very strong image of the title of the film. The procession was a 'happening'. Of course, it became a fantastic piece of publicity. I knew there'd be pictures of the preview in all the following day's papers. But for me the most important thing was the 'happening'. It turned publicity into a living thing. I don't mean that it's totally innocent or uncalculated, but the aim of the publicity is much less important than the way it's staged. The commercials in my films are very conventional in spite of being parodies; for the promotion of a film, the advertising becomes an explanation and, by extension, an aesthetic complement to the film itself. What interests me most in the staging and creation of an event is to give back to cinema something it's lost in the last forty years: the fact that films are in themselves great popular events. Cinema, in its capacity to bring crowds together, has been replaced by sport and music. I'm therefore very keen on the idea of rediscovering, through the staging of a preview, the climate of euphoria and social celebration such as shown at the première of the film in *Singin' in the Rain*.

When I visited the set of High Heels, *your brother and producer Agustín showed me the poster for the show by Becky del Paramo – played in the film by Marisa Paredes – and explained to me that for the opening of the film hundreds of these posters would be put up throughout Madrid announcing a concert by a singer people would later discover was a character in the new film by Pedro Almodóvar. It's a lovely idea which reflects this sense of publicity as a fictional extension of the film.*

Yes, unfortunately we couldn't do it because we ran out of posters. It was my idea and I was very keen to do it. It was a way of giving the fiction an

afterlife, of introducing the fiction into the life of the city and bringing to life a character who only exists in film.

In a way, you did the same thing in Trailer para amantes de lo prohibido, *a medium-length video in which a housewife lives a similar adventure to Carmen Maura in* What Have I Done to Deserve This? *and meets a man who wants to take her to see the film. The poster for* What Have I Done to Deserve This? *appears several times in* Trailer. *In this way, the advertising enters into the life of the city since the video is shot with a mixture of artifice and realism almost entirely on location. As in a musical, songs replace almost all dialogue.*

Precisely. It demonstrates the idea that one can turn advertising into a genre of its own, a very free genre, ideal for comedy and unencumbered by too many psychological or narrative rules. *Trailer para amantes de lo prohibido* was born of a commission. I'd just finished *What Have I Done to Deserve This?* and Spanish television asked me to make a trailer for it. The idea bored me, so I decided to make a video where, during a story both different from and similar to the film (the main character has also killed her husband), the poster for *What Have I Done to Deserve This?* would appear. It was fun to make because I'd always dreamed of making a musical where characters stop talking and start singing. The fact the film was short and shot on video gave me great freedom. I simply asked the actors to mime to the songs I wanted to use without bothering to give each character its own personal voice. The heroine of the film sometimes sings with Eartha Kitt's voice, sometimes with Olga Guillot's.

In turn each character sings the same song called, I think, 'Soy lo prohibido' – 'I am forbidden.'

The whole film is a representation of the forbidden. The song is first sung by a prostitute, then by a little girl – because she too is the object of forbidden desire – and, finally, by Bibi Andersen who plays a woman out of a *film noir*, a creature of pleasure who sleeps with all the men she desires. By virtue of her own personality – she is a transsexual – Bibi brings to this representation of the forbidden another, more subterranean, dimension.

You didn't continue to develop this theme of the forbidden?

No. I especially liked the song; it spoke of the sensuality of secret desires. When I first heard it, I had the idea of a musical film whose script would be closely linked to the lyrics of other songs I wanted to use. But, in any case, my films aren't moral enough for them to be concerned with the forbidden

or perhaps they are so moral they forbid me to speak of the forbidden. Whatever the case, what's forbidden according to conventional morality I don't consider forbidden.

What Have I Done to Deserve This? is your least colourful film. It's shot in dull colours, evokes a sad rainy winter, accentuated by social misery, and gives a picture of Madrid rarely seen in your films. This visual sobriety has a socially interventionist power. It gives the film a critical dimension your other films don't seem to have or, at least, don't seem to have so clearly.

The dull colours reflect the ugliness which surrounds the life of the character played by Carmen Maura. Recreating that ugliness was as hard as creating the brilliantly colourful sets of *High Heels*. *What Have I Done to Deserve This?* is, in fact, my only film where everything one sees stems from a realist intention. It's also my most social film. I've never dissociated my characters from their social reality, but in this case the film is specifically about a social victim. She's a very important character for me because the film speaks of my own social origins. My life has changed and my social status with it, but I never forget the fact my background was very modest. Since I've started making films, I've often met people whose views I don't agree with. When I encounter them, I suddenly feel fighting within me the little child of a poor family for whom these people are the enemy. It's neither a systematic nor an ideological reaction, but it shows the importance for me of remembering the social class one comes from.

Out of all my films, *What Have I Done to Deserve This?* contains the greatest number of personal memories of my own family. The character played by Chus Lampreave was inspired by my mother; she speaks in exactly the same way. Carmen Maura's clothes, which were very important to me, belonged to my sisters or friends of my sisters. It was vital Carmen's clothes look worn, that they should have the ugliness of overuse. We shot the film in an area which dated from the Francoist building boom. The buildings represent the idea of the upper class supplying the proletariat with comfort. But they're unlivable places; people call them beehives. When I used to work at the phone company I'd go past these housing estates on the freeway and the vision of these vast buildings would stay with me for the rest of the day. I was genuinely happy to make them the location for my film. We shot the film in the very same place without changing a thing.

What Have I Done to Deserve This? is one of your most beautiful films and no doubt the one which most influenced the rest of your work. Having confronted social realism so directly, you no longer felt the need to treat it in

What Have I Done to Deserve This?: Chus Lampreave.

such a detailed manner in order for it to be present in your films. Your relationship with reality was once and for all given a solid base through the story of a 'social victim' as you put it. In High Heels, *when Becky del Paramo moves back into the flat where her parents lived, what may have been a simple idea in the script becomes a very powerful scene. Without insisting on the point, you manage to make the moment true both emotionally and socially. I imagine you wouldn't have been able to attain such exactness, such truth in such a short scene if you hadn't taken the time to explore in such depth your relationship with realism in* What Have I Done to Deserve This?

That scene in *High Heels* is one of the few moments of the film linked to my own life and you've put your finger right on it. *High Heels* has nothing to do with my relationship with my mother, but I'm intimately linked to the moment in the film when Marisa comes back to die in her parents' flat, her birthplace. The scene's also important because it situates the character socially. We realize the woman came from a very working-class area, her parents were poor and, in spite of the sophistication of her present life, she's like an animal who comes back to die where she was born. In general, my films speak of mothers, such as Becky, played by Marisa Paredes, and not

fathers. However, it's one of the rare scenes in my films which has to do with my father. He died of cancer twelve years ago. At the time, my family lived in Extremadura. When my father felt the end was near he asked my mother to take him back to the village of his birth. He was very ill. We all went back to the village, but obviously we no longer owned our family house. So my father moved into his sister's house which, in fact, happened to be his exact place of birth. His sister had the tact to give him my grandmother's bedroom and the very bed where he was born. When he arrived my father only had a dozen hours left to live, but the pain had entirely disappeared. It's amazing to see that death waited for him to return to his birthplace in order to take him away.

I've never spoken of it before but that is the background to the scene in *High Heels*. It's a very short scene and suggests nothing explicitly, but that's what it contains for me. Becky del Paramo returns from Mexico; we understand this from the way she decorates her parents' flat. I very rarely use old furniture in my films but, by contrast, I decorated Becky's bedroom with the dark, old, traditional Castilian furniture which recalls the atmosphere of her childhood.

Matador

Sex

Death

Abstraction

Male characters

The genesis of a story

FRÉDÉRIC STRAUSS: *I consider* Matador, *shot two years after* What Have I Done to Deserve This?, *to be the strangest film of your career. It's the least like the others, the only film where the theme – in this case, death, the fascination with death, and destiny – is more important than the story.*

PEDRO ALMODÓVAR: Yes, it is my strangest film, even though it's a film strongly related with what I'm most concerned with. I understand your point that the theme seems more important than the story, but do you mean that there is an imbalance between what is shown and what I intended to tell, or that what I want to tell isn't told?

I mean that certain images in the film are first and foremost a reflection of the theme of death, while in your other films the mise en scène *serves the story first then the theme. The relationship between the matador and the attorney exists for me insofar as they are symbols and embody certain ideas.*
Yes, it's my most abstract film, even though it deals with the most concrete matters, sex and death. It's also my least naturalistic film, the most removed from an objective reality.

I tried to make a kind of fable. The principal characters are heroes straight out of myth and legend; they couldn't possibly represent what is possible in real life. And I found it impossible to expect the audience to identify with two murderers. I wanted them to identify with the sensibility, the mentality of these murderers, with the idea of death they embody rather than its

reality. *Matador* is a difficult film to discuss because we should be talking about what the characters represent rather than what they are in reality. I also consider it my most romantic and pessimistic film. There are also many other elements in it apart from the love story; bullfighting, for example, which is one of the most specific and representative symbols of Spanish culture. The Spanish venerate the world of bullfighting even more than they do religion. Given the choice, they'd canonize a matador rather than the founder of Opus Dei. Out of all the countries it was shown in, *Matador* caused the most uneasiness and had the least success in Spain. To talk about the pleasure and sensuality of bullfighting is taboo in Spain.

In a very abstract way, the film also deals with two forms of Spain as represented by the two mothers in the story. Modern Spain is personified by Chus Lampreave, who plays the mother of the model. A spontaneous free-thinker, when her daughter tells her she's been raped, all she can think about is the state of her daughter's clothes after the attack. She washes them and later wears them herself. By contrast, the mother of Antonio Banderas, played by Julieta Serrano, typifies what I consider to be most terrible in Spain: the castrating mother. She is responsible for her son's terrible neurosis and guilt complex. She constantly judges and condemns and stands for

Matador: Modern Spain personified by Chus Lampreave (right).

what's worst in religious education in Spain. We were all brought up here in an atmosphere of terror, the terror of punishment – the worst punishment of all being hell itself.

Matador is not a film about bullfighting. I simply juxtaposed the ceremony of the *corrida* with the personal relationship between the lovers in

Matador: The relationship between sex and death.

order to deal with the main theme of the film, the relationship between sex and death. There is also an inversion of traditional male and female roles in the relationship between the bullfighter and the attorney. Even though bullfighting is a very masculine world, the *torrero* takes on the female role in the *corrida*. When he puts on his shining costume, hard like armour, he resembles a gladiator. But the costume is also very tight-fitting, the way he moves in it isn't entirely masculine, he hops about like a ballerina. During the first stage of the *corrida*, the *torrero* represents temptation. He teases the bull, seduces it. It's a typically feminine role. By contrast in *Matador*, Assumpta Serna has from the very beginning a very masculine role. She is the active partner in her relationships with men; she ends up penetrating and killing them with her hair pin, in a deliberate imitation of a *torrero*. In this way, there is a constant inversion in the film of male–female roles.

Matador: The lovers (Assumpta Serna and Nacho Martinez).

Sometimes, the woman is the *torrero*, sometimes she's the bull. She's so masculine, one could almost characterize the relationship between the two lovers as homosexual.

But what was your intention before you gave these elements a coherent structure? Before you formalized them so successfully in the script?
When I started writing *Matador* I wanted to make a film about death. Death is something I cannot accept or understand. By writing the film, I wanted to discover my position in relation to the very real fact of death. I didn't come up with anything very profound and realized that I couldn't deal with a subject which seemed to have no place in my life. In other words, I could only conceive of it if it became related to sexual desire. To some extent I agree with you. In my opinion, writing and making the film turned out to be a fruitless exercise. I pursue a subject I cannot master, I deal with a great many things which should help me tackle the subject, yet all I arrive at is a kind of theorem which could be expressed thus: if one dreams of extraordinary pleasure and life furnishes one with the opportunity to realize it, one must be ready to pay an extraordinary price for it. That summarizes rather well the story of the film.

When you write a script are the themes the basis for the writing? In the light of the notion of a theme which Matador *exemplifies, how do you work in general?*
I discover the theme of a film as I'm writing it. I hardly ever know what it is before I start writing, which is why writing tends to be such an adventure for me. I suppose the theme is within me, but only appears in my conscious mind after certain stages. Often the narrative intent which makes me write is a mere pretext. Often what I thought was the centre of a story disappears entirely as I'm writing. Which film would you like me to talk about?

Tie Me Up! Tie Me Down! *It deals with one of the principal themes of your films – how to build and create a family – without making your own ideas on the subject explicit. They are implicit, rather, within the characters and the story. The film attains a balance between a very strong theme – which could turn the story into a mere illustration of it, as in* Matador *– and a very strong story, which could, by its very coherence, operate independently and become merely anecdotal. This is partly the case in* Women on the Verge of a Nervous Breakdown, *where there is no dynamic link between the story and a given theme.*
Tie Me Up! Tie Me Down! was the film I prepared least. But I'll explain how it came about.

I shot *Women on the Verge* . . . entirely in studio. At the time I was still fascinated by the slightly underground notion that one should show both the converse and the obverse of things. As applied to cinema, this meant showing the artificiality of making a film. I like sets for what they are, representations of reality, and I had to stop myself from moving the camera a little and filming the sets of *Women on the Verge* . . . as if they were purely artificial constructs. I really wanted to show how these sets were built. While making the film, I gave this desire free rein by writing a story which, because it was set on a film set, would allow me to film the sets both as illusions and representations of reality. *Women on the Verge* . . . was also the first film I shot almost entirely in studio. We didn't have much money and my brother would often tell me how expensive it all was. So, I suggested we make a film which would re-use sets of *Women on the Verge* . . ., thereby recouping some of the outlay. So, *Tie Me Up! Tie Me Down!* was born out of both a financial consideration and my desire to step out of the set of a movie in order to film it.

One weekend, I wrote a story which took place in the studio we were using. Obviously, I had to stretch credibility a little because I wanted to film

in the one place. To justify all the characters staying in the studio without re-making *The Exterminating Angel*, which shows the best way of not chan-ging location, I imagined the story of three dangerous murderers who escape from prison and hide in a hangar outside Madrid. Since there's no real film industry in Spain we build our studios in rented hangars. The three convicts enter the hangar and find themselves in a film studio, only the film is nearly finished. The film-makers leave but the convicts stay. It's the first time they've ever possessed a house. Although it's a fake house and nothing works, it's a very beautiful house and they think it's wonderful. What they don't know is that the crew and cast are coming back in the evening for the wrap party. When they come back, the convicts hide in the production offices and in the lavatories and, to their great surprise, find themselves eavesdropping on the party. When I was writing this story, I'd just seen William Wyler's *Desperate Hours*, in which a man keeps a whole family hostage in a house. I've often been asked whether *Tie Me Up! Tie Me Down!* was inspired by Wyler's *the Collector* and I'd always reply, which would always amuse and surprise me, that yes I'd been inspired by Wyler, but not by *The Collector*.

So, the fugitives watch these people drinking, the producers arguing with the electricians and all the TV cameras filming the party. The convict hidden in the lavatories had already seen the lead actress when he first arrived in the studio and had fallen passionately in love with her. We also assume he's seen her in movies and already adores her. He doesn't want to leave the lavatories because he wants to meet her and make love to her. Several girls come in, but they're not the one he wants. He has them all and the girls don't mind a bit. On the contrary, they're delighted, they think it's one of the surprises of the party and even tell their girlfriends to go to the lavatory because the guy's such a good lay. More and more girls turn up and soon the poor chap's exhausted. At last, the real object of his desire arrives. There follows a very violent scene because she's the only girl who doesn't want him. I remember it clearly because he finishes by tying her up and telling her he's mad about her. The story develops in such a way that everyone realizes he's with her in the lavatory and the other two convicts are forced to take the crew and cast hostage. The relationship between the boy and the girl evolves in those circumstances.

I wrote the story over a weekend, but didn't get to finish it and I put it in a drawer. I re-read it when I'd finished *Women on the Verge* . . . and found it very amusing. Perhaps I should have filmed the story as it stood, but I had to finish writing it and get back to work. As I was doing so I realized that what interested me was the story of a couple who are forced to relate to each

William Wyler's *Desperate Hours.*

other. The end result was far removed from the original concept, making a cheap film using the same set twice. I did end up using part of the set of *Women on the Verge* . . . but it's a detail.

So Matador *was the opposite. You knew the subject for the film right from the start?*
Yes, it was quite different. I had the subject and tried to keep to it by writing

the story. The subject's there, but when I look for it in the film I get the feeling I can't find it.

Matador *is the first film where you deal with male characters, played here by Nacho Martinez and Antonio Banderas. Imanol Arias and Antonio Banderas were both very young in* Labyrinth of Passion *and Carmen Maura's husband in* What Have I Done to Deserve This? *is somewhat caricatured, as is the husband in* Pepi, Luci, Bom. *In* Matador *the men are mature, they have real identities and the film brings out their sexual presence. From* Matador *onwards, your male characters are very well delineated, a fact which your reputation as a great director of women tends to blind us to.*
Yes, *Matador* is the first film where I really tackle male characters and give them an important role in the story. The fact I'm seen as a director of women

Matador: 'The first film where I really tackle male characters.'

I often think is simply due to numbers; there are always more women than men in my films. But I also think I'm a good director of men when the opportunity presents itself. Antonio Banderas is the actor who best conveys my concept of male characters. In the same way, Carmen Maura is the actress who has best absorbed and communicated my idea of the female.

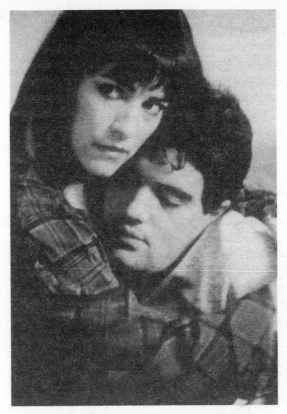

Matador: Carmen Maura and Antonio Banderas.

One of your most successful male characters is Ivan in Women on the Verge . . .

Yes, he's probably my best one. The male characters in *Matador* are absorbed into the symbolic structure of the film. Ivan, on the other hand, is a naturalistic portrait of a man. He's the character I've treated with the most realism. The actor who plays him, Fernando Guillen, was best known for his television roles. He's an actor of the old school and I took him out of the conventional, dated genre he was working in. After *Law of Desire* (the first film he did with me), and especially after *Women on the Verge* . . ., his career changed completely. He's since worked in much more modern films and plays. I always liked the way Fassbinder would do this: pluck an actor out of his normal context and show him from another point of view. He cast Karl

Böhm, who had been in *Empress Sissi*, in *Fox and His Friends (Faustrecht der Freiheit)*, and gave him the kind of part he'd never played before. Böhm was a revelation. It was very powerful.

Did the fact of having begun working with male actors and characters in Matador *then allow you to tackle the subject of the homosexual relationship in* Law of Desire?

I don't know. I wrote *Law of Desire* before making *Matador*. I wrote the two stories at roughly the same time and they have a lot in common, not only chronologically but thematically. I deal with sex in *Matador*, which is something very concrete, in a very abstract, metaphorical way, whereas in *Law of Desire*, I deal with desire, which is very abstract, in a very concrete, realist way. Obviously, sex and desire are intimately linked and there are moments when they become one. The two films are like two sides of the same coin and I shot them in the same year. *Matador* came first. I'd written the script of *Law of Desire*, but the film took a long time to set up. So I wrote a second script, *Matador*, while I was waiting and shot it first. Then, because the other script was ready, I immediately started making *Law of Desire*.

Law of Desire

Production

Brother

Factory

Desire

Ne me quitte pas

FRÉDÉRIC STRAUSS: Law of Desire *was the first film produced by El Deseo (Desire), the production company you set up with your brother Agustín. What desire did this move into production represent?*

PEDRO ALMODÓVAR: My relationship with producers had never been very good. None of my films has ever lost money, but I'd always felt the producer wanted to make one film and I another. This can lead to disagreements. But what really made us found El Deseo was a law brought in by Pilar Miró and which carried his name. From 1983 onwards, it set up a system of finance inspired by the French *avance sur recettes* (advance on box-office receipts), which made it much easier for Spanish film-makers to produce their own films. For *Matador*, the last film I made before the birth of El Deseo, my producer simply went to the Ministry of Culture with a dossier I had prepared myself, asked them for a subsidy and then pre-sold the television rights. Producing was strictly a bureaucratic task. He played no active role in the production. I was not at all interested in continuing such a non-collaborative relationship. It also makes sense to be the owner of one's work. With my first five films, I felt I had had five children all by different fathers with whom I was always disagreeing. After all, the films belonged to these producers not only as financial but also, to some extent, as far as their initial conceptions were concerned, as artistic enterprises too. Producers often commit atrocities to the negatives and I wanted to retain my control over them: if Cuba wants one of my films, and I'm its rightful owner, I can supply it.

But El Deseo was faced with a huge problem right from the very start. The script I'd written, *Law of Desire*, antagonized all the people who could have supported us. The Miró law was already in existence, but we received no help at all from the Ministry. The television stations also refused to buy the rights.

Do you think the difficulties you had in financing the film were due to a certain moral censorship?
Absolutely. There is no longer any official censorship in Spain, but moral and economic censorship still exist and I felt them keenly while making *Law of Desire*. It's the key film of my career. I've received many prizes for my films in Spain, but none for this one. I don't mean one should measure the worth of a film by the number of prizes it wins, but the silence was significant. The subject of the film discomfited the members of the commission for the advance. I was already well known at the time, both in Spain and abroad, and I was forcing the system to face its own contradictions.

Curiously enough, it was a Catalan reading committee and the Director of the Cinema Centre, Fernando Mendez Leite, who decided to help me. It was a huge crisis but, finally, we were given a little money. I then did what no film-maker should normally do: I asked for a personal loan from my bank. If the film hadn't been a success, both my brother and I would have been bankrupt. Both our money and the money we didn't have was invested in it. But we decided to go for broke. We didn't have any choice anyway. Carmen was asking whether we were making the film or not – she had other proposals. I told her we'd make the film come what may, even if it meant going back to Super 8.

Luckily, *Law of Desire* was a success. Ever since, I wake up in the morning thinking about those days, knowing we did the right thing. I couldn't make the film better now than I did then and I'm very proud of it. It's very important we own it and that we retained the power of choosing who would distribute it, how and where, because it's easy to present a false image of a film on its release. After *Law of Desire*, producing *Women on the Verge of a Nervous Breakdown* was very much easier.

When did you move into these offices? The bright colours are reminiscent of Women on the Verge . . .
After *Women on the Verge* . . . During *Law of Desire* and when we started *Women on the Verge* . . ., Agustín's office was a cardboard box. He carried it about everywhere.

Agustín had, I believe, already worked on your previous films before producing Law of Desire. *How did he come to be a producer?*
Agustín's a chemist. He'd been a metallurgist, a professor of mathematics and an accountant. He's at ease with figures, with anything to do with economics. He's very brilliant in that field. When we decided to found the company, Agustín immediately set to work on one film after another. One such film was *Matador*. Within a year he had had experience of all aspects of production. It was fast, but effective.

Since Law of Desire *you are both a director and producer. How do you combine these two functions in practice?*
I don't really feel as if I am a producer. That's Agustín's role. El Deseo was our joint idea, and as a director I enjoy the freedom I give myself as a producer. When we receive submissions from outside, I read them and help decide between them, but in practice my work isn't that of a producer.

Do you also write your scripts in the El Deseo offices?
I often come here but only for things to do with my public persona and the films which have to do with me personally. It's a lot of work. But I only write at home.

Do you tell Agustín the idea for your scripts? Do you tell him about them as they evolve, before he reads them?
Agustín has always been my first audience. The minute I have an idea, even before I develop it, I tell him about it. He's always present. Oddly enough, – actually, I don't know whether it's odd or not – Agustín is the person who understands me best. He's always had a profound understanding of everything I've done. I don't know whether being the witness of such things is a burden or a privilege because we never discuss it. Agustín is the only witness to my whole life. My first memory of him is of a child observing me. There are five years between us. He remembers me since he was three and sometimes tells me things about myself I've forgotten.

How does Agustín react to your scripts? As a brother, as a potential audience or as a producer?
As an intimate. Not as a producer, more like the reader of a novel – which is much more interesting. Agustín has such respect for me he never speaks to me as a producer during the gestation of a script. He's frightened it would distract me.

So it's only when you've finished the script that you talk to each other as film-makers and producers?
That's right.

The Spanish press have often portrayed El Deseo as the Almodóvar 'factory'. Is the term justified?
I don't know. People do like speaking of the company in those terms. It's true we always work with the same people: Esther García, our production manager; Pepe Salcedo, our editor; Juan Gatti, our designer. It's like a family, all the more so because there are two brothers at the head of it all. But we aren't the kind of factory which welcomes and promotes artists; that's a term the Spanish media uses because everything I do tends to be mythologized. So they talk of the Almodóvar Factory and of Almodóvar's Girls. I'd like to use El Deseo to support people I like, singers, artists, but for the moment I only do this in particular cases. In fact, if we don't function like a factory it's through lack of time because in reality only my brother and I look after everything here. We'll carry on producing the work of young film-makers – such as Alex de la Iglesia's *Acción Mutante* – but El Deseo will never become a conventional production house making several films at once. We take great care over each film and we can only do this by working on one film at a time.

Your production manager, Esther García, inspired the character played by Loles León in Tie Me Up! Tie Me Down! *Having met her, one can't fail to be struck by a charm and a strength of character similar to all the women in your films. If there isn't a factory, there's still a trademark.*
Yes, there is. Esther inspired Loles León's character in all its aspects, both through her coquettishness – which we all succumb to – and the fact that she is both the mother and father of the family. A production manager must be more of a man than all the men she works with. In Spain, crews are almost entirely male. Even if that's changing a little, men find it hard to accept the authority of a woman. Esther, therefore, must show she is as much of a man as they are, but she also uses her female seductiveness. Women have an enormous capacity for production work. They have always carried the burden for organizing a family. Running a production is very similar to running a household.

Law of Desire *is very close in its visual form to your present work, notably in the use of sets, colours and lighting. Is this greater coherence due to the fact the film was produced by El Deseo?*

Law of Desire: Carmen Maura, the representation of desire.

Yes. Even though we made the film for very little money, I certainly felt freer. But the fact that the story and the characters were very close to me allowed me to dig deeper into things. I was able to develop much better the whole visual, representational aspect of the film. But I think my interest in colours, costumes and sets was already present in *Matador*. It was while making that film that I began to understand my interest in the visual coherence of a film and my fascination with cinema as a language. Perhaps this was because the film was more abstract and the stylization more important.

Does the character of the director in Law of Desire *reflect the personal quality of the film, or did he interest you as a character on his own?*

Both. One can only speak of certain things, such as desire, by speaking of oneself. But what interested me most in the character was what was least autobiographical, even if those elements were also part of my life and work. When I started writing the film, I wanted to deal with the creative process: the way a director's life permeates his work; how a director plunders his life, seeming to live only for writing stories; and how, during the creative process, this union between his life and his typewriter turns into something almost monstrous, to the extent that it becomes dangerous for him and for others. The creative process of Pablo Quintero, the director played by Eusebio Poncela, proves fatal for the characters played by Antonio Banderas and Carmen Maura. One scene shows this very concretely: when Carmen reproaches Pablo for being inspired by her, he replies 'You become me.' That's what links me most to the character.

It's the key film in my life and career. It deals with my vision of desire, something that's both very hard and very human. By this I mean the absolute necessity of being desired and the fact that in the interplay of desires it's rare that two desires meet and correspond. This is one of the tragedies of the human condition. Eusebio has a great need to feel desired but, as he tells Antonio, not by anyone. There's something very pathetic about an artist or intellectual who confronts his own condition and identity. For Antonio, desire is something immediate and physical. But Eusebio translates it through his intellect into a medium. Which explains why, at the end, he cannot see that the object of his desire is standing right next to him. That's his personal tragedy.

The image of the director in the film is that of a man handicapped by his own creativity, a man who, to some extent, by-passes life. It's a strange image because you, by contrast, seem to seize life through cinema. You communicate with others and communicate to them your very lucid vision of the world which surrounds you.

Yes, in that way I'm very different from the director in the film. I would have liked to have made him more similar to the way I live and work, to make him more alive and his creative energy more vital. But I had a problem with Eusebio Poncela and this prevented me from taking him where I wanted to go. It's something almost chemical. The director I wanted to show was a man full of life who, if he took drugs, would take a stimulant like cocaine. The problem was that Eusebio was taking a different kind of drug altogether. This was very frustrating while we were shooting. I wanted to project the way I lived and the result was the opposite. This explains why the character played by Carmen Maura, initially a supporting role, unexpectedly became

Law of Desire: 'In the interplay of desire, it's rare that two desires meet and correspond.'

the representation of desire and the vehicle for what I wanted to say. In the end, *Law of Desire* is still one of my favourite films, even if my personal intentions weren't fulfilled.

But one can see quite clearly the creative process you speak of in the film. It creates a fascinating effect: one feels the script of the film is being written by the director almost as it happens.
Good, because that's what I wanted. The director is in love with a young

man who's travelled south. The young man loves him too, but not in the way the director needs to be loved. The director gets a letter, a sympathetic letter, but not the letter he wanted to receive. So he sits down at his typewriter, writes the letter he wanted and sends it to the young man to sign and send back. At that moment, the director lives his life as a filmmaker, not as an individual. As a director, he refuses to accept things as they are. He directs them, creates them and imposes on them the forms and qualities he desires. He almost becomes the creator of his own life.

It's a kind of professional deformation which I often feel myself. A director who is used to writing his own scripts acquires a kind of wisdom when faced with life's variety. It's more the wisdom of a writer. As a writer, I order the elements of a story I'm developing, but the story itself is also driven by its own internal logic; it generates its own motion.

In the same way, we can occasionally project in life what will happen in a given situation. I've always liked to think that the great creators in cinema deal with the future, rather than the past or even the present. Perhaps it's merely personal, but I like to believe that film foretells the future. It's a theory I've developed in several of my films. In *Matador*, when the two main characters go to the cinema, they see their future on the screen. It's the last scene of King Vidor's *Duel in the Sun* and shows exactly how their lives will end. Jennifer Jones and Gregory Peck kill each other and die together.

Songs sometimes fulfil the same function in your films. In High Heels, *when the characters listen to 'Un año de amor' they see a past, their past, which will be repeated in the future. Brel's 'Ne me quitte pas' has a vast premonitory resonance in* Law of Desire.

Songs play an active part in my films. They're not just decoration, they're a form of dialogue and tell you a lot about the characters. In *Law of Desire*, I rendered a kind of unconscious homage to French culture by using Brel's song and Cocteau's *La Voix Humaine*, two texts which for me have the same meaning. 'Ne me quitte pas' is, in fact, very significant and revealing in relation to the characters in the film. Firstly, it's a song the director listens to a lot at home. He plays the record the night Juan, played by Miguel Molina, comes to see him. But Juan is the one who will abandon him and when he rings at the door he hears the song 'Ne me quitte pas'. For the other characters *La Voix Humaine* is more relevant in terms of abandonment.

When the little girl sits on the camera dolly and sings the song looking straight into camera, it's a magnificent and very moving moment. One of the best in the film.

I love that scene! The little girl has been abandoned by her mother, played by Bibi Andersen, and has stayed with her mother's fiancé. When Bibi comes back to the theatre, she sees the two women in her life crying 'Ne me quitte pas': Carmen through Cocteau's text and the little girl via the song. The cry becomes almost unbearable because it's uttered by the two women Bibi abandoned. I don't know whether such an explanation is important, but it shows that all my films have a logical basis. But I don't want to give the impression of justifying decisions often made irrationally. They can arise out of the deepest emotions.

Carmen Maura plays a transsexual in Law of Desire, *but Bibi Andersen, who plays the mother of the little girl, is a real transsexual. Knowing it makes no difference to one's appreciation of the story. Was this distribution of roles a kind of private joke on your part?*
Not at all. For me Bibi is a woman and I've always known her as a woman. Cinema is representation in all senses of the term and it's through this representation, not through a documentary process, that I arrive at the truth of reality. This doesn't mean I reject documentary as a genre, but I'm sure if I were asked to make one I would show something quite different from what the film is meant to contain. In film, it isn't a matter of the actors being themselves, but rather the opposite of what they seem. I believe human beings have several characters within them, masculine and feminine, good and bad, martyrs and lunatics. For an actor it's more interesting to play a character which is within him, but from which he also feels the most distant. I didn't want a real transsexual for the transsexual in *Law of Desire*, but an actress who could interpret a transsexual. This is very difficult to do because a transsexual won't show his femininity in the same way as a woman. A woman's femininity is much more relaxed and serene. I was interested in a woman showing the exaggerated, tense and highly exhibitionist femininity of a transsexual. So I asked Carmen Maura to imitate someone imitating a woman.

Carmen Maura and Antonio Banderas are astonishing in the film. They manage to communicate the emotional cracks in their characters, their broken identities. Their performances are at the same time highly physical and cerebral, sensual and tortured psychologically, but never banal. It's very impressive. How did you work with them on the film?
Carmen's been very good in all my films. Even though the part that brought her worldwide fame was the one she played in *Women on the Verge . . .*, her greatest creation and the best moment of her career was in *Law of Desire*.

Law of Desire: 'I've never seen performances of such intensity.':
Carmen Maura . . .

The same thing happened with Antonio Banderas. He has a fantastic emotional power in *Law of Desire*. He's overwhelming. But the part which launched him internationally was the one he played in *Tie Me Up! Tie Me Down!* where I don't think he's as extraordinary. Antonio's animal quality is fully developed in *Law of Desire*.

I last saw the film on television. Every time I see it, I'm staggered by the two of them. My reaction has nothing to do with the fact I directed the film. I've never seen performances of such intensity. It's as if Antonio and Carmen were flayed alive. I'm not sure they know themselves how they attained such a level of performance. I remember that during the shoot they seemed as if in a trance. For a director like me, who enjoys working with actors, it was an extraordinary experience to watch them work like this. I was their first audience, and a privileged one too, because I knew best what they were trying to do. It was very impressive and I have shivers every time I see the film. I'm really pleased all that is visible because it's what I felt while making the film.

Two convictions are essential when working in such a hypnotic manner: one, the actor must be convinced that they are the only actor in the world capable of playing the part they've been offered – even if this certainty is, in part, artificial – and two, they must be convinced that I am the only director capable of bringing out the full power of their performance. This is the way I worked with Carmen. She then did prodigious things that no one could ever

and Antonio Banderas.

have imagined. It doesn't mean that these convictions are necessarily true, but it does demonstrate that if they do exist, an actor will give their best possible performance.

How did you discover Antonio Banderas?
Antonio had arrived from Málaga. He was an extra in a play. I saw him, arranged a screen test and knew at once he'd be a movie star. It was his first time in front of a camera and it was clear he was born to do it. We were lucky enough to have met at the right time. This happened with all the actors I've discovered, Rossy de Palma, María Barranco . . .

Do you organize casting sessions for your films?
Sometimes. Other times I have a very clear idea who I want and contact the actor directly.

The first scene of Law of Desire *shows a young man masturbating under the orders of the director. It's a very lively celebration of the oral gesture of a director, of his almost divine power to create something with his voice. I saw you working on the set of* High Heels *and this representation of the power of the voice seemed very reminiscent to your very oral approach to direction.*
The role of the director resembles that of God because the power of representing one's own dreams is godlike. The director is a god because he is a

Labyrinth of Passion: Antonio Banderas's first appearance in an Almodóvar film.

creator. It doesn't matter if his creation manifests itself in a world parallel to reality. I believe a film-maker is an oral figure. In any case, I am an essentially oral director in that I almost hypnotize my actors with words, something which they perhaps don't even realize.

In the first scenes of *Law of Desire*, the director is an oral personality who orders what must be done. For me, the voice of the whole film is the director's, even when played by the other actors. From the start, I define and establish the subject I'm interested in, desire. A young hooligan, a sort of gigolo, is masturbating, but what's important is that someone is employing another person to make love. The service the young man offers isn't a sexual act, it's almost the opposite. What the man wants is for the young man to tell him he desires him. We therefore establish at once that the main character of the film is a film-maker whose great problem is to feel desired. He pays the young man to say 'Fuck me!' The director in the scene is therefore already directing his own life. Perhaps this also entails translating one's frustrations into something else. In the same way as he writes the letter he'd like to

receive, he gets the young man to repeat the words he'd like to hear. He even obtains the tone he'd like them spoken in.

That's why it's so pleasurable to listen to the actors in your films. Quite apart from the meanings their words carry, their elocution seems a creative act on its own. It also means that the power of the director's voice exists only in its echo, via the actor's voice.

Voice work is one of my obsessions. It's what's most developed in my way of directing actors. I'll often choose a take for the sake of the voice. That's why it's very important to see my films without dubbing. I've often asked myself, when I'm out promoting my films, what would happen if I were struck dumb. Perhaps the only advantage would be I'd no longer have to do interviews.

But I also try to imagine what would happen if I had no voice on set. It reminds me of a story I haven't yet worked through – I don't know whether I ever will, but I like it. It's the story of a director who is struck dumb while making a film. He tries to make himself understood by other means, but the actors take advantage to have their revenge. They start acting the way they want to act and free themselves from the shackles the director's voice once held them in. The crew ignore him. He loses all authority. It's tragic for him. But when the film comes out, it turns out to be a hit, thereby proving to him his tyranny was pointless. I believe the exact opposite, but I like the idea of showing the reverse of what I think.

The director then decides to admit that, as a film-maker, he is utterly worthless. Then, when he finds his voice again, he tells no one. He continues working because he cannot give up making films and learns sign language. He has the wonderful idea of making a musical with actors who are dumb, whose talent, even though they're amateurs, has never had the opportunity to express itself because of their handicap. Of course, the musical's dubbed, everything's in playback and it's an even bigger hit. The actresses who had revolted earlier come back and beg him to use them again. And because it's the only way of communicating with him, they end up learning sign language too.

I had the idea for the story at the Lancaster Hotel in Paris. I'd just done my fifth or sixth interview of the day and wondered whether I could carry on making films without a voice.

The director regains his power in the story?

I don't know! I'm obsessed by actors' voices and sometimes realize that what I'm asking them to do isn't always the only way of getting what I want. I'm

very obsessive in my work, but I don't think it's the only way of working. I even think one could work wonderfully well in a completely different way. But it's the only way I can work. It's perhaps the worst way because it eats up one's life and becomes a sort of passion; one can no longer control oneself. I only know how to work by becoming the victim of my passion for it.

Women on the Verge of a Nervous Breakdown

Theatricality

Title sequences

Design

Colours

An earthly paradise

Pedro Almodóvar.

FRÉDÉRIC STRAUSS: Women on the Verge of a Nervous Breakdown *began as an adaptation of Cocteau's* La Voix Humaine. *This is surprising given the fact that the film is the purest of your comedies. And in formal terms it's also the most finished, one of the lightest.*

PEDRO ALMODÓVAR: Yes, and also shows my lack of fidelity to my original idea. It's a good example of what we were talking about earlier. I start writing from an idea, but only by writing do I discover my true subject. I loved the scene you mentioned in *Law of Desire* – where the three women meet in the theatre – and I adored Carmen in the film. So I decided to have an overdose of Carmen Maura. I wanted to work only with her and see how far we could go. *La Voix Humaine* seemed perfect because it was a monologue and I wanted to make a film with just one actress. What's more, the role is fabulous. But Cocteau's text only lasts twenty-five minutes, not long enough for a feature. So I decided to add on an hour which would tell the back-story of the same woman. My idea was to start two days before the famous phone call. When I reached the end of the forty-eight hours, I realized my script was much longer than I'd planned, that I had a great number of female characters and that Cocteau's *La Voix Humaine* had utterly disappeared from the text – apart from the original concept, of course: a woman sitting next to a

The famous phone call: Carmen Maura . . .

and Fernando Guillen.

suitcaseful of memories waiting miserably for a phone call from the man she loves.

Even though Cocteau permeates the whole film, the main theatrical influence is much more Feydeau and boulevard comedies. It was only when I'd finished writing that I understood I'd found what I was looking for. While I was shooting the film, I also realized it recalled the type of American comedies which are often adaptations from the stage. The script of *Women on the Verge . . .* was written for the cinema, but it often reads as if it were adapted from a play. Oddly enough, my films have often been turned into plays. This may be due to their rather theatrical dramatic structure, something I hadn't been aware of until I learnt they were being re-produced on stage. *Women on the Verge . . .* is about to be put on in Rio, *Tie Me Up! Tie Me Down!* in Italy, *Dark Habits* in Madrid. There are other projects too.

In the three films you've just mentioned the action occurs almost entirely in one location. Clearly, this explains why they might adapt easily to the stage.

Women on the Verge . . .: 'I think my films suffer from an overabundance of characters.'

But the strangest thing about these films is that, structured as they are, they function entirely as films. Nothing in them evokes the theatre; their style, their rhythm, their life are purely cinematic. You could choose to avoid such theatricality by not limiting yourself to the one location.

Perhaps, but I have to find a way of controlling my subjects and concentrating on the action. I have an exuberant imagination and when I start writing, the story can develop in an anarchic manner. Generally, I often think my films suffer from an overabundance of characters. For *Women on the Verge* . . . and *Tie Me Up! Tie Me Down!* I tried very hard to centre everything on the main characters. This is especially clear in *Tie Me Up! Tie Me Down!* because the couple live in a hermetically sealed apartment. But in *Women on the Verge* . . . the doors and windows of the apartment are always open; a mass of people passes through them. *Women on the Verge* . . . is my most rounded, finished script. Oddly enough, it was the one that took the least time to write.

And among all these characters there is the answering machine. You give this object a role even more important than that of the electrical appliances in What Have I Done to Deserve This? *It's almost a character in its own right.*

And you use it contrary to the clichéd way most film-makers do. It doesn't aid communication at all.
I had wanted an answering machine that was a kind of monster, bristling with flashing lights. But we couldn't make it. The machine in the film doesn't really have the presence I wanted it to have. This made it difficult to compose shots where the machine was in the foreground and Pepa behind. When Hitchcock wanted a teacup in the foreground with characters in the back, he had a giant teacup made. You think it's the lens which enlarges the object whereas in fact it's a trick. It's an effect best used with only one object, such as the answering machine in *Women on the Verge* . . .

The film's format clearly refers us to American comedies. Is it in cinemascope?
No, it's 1:85, an enlarged format which looks like cinemascope. I used it again in *High Heels*. It's an elegant format for comedy. I've never shot in cinemascope. Occasionally I want to, but at the same time I find it a little frightening. But I'm sure I'll use it for my next film.

Women on the Verge . . .: Almodóvar on the terrace set.

However, I don't respect all the laws of comedy in *Women on the Verge* . . . The format, the sets, the dramatic structure are all comedic. The performances of the actors too; they speak very fast, as if they aren't thinking about what they're saying. But in comedy you'd shoot two-shots and medium angles as opposed to close-ups. You'd never shoot an extreme close-up as I do with the microphone in the dubbing sequence. And the rhythm of the film isn't entirely comedic either. This is probably due to my own indiscipline and my lack of respect for genres. But there were also subjects I wanted to deal with in the film which weren't comic. The whole finale is the finale of a comedy, but the tone of the dubbing scene is quite different. I underline the importance of the man's voice. It's a voice that drives all women crazy and can even cure his own wife of madness. Hearing it brings her back to the real world and she leaves the mental hospital where she was a patient. That's why I shot those inserts of his mouth and the microphone. That way the microphone starts resembling a magic wand.

I very much like the beginning of the film. It's a sequence of shots accompanied by Lola Beltrán's song, 'Soy infeliz', which leads up to Pepa waking up. Did you story-board this sequence?
Yes, I did. But I had to adapt it all to the set. I consider comedy to be the most artificial of genres. I therefore wanted to start on a model of Pepa's apartment block and give the impression, helped by the sunlight pouring in through the window, that the model was the real thing. Then I'd pan across to the bed Pepa was sleeping in and the audience would then realize the building was a model. I remember I wanted to do this in one go, but for various technical reasons I was forced to split the opening sequence up into several shots. Losing the effect was very frustrating.

Women on the Verge . . ., was your first film with the camera operator Alfredo Mayo. He then replaced José Luis Alcaine as your lighting cameraman on High Heels. *What were the reasons for this?*
Alfredo Mayo is without doubt the best camera operator in Europe. José Luis Alcaine who lit *Women on the Verge* . . . and *Tie Me Up! Tie Me Down!* is the best lighting cameraman in Spain and the most knowledgeable in his field. But even though I've always considered José Luis to be the best, he knows it too and it creates a certain routine. Knowing you're the best makes one less forthcoming than a person who knows he still has to learn. That's why I changed. Alfredo is less experienced, but he's a very talented lighting cameraman. He's also humbler and more inclined to experiment. He has a great deal of know-how, but because he's only been lighting for five years he

still has the illusions of a beginner. Also, our collaboration is closer and more spontaneous than it's been with other members of the crew.

Who was your lighting cameraman before José Luis Alcaine?
Angel Luis Fernandez. He was very young and intuitive. But sometimes when you work a lot with the same person things tend to get rusty. And I make people work very hard. I ask my crew to prove themselves as if each film were their first. But energy and curiosity fade with time. Physical fatigue takes its toll as well. That's why I change my crew. Angel Luis's photography is superb on *Matador, What Have I Done to Deserve This?* and *Law of Desire*. But I felt he wasn't as responsive on that last film as he had been before. People don't always develop at the same pace. This is the case in all relationships. There comes a moment when you develop at a different rhythm and your friends might lose interest. So you have to decide whether to continue alone or with other people. It's always a painful decision.

From Women on the Verge ... *onwards, the photography of your films is more polished, more sophisticated even, than before. So much so that* Kika *seems a rougher film.*
I agree, but that wasn't my intention. For *Kika* I asked Alfredo Mayo for something more complex. But sometimes what a technician suggests is valuable too, even if it isn't what you initially dreamt of. In all these fields, the most interesting thing is the tension between what you ask for and the way a technician will try to provide it.

In general, the photography of your films is highly finished without being too refined. There are very few photographic effects. It certainly doesn't bear the personal marks of the cameraman. It's a good balance.
No, it's never too refined. The photography of Kieślowski's *Three Colours: Blue* is very beautiful, but it's far too personalized. There are far too many filters and personal effects on the part of the lighting cameraman. This tends to happen with great cameramen. The photography of *Days of Heaven,* for which Nestor Almendros won his Oscar, is an example of work where a technician stamps his mark far too firmly on a film. But it depends on the film. Jack Cardiff's work on Michael Powell's *Black Narcissus* is extravagant, but entirely successful.

The title sequence of Women on the Verge ... *is an unforgettable piece of bravura. The college of images is a visual feast. They also celebrate the artifice you mentioned. Lola Beltrán's song adds a very romantic nuance to*

these pictures of ideally beautiful women. How did you come up with this sequence?

'Soy infeliz' is an old Mexican song and fits in very well with the story of the film. A woman sings of her sadness at being abandoned. Lola Beltrán's a wonderful singer. Another song closes the film. It's sung by La Lupe and called 'Puro teatro'. This time it's a woman telling her lover he lied to her. In fact, 'Puro teatro' means pure hypocrisy, the hypocrisy of men, of course. And this fitted in perfectly with the ending of the film.

As for the title sequence, I worked closely with the designer Juan Gatti. He worked in fashion – he still does – notably as a photographer. There are very few designers in Spain who work only in cinema. I've used artists – such as Cesepee for *Law of Desire* – for all my posters. Since *Matador*, Juan Gatti has been in charge of all the graphics. His work on *Women on the Verge . . .* was much admired. Italian *Vogue* asked him to be their art director for two years. I asked Gatti to cut out photographs from women's magazines of the Fifties and Sixties and to make a collage of them so that the audience would enter the film as if flicking through a magazine. It's an opening in the style of certain American comedies, such as Stanley Donen's *Funny Face*, which happens to be set in the fashion world. I very much like that type of title

Funny Face: 'An elegant pop aesthetic.'

sequence. I wanted to establish a kind of elegant pop aesthetic which would introduce the audience to the feminine world the film goes on later to explore more deeply. The title sequence and the song are almost like the overture of an opera. And Lola Beltrán's voice is like the voice of all the women in the film.

I very much like the title sequence because the spirit of collage permeates the whole story. The film's a kind of mosaic of different female physical types. Did you choose your actresses with that intention in mind?
No. I looked for the actresses who'd fit the roles I'd written. But it's true; in general, I'm interested by expressive faces. And they don't have to be pretty. In this film all the faces are very expressive and hardly run-of-the-mill. They're very particular and express very strong personalities. Nowadays, I wouldn't make the same title sequence because in the last four years that kind of Seventies pop aesthetic's been much overused. But I like title sequences and films where the title sequence is a work in itself. As in the James Bond series and *The Pink Panther*, it can be both autonomous and part of the film which follows. Martin Scorsese, who's the most intelligent of the American cinephiles, used Saul Bass for *Cape Fear*. Bass's posters, and his wonderful work for Hitchcock in particular, were an enormous influence on me. He was the inspiration for the poster of *Tie Me Up! Tie Me Down!*

Juan Gatti, with whom you developed the title sequence of Women on the Verge . . ., *is also the art director of all the press books for your films. They're graphic masterpieces. He also works on the posters and all your promotional material. Who has the initial ideas?*
I do, normally. Sometimes we sit at a table and flick through books, magazines and collections of film posters to find images which might start us off. I steal a lot of ideas. But there's a great difference between the image we start from and the one we end up with and that's where Juan comes in. When it comes to promoting a film, I'm always full of ideas. I also want to invent all kinds of objects. But often that's too expensive and time-consuming. A film can engender a vast quantity of artistic creations. To make them, to market them, is a job all on its own. We managed to do this with the magnificent hair-pin the heroine of *Matador* uses to kill her lovers. It was much more expensive than the pin in *Batman* and, like Jean-Paul Gaultier's dresses for *Kika*, it had a value quite independent from the film. Such merchandizing isn't as predictable as what the Americans do. But one day I may have an exhibition of all the objects contained in my films, all the art they've inspired.

Women on the Verge . . . *amply shows the array of visual creation present in your films. Was this because you had a bigger budget?*
Yes, and because I wanted to go in many directions at once – not just one.

Objects and furniture contribute a great deal to the strength of your sets. Are they created specially for your films or do you buy them when they're needed?
There's a mixture of everything. Some very specific objects, such as the monster's mask in *Tie Me Up! Tie Me Down!*, were commissioned from artists. But most of them come from my travels all round the world. All the glass objects in *Kika* I bought myself. Some are very expensive creations by Italian designers, others come from Spanish supermarkets. The crystal in *Kika* is a metaphor for fragility and a reference to the lens of a camera. Glass represents the work of a photographer and transparency, voyeurism. I have to give myself reasons to use these objects quite apart from their aesthetic appeal. Sometimes these reasons are a little superficial, but I don't mind that.

The very bright colours of the sets are very Spanish, aren't they?
Yes, they are, but they're hardly used in Spain. For me it's also a way of talking back to my past. Spanish culture is very baroque but in La Mancha, where I come from, it's terribly severe. The vitality of the colours is my way of fighting the austerity of my origins. My mother dressed in black almost her entire life. It's only in the last few years I've heard her say she'd like to wear a coloured dress. Since she was three, she has been forced to wear mourning for various members of her family. My colours are my natural response to an enforced austerity I began to feel while still in my mother's womb. Because human nature possesses a natural capacity for resistance, my mother conceived a child who'd be able to counter all this blackness. I was born in La Mancha, but I grew up in the Sixties and the pop explosion made a deep impression on me. I also seem to have an unconscious affinity for the colours of the Caribbean, as if I had a subconscious memory of the Spanish conquistadors who went to the New World, as if they were my distant ancestors. And don't forget Almodóvar is an Arab name.

I'm trying to rationalize what's perhaps a natural partiality to colours. It corresponds both to my personality and to the baroque behaviour of my fictional characters. Explosions of colour fit in very well with high drama.

Do you have a favourite colour?
It depends on the period. During *High Heels* I was obsessed with a combination of colours: red and blue. There's always a lot of red in my films. I don't

know why. But we can find an explanation for it if you want. The strangest is that red in Chinese culture is the colour of those condemned to death. This makes it a particularly human colour because all human beings are, after all, condemned to death. But in Spanish culture red is the colour of passion, blood and fire.

Women on the Verge . . . opens with Pepa's voice-over. We are plunged into her deepest feelings, feelings which will soon be turned upside down. Voice-overs aren't common in your films and to use one in a comedy such as Women on the Verge . . . *is surprising. But the voice-over brings a reflective quality to what is a very pacy narrative. It gives us a glimpse into Pepa's interior world, and into her past. It's very rewarding.*

The voice-over has much to do with the technical problems I had with the opening sequence. I decided to use it for the sake of clarity and to bind all the shots together. It then became the basis for all the images of the film. And it ended up working very well. It was only at the end of the shoot that I decided to use a voice-over. Even if it's a little forced, the voice appeals to me because it explains Pepa's predicament; also, because it compares the Pepa-Ivan couple to animals on Noah's Ark, which is an idea I'm very fond of.

Julieta Serrano, who was in Pepi, Luci, Bom, Labyrinth of Passion *and then* Matador, *is wonderful as Ivan's ex-wife. The way she expresses the sheer madness and unbridled passion of her character is one of the best things in the film. How did you direct her and how did you first come to work together?*

Julieta's a great actress. She could be the Spanish Gena Rowlands, but she doesn't have the kind of ambition which drives an actress to found her own company, so her career depends very much on those who cast her. Julieta's a great stage actress, but she hasn't had the chance to show all she's capable of, especially on film. I've always liked her. We became friends before I made *Pepi, Luci, Bom*. We met by chance acting together in a play. Julieta's a great tragedienne and like all great actresses she also has an immense gift for comedy. She was therefore perfect for the woman in *Women on the Verge* . . . It's a character straight out of Greek tragedy. She is totally at the mercy of fate. When you see her on the motorbike, her hair flying in the wind, it's as if she were being stretched and torn by her own destiny. Her awareness of her fate is tragic, but the way she expresses it is purely comic. Only a great actress like Julieta could have communicated the truth of the character without succumbing to parody.

Did you choose her clothes?

Yes, I'd found some dresses by Courrèges and had them re-made for Julieta. I love those clothes from the Sixties. They also have a dramatic function in the film. The woman Julieta plays went mad twenty years earlier. For her the intervening twenty years haven't existed. She lived them insensibly, in a vacuum. That's why she hates her son. All the while she's trying to believe she's still living in the time she was with Ivan, her son proves that twenty years have indeed passed. Her madness lies in not recognizing time has passed. She still dresses as she did twenty years earlier.

Julieta Serrano: dressed in Courrèges, living in a vacuum.

It's both a very powerful dramatic idea and a very comical image. When Julieta holds the other characters hostage, she expresses all the folly of her love. She must destroy all her memories of Ivan because every time something reminds her of him, she becomes once again the slave of her passion for him. But, as she says to Carmen, there's no point destroying all her memories of Ivan if Ivan himself is still alive. So she decides to kill him. She's logical even in her madness.

Julieta's character is essential. It represents what all the other women in the film could become if they don't control themselves. María Barranco, the

model who has an affair with the terrorist, Carmen Maura and Julieta represent three stages of frustrated love. As for Rossy de Palma, she's an innocent virgin but her fiancé is dumping her for another woman. She won't remain a spectator of other people's passions for much longer.

In this type of comedy, there is usually a routine, conventional dénouement. By contrast, the finale of Women on the Verge . . . *is both very original and very strange. Indeed, it's one of the best scenes in the film. How did you arrive at this ending?*

It's something I've seen many times in classical theatre. The gazpacho in the film is a kind of magic potion. Like the potion in *A Midsummer Night's Dream* it can change the life of the person who drinks it and transport them to another world. The gazpacho transforms Rossy de Palma into a real woman. And her dream completes the transformation. When she wakes up Carmen tells her she's lost the kind of hardness and lack of sympathy typical of virgins. I don't know when I thought up the scene, but it's quite possible I wrote it while we were shooting. A film like *Women on the Verge . . .* should be shot as much as possible in chronological order, which is how I worked. The finale was the logical outcome of the preceding action and of my knowledge of the characters.

Antonio Banderas: proof that twenty years have passed.

Women on the Verge . . .: the magic potion.

Women on the Verge . . . possesses qualities your other films don't always have. There's a formal virtuosity and a tightness of narrative which the energy of the mise en scène serves to accentuate. It's your most limpid film, but also the least complex and the least bizarre. In the end, it even lacks a certain mystery.

The whole film breathes a kind of facility. Maybe this is because the script operates much more at face value than those of my other films. It's the film where one sees the least doubts. The thesis of the film, once Cocteau had disappeared, was to posit a feminine universe where everything is rosy, an idyllic town where everyone is nice, a universe that's totally humane. The only remaining problem in this earthly paradise is that men continue to leave women. It's the perfect starting point for a comedy: the taxi driver sings, he's like Pepa's guardian angel, the chemist is a wonderful woman. Obviously it's all ironic because city life is nothing like this.

Kika began as this kind of comedy, but posited the opposite: the characters live in a veritable hell, as if the film were set after the Third World War, city life has become sheer torture (which I believe it has) and the only way of surviving is by having a sunny disposition.

Women on the Verge . . .: The singing taxi driver (Guillermo Montesinos).

Like Patty Diphusa, the incorrigible optimist . . .
Exactly. For example, Kika is raped and tells her husband, 'You know girls are raped every day and today it was me.' She doesn't want to make a drama out of it. That's the kind of disposition I mean. *Kika* was much more difficult to write than *Women on the Verge . . .* The story was much less linear and much more complex for the audience to understand.

Tie Me Up! Tie Me Down!

Directing actors

Proofs of love

The new family

Time

Porn

FRÉDÉRIC STRAUSS: *After* Women on the Verge of a Nervous Breakdown, *just when your audience wanted an overdose of Carmen Maura, you made* Tie Me Up! Tie Me Down! *with Victoria Abril. How did you come to choose her? And why have you no longer worked with Carmen Maura?*

PEDRO ALMODÓVAR: *Tie Me Up! Tie Me Down!* was a film for a young actress, younger than Carmen. But it's not, of course, the only explanation for the end of our collaboration. After *Women on the Verge* . . . our relationship became impossible for personal reasons. And it continues to be so. It has something to do with the intense way I work with actors. My relations with Carmen entered non-professional areas. It caused us both a great deal of pain. It's a long story . . .

I had already called Victoria to offer her the part María Barranco played in *Women on the Verge* . . . but for some reason or other she couldn't do it. She regretted it afterwards. So Victoria was already an actress I was thinking about. The adventurous outlook of the heroine of *Tie Me Up! Tie Me Down!* needed an actress who could easily move from pain to irritation and tragedy. And her sombre side was precisely what I liked every time I saw Victoria on screen. She seemed perfect for the part.

How did you work with her? Unlike Carmen Maura or Antonio Banderas, she'd already had an illustrious career as an actress before she met you.
We had to learn to work together. Her method is quite different from mine. Victoria needs absolute certainty before going for a take. I, on the other hand,

Tie Me Up! Tie Me Down!: Victoria Abril.

even though I prepare a scene thoroughly, often see things while I'm shooting. Victoria wasn't at all used to such a level of improvisation. Nor was she used to a director who'd ask for so much at the last moment. It worried her. I didn't want her to learn her lines by heart. I wanted her to stay receptive. She told me she only understood why when she realized that it wasn't she who had to invent but me, and that all she had to do was to be receptive to the ideas I gave her. She also found her character disconcerting. The character's an extremely emotional woman. Victoria was ready to explode and scream, but she was also extremely modest and loath to express the simplest emotions both as an actress and as a woman. All this was very frightening for her, not only because she had to be convincing, but also because I always ask for personal input from my actresses. It's a journey we took together.

Personal input; do you mean the actress has to live the character all the time, even off the set? Or do you mean her private life should inspire the part?
No, I never immerse myself in the private lives of the actors. If I want an actor to express great pain, I won't ask him to think about how his father died five years ago. What happens is that the actors are naked before me and often I can't help but see things they'd rather hide. When these things affect

Almodóvar on set with Abril.

their work, I have to tell them. Sometimes I end up identifying some very violent internal conflicts. In *Tie Me Up! Tie Me Down!* Victoria found it extremely difficult to tell her sister Lola, played by Loles León, 'I like you' in a natural way. I was forced to tell her that I could see it was difficult for her to say such a thing spontaneously to someone. Victoria admitted she never said such things. Technically, she could say the line, but I wanted more than that. An actor cannot lie to a director and something well executed technically isn't good enough for me. Victoria had to learn to say 'I like you' properly and the only way of getting her to do this on screen was for her to learn to say it in life. The work, therefore, has nothing to do with 'using' an actor's private life. Simply that, if a personal problem affects a performance, one must learn to solve the personal problem first.

In these very intense and close relationships that you have with your actors, do you sometimes stop directing and relate to them as an individual, rather than as an experienced director?
Absolutely. When I squeeze these personal things out of an actor, it's because I've initially done it to myself. I want my actors to take emotional risks, but I always take those risks first. In the context of our relationship, I occupy the place of the director, I'm a symbol of power. But I'm also implicated

persnally. This can produce very good work although, as in Carmen's case, there can be complications.

What struck me when I watched you shooting was your tenacity, the obstinacy and gentleness with which you accomplish such intense work with the actors. You control everything, but you don't at all give the impression of being a director-dictator.
There's a dark rumour that I'm a sort of vampire. I don't behave like that, but it's always easier to present things in that light. Actors say so much about me, they've ended up creating a kind of myth. But if anyone knows how I behave during a shoot, they do. I'm not a dictator. I'm a mirror that can't lie. Any violence which arises comes from what the actors see in that mirror: an image of themselves to whom they know they cannot lie. I'm not sure it's a good thing to make an actor so aware of what he's doing because often it can frighten, even paralyse him. In fact, I don't work like that systematically. It depends on the actor. With Antonio, for instance, I never do. I direct him like a child. I know what he's doing in my films, but he never has. Yet no one could have played those parts better. I love directing actors like Antonio. They're totally intuitive, physical, natural, like animals. With Carmen and Victoria, it's the opposite. I tell them everything. But they're both highly aware of what they're doing technically and highly intuitive too. They unite both elements, which is precisely what's good about them. They're actresses who don't parade their technique, but who have it in spades. That's very rare.

I can see the method in American actors who've come out of the Actors' Studio. I can see the method in Robert de Niro. It leaves me cold. I stop believing. Jane Fonda's the best example of a perfect performer whose technique, though, is totally apparent. Sometimes, as with Laurence Olivier, the technical demonstration becomes a magnificent lesson in itself. In such exhibitions of great acting the virtuosity becomes the spectacle. It's extremely rare, though.

This kind of technique is rarer among French actors.
Let me think. Yes, the French acting method is different. Technique is less obvious. Sometimes it doesn't come into it at all. I consider French actors to be like the best American supporting actors. I don't mean French actors can only play supporting roles but, just like American supporting actors, they have a spontaneity, a trueness which springs from the earth, from life. Jean Gabin wasn't a technical actor. Neither was Lino Ventura. Their talent sprang from their personalities. Like Simone Signoret – or Jeanne Moreau,

who has a vast technique but also knows how to give herself of herself. That's what makes her so unique.

From the point of view of the hugely successful Women on the Verge of a Nervous Breakdown, Tie Me Up! Tie Me Down! *seems a very personal film. As I was saying earlier, before you described the genesis of the story, the fundamental theme of all your films takes here an added, stronger dimension. Behind the dramatic motif of the film – basically a thriller where a man imprisons a woman – lies the theme of the family, how to begin a family when one has lost one's own, as Ricky does in the film. You describe a very conventional desire in a most unconventional context. Such a paradoxical approach makes for a very strange and intriguing film.*

I think *Women on the Verge . . .* was just as personal as the other films, but the genre was more effective, more direct and less mysterious. In *Women on the Verge . . .* I deal with a man and the pain his absence causes. In *Tie Me Up! Tie Me Down!* I deal with the opposite: a man and the pain caused by his unwanted presence. This brings us back to marriage, to two people living together in the same house. *Tie Me Up! Tie Me Down!* is a much more dramatic film than *Women on the Verge . . .* and, by implication, more personal. But it's true, I do identify completely with what's said about Ricky. I perfectly understand his problem; the difficulty a lover has in proving his

Tie Me Up! Tie Me Down!: Antonio Banderas – a man . . .

love to his beloved, the insecurity he feels in never knowing whether his partner understands his feelings, uncertainties which are an integral part of love. I need to be told I'm loved every day, and every day it's as if I were being told for the first time. I never take it for granted. Love can disappear in a day, it's like a miracle and miracles must be acknowledged each day. There are many things in *Tie Me Up! Tie Me Down!*, but the main one is Ricky's desperate struggle to become a normal person. In other words, having a car, a wife, a credit card, a family, a house, all the petit-bourgeois values. Of course, I show this with a great deal of irony. But I know that for the marginalized, those who've never had anything, possessing such things is their greatest dream. Ricky's intellect is literal, animal. The only thing he ends up attaining is the comic, emotional side of an imitation of reality. It's very infantile. After all, all children imitate. In fact, Antonio plays the part as if Ricky were ten.

Already at the end of Dark Habits, *one of the nuns formed a bizarre sort of family with the priest and the tiger. In* Law of Desire, *Carmen Maura's character tells of her life with her father who took her to Morocco and paid for her sex change. Conventional families are blown apart in your films, but they're always replaced by new families, odder families certainly, but also more satisfying.*

. . . and the pain caused by his unwanted presence.

Yes, I don't find the normal family very satisfactory. But like animals, human beings need each other. So man ends up making his own family along with his closest friends. These new families are highly heterodox, but they're real families none the less and express a real need for affection: such as the family formed by Bibi, her daughter and Carmen in *Law of Desire*. In *Women on the Verge of a Nervous Breakdown*, Pepa recalls with nostalgia a calm, rural family life. That's why she has all those animals on her balcony. I'm very close to Pepa that way. I suffer from the same kind of familial nostalgia.

You build the entire structure of Tie Me Up! Tie Me Down! *around this desire for a family embodied by Ricky. By confronting the subject head on, you seem to have explored it thoroughly. But* High Heels *is yet again the story of a re-invented family. Rebeca ends up with the judge who had seduced her by imitating her mother. She even bears his child. It's a little as if she had married her mother. The theme therefore repeats itself again and again.*

Yes, it's one of my obsessions. Just as Ricky in *Tie Me Up! Tie Me Down!* is immature, so is Rebeca. She's intelligent, but her mother's absence has prevented her from growing up – even physically, as the shots of her dwarfed by Bibi make abundantly clear. I was very keen on this image of Rebeca as a

The family of actors in *Tie Me Up! Tie Me Down!*

little girl. Bibi's presence was strikingly effective in that way. Family relationships are often dangerous. They can even become psychotic. Rebeca hasn't grown up and she needs a mother. She doesn't behave towards her mother like a daughter, but like a husband. I think women are very determined that way. So it's Rebeca who creates a family with the judge just as it's the women in *Tie Me Up! Tie Me Down!* who take Ricky into their family, of which Lola, Marina's elder sister, is the head. It's an optimistic ending. If I'd continued the story it would have been even more comical; you would have seen Ricky imitating a father.

I very much like the scenes in Tie Me Up! Tie Me Down! *where Ricky and Marina organize their domestic lives like a conventional couple, calmly sharing the household chores and so on. You give the very paradoxical impression of someone who had to create a very strange and exceptional situation in order to show very ordinary things. It's a banal form of intimacy which either doesn't occur in your other films or you chose to leave out, perhaps.*
That part of the film was directly inspired by my own life. But I think it's something many people have experienced: recognizing the sound of one's partner arriving, saying 'it's me' before you even see them. It's always an emotional moment. The situation becomes comic in the film. Ricky announces his arrival so as to calm Marina when it's precisely his arrival which terrifies her. He fixes the tap, he does the things any man would do for his girlfriend. These little things become much more significant within the situation the film describes. It's a general rule that anything can become expressive the second one takes it out of a certain context and places it in another. In *Labyrinth of Passion*, the father uses creams to lose weight and keep trim. It's much funnier than if a woman of sixty were using them. It's much better because it's a man.

Tie Me Up! Tie Me Down! *also contains your most incendiary vision of the body.* Law of Desire *was incandescent in its physicality, but* Tie Me Up! Tie Me Down! *is almost hard-core. I use the term deliberately. As we can see from the very suggestive excerpt from a porn film which I presume you must have shot yourself, Marina used to be a porn actress. How did you feel when you shot the sex scenes of the film? They give the impression of flirting with pornography and vulgarity precisely in order to show how different they are from real porn.*
The *mise en scène* was totally different from porn. Apart from one midshot, the actors are shot almost entirely in close-up. You can only see their faces. But their faces are so expressive they evoke all the pleasure their bodies

experience. It's the scene in *Tie Me Up! Tie Me Down!* I'm proudest of. It's totally physical, natural and joyous. The characters say strong things, but in a very natural way. It shows the future of the couple; Marina will have the dominant, male role. I also explain that Marina and Ricky have met before. She doesn't remember because the day they met she was high on drugs. He tells her how they first met and reminds her that he promised to find her again. She doesn't remember this either because she's made love to so many men and a lot of them said the same thing. But when he penetrates her she suddenly screams, 'Yes! I recognize you!' It's a hilarious moment. I was asked to cut the scene for the American release and threatened with an X certificate. I found this insulting. *Tie Me Up! Tie Me Down!* is almost a romantic fairy-tale, but many people attacked it because they took it for precisely the kind of sadomasochist movie it isn't. A lot of people went to see it in the States with pre-conceived ideas and expected God knows what. I'm very pleased with *Tie Me Up! Tie Me Down!*, but the film suffered from coming after *Women on the Verge* . . . It compounded the misunderstanding.

It's also a film which deals with time in a very emotional context. Ricky asks Marina how long it will take for him to prove to her he's a good husband and the film minutely studies the evolution of their relationship. It's a very dense time structure. Tie Me Up! Tie Me Down! *seems to be a film by a man obsessed with time.*

Time in the film coincides with real time. This happened unconsciously, as with so many other things in my films. But you're right, I've been obsessed with time ever since I was a child. When I was ten I was fascinated by creators who had expressed their talent at the same age. Mozart had already composed several pieces by then. I'd done nothing. Then when I was eighteen I learnt that Rimbaud had written his greatest poetry at the age of eighteen and I'd still done nothing! I looked for an example I could identify with. When I found a writer who hadn't started working until he was forty, I felt instantly reassured. I've always felt the pressure of time. It's nothing to do with the fear of getting old but with the desire to make one's mark in time, to do something which is related to time. In the apartment I lived in a few years ago there was this long corridor which I started decorating with the evidence of everything I'd done: books, records, films. Even though I didn't mean it to be conceptual, it became a kind of metaphor for time. One walked down the corridor at the same pace my work evolved!

High Heels

Horror movies

Songs

Editing

Hollywood

Melodrama

FRÉDÉRIC STRAUSS: *Shortly after the release of* Law of Desire *you mentioned in some interviews that you were finishing writing a project called* High Heels. *Was this the film you later made?*

PEDRO ALMODÓVAR: Not at all. Before making *Women on the Verge* . . . I was indeed writing a script called *High Heels*, but I didn't finish it and the only thing left from it is the title. But the story is, in a way, related to *High Heels* because it was about a mother and her two daughters. It was a film about flamenco, blood and fire, three things I like. The story was about a lame flamenco dancer whose mother was burnt to death in her house. Or so she thinks. In fact, the mother's still alive. She's Catholic, very possessive, obsessed with sin, lust in particular, and returns as a ghost to haunt her two daughters. She even moves in with one of them who, amazed that a ghost can eat and live normally, ends up fighting her. Finally, at the end of her tether, the daughter goes mad and sets fire to the house. This time the mother is genuinely burnt, but still she doesn't die. She is disfigured, like a real ghost from a horror movie, and decides to travel south to see her other daughter who lives by the sea. Each time this daughter makes love, the ghost appears at her bedroom window and terrorizes her. It was a very funny story about how to live with a ghost and a repressive mother. Unfortunately, I never finished it.

There are many veiled allusions to horror movies in your films. The title sequence of Matador *is a compilation of typical horror movie images; in* Tie

Me Up! Tie Me Down!, *there's a poster of Don Siegel's* Invasion of the Body Snatchers *in Marina's dressing room. It strikes me that your interest in horror movies may lie in the way the form deals so directly with the audience, the way an audience can be frightened and enjoys being frightened. Your films also play a great deal with the audience, most of all through the rules of comedy which you may or may not respect, but also through visual effects, strong images such as the masked monster in* Tie Me Up! Tie Me Down!

The images in the title sequence of *Matador* come from very bad horror movies – bad ones are always the most entertaining: films by Jess Frank, the worst kind of schlock horrors they used to make in Spain and Italy in the Sixties and Seventies. I used the poster of Siegel's *Body Snatchers*, a film I adore, because the 'body snatchers' are for me a kind of metaphor for heroin, a drug which 'steals' your body. I'd very much like to make a horror movie, but I don't know whether I'd be able to. There are several reasons for my interest in horror. Horror movies don't represent our fears but something much deeper, more obscure and much more human. The human body is the basic material of the horror movie. It uses it in an almost surrealist manner. The body is cut up, deformed. That's the landscape of horror, where everything happens. It's very interesting. It's also a very flexible genre. It can be funny, wildly exaggerated – which I like.

But when you make a film, do you think of the audience? Do you imagine its reactions?

I'm a very active spectator myself. I go as often as I can to the cinema. I like seeing new films. I make films hoping people will go to see them, but I don't feel as if I'm talking to an audience because I can't visualize them. They're something abstract, a mystery to me. Nor do I work like a director of horror movies, films where audience participation is of the essence, where the dialogue between movie and audience is the most direct.

How did you progress from the script called High Heels *to the film you eventually made?*

I always write a script while I'm shooting another. I started writing *High Heels*, the script I did make, before making *Tie Me Up! Tie Me Down!* The initial idea was a confession on live television. I've always dreamed of seeing that during the news and, because I never have, decided to write one instead. When I finished *Tie Me Up! Tie Me Down!* I re-read the few pages I'd written and liked them a lot. So I then tried to explore the character of the woman who was capable of confessing herself on a TV news bulletin. While examining her motives, I came up with the character of the mother.

When I was watching you direct the film, I thought you were trying to create a kind of suspense around the Femme Letal–Judge Dominguez characters, both played by Miguel Bosé. Seeing the film, I realized the opposite. An attentive audience can easily guess the double role from the opening credits; Miguel Bosé's name is superimposed on a picture of Femme Letal. So, no suspense.

No. I didn't want that. It might have been useful, but I was much more interested in the fact that Rebeca – Victoria Abril – doesn't know that Femme Letal and the judge are the same person. That she couldn't recognize him had to be believable. I also considered making Femme Letal the murderer of Rebeca's husband. In this way he would have eliminated his enemy. I would have chosen that option if I'd been making a thriller. I looked at the murder from each possible point of view because all the characters are plausible and potential murderers. In fact, I was interested in Rebeca being the killer, but by making the smallest adjustments to the script I could easily have chosen someone else. Another possibility was to exploit much more fully the police investigation led by Judge Dominguez.

I finally chose the most obvious solution, so obvious it was almost surprising: Rebeca confesses to the crime but no one believes her. The process interested me. She confesses three times in the film and each time she's

Miguel Bosé as Judge Dominguez . . .

and Femme Letal.

truthful and sincere. The three confessions are complementary and give an ambiguous impression. It was a huge risk – mainly because watching an actress confessing the same thing three times could have been rather boring. But Victoria managed to perform three different confessions, all very moving and different. From the start, this way of handling the story had the advantage of being less obvious than having a false and a real killer such as in Hitchcock. Rebeca could be either one. The problem is she is always accusing herself. Although confession is a passive act in which one becomes the victim, guilt for Rebeca becomes something she can manipulate. She uses her confessions for her own ends. It's rather abstract, but I hope the film makes it clear.

With Rebeca the listener of the confession disappears. One always confesses either before God or the law, but Rebeca controls her confessions and ignores them both. This is very important in terms of her character. She is both the origin and the goal of her morality. This gives her an added dimension. In her first confession, she shows she is totally alone, she only has the lens of the TV camera to talk to. But she also reflects the truth of the news bulletin; she recites things that have happened and pushes the form to its furthest limit. By confessing she is punishing herself. Her mother watches this pathetic spectacle and also feels punished. Rebeca confesses and at the

same time points the finger at her mother, played by Marisa Paredes, and her husband. She is therefore using the confession not just to accuse herself but others too.

Just as the mother confesses to save her daughter.
The mother explains her decision very well in the film. She says she wasn't generous. In fact, she was rather mean towards her daughter, but she wants to leave her her most precious heirloom: her fingerprints on the gun. These fingerprints represent the love she feels for her daughter, which is why Rebeca treasures them so dearly. The scene seemed brutal when we were rehearsing, so I tried to soften it a little. When the judge tells Rebeca he can't accuse her mother for lack of proof, Victoria pales and replies that if he needs proof she'll get it. She said this with such determination, she was almost frightening. I told her we'd have to rework the scene so that her character wouldn't seem so cruel. Victoria switched to an expression of infinite pain, but I had to direct her a great deal because, like Carmen Maura, she wasn't conscious of what she was doing. I told her to allow Marisa the opportunity of refusing to put her prints on the gun, so that her character would in some way respect the death of her mother. Marisa therefore asks whether she has the revolver, Victoria says yes, but doesn't give it to her and asks her whether she's sure about what she's doing. Marisa then replies with the greatest naturalness, 'Yes, I am.' Victoria holds out the gun; she's suffering a great deal, she almost doesn't want to give it to her. She is partly manipulating her mother's guilt and pain, but she will respect her decision whatever it might be and, in the end, it is the mother who decides.

None of this was in the script. When one's writing one can't be aware of this kind of dysfunctionality. One has to see the actors' faces as they perform to understand it. There is no such thing as the perfect script, it must be tested while making the film, by the flesh and blood of the characters. Only then can one know whether it's good or not.

There's another very pathetic moment in the finale when Rebeca sees the high heels of the women passing in the street. She tells her mother the sound of high heels reminds her of her mother coming home when she was little. She turns round and realizes her mother died while she was talking. It's an agonizing moment because her mother could have told her she loved her, but time ran out on them. Rebeca therefore has to finish speaking to a dead woman. It also means her mother remains a fugitive. She is always leaving her.

High Heels *is your most complex film psychologically. It's almost psychi-atric. At the same time, all the emotional conflicts, all the identity crises of the characters are turned into a spectacle, such as Rebeca's confession on TV or the drag show where you explain that Rebeca will satisfy her emotional needs through a copy of her mother.*
Absolutely. Even if I don't think about an audience, that element of the film is a kind of treat for them. Everything becomes a spectacle.

It's what differentiates your film most from Bergman's Autumn Sonata. *Why did you decide to refer openly to Bergman's film through one of Rebeca's monologues?*
Through my films, I deal with all the things that are part of my life and experience, and cinema is one of them. As I said earlier, I'm a very active spectator. Yesterday, I saw John Cassavetes' *Opening Night* and I took to the film like an intimate confession in which I played an active part. Seeing it was an active emotion. It was the most intense moment I've experienced in several months. I'd be terribly proud if I could make a film like that! It contains all the elements I like: an actress, a play, the relationship with a director, the lover who's an actor, and an unfathomable depth of pain. Gena Rowlands' performance is stupendous and Joan Blondell is fantastic in a

Daughters and Mothers: *High Heels* (Victoria Abril and Marisa Paredes) . . .

part totally different from those she normally plays in her comedies. It's a magnificent film.

It isn't a sign of passive complicity, therefore, when I quote other directors in my films, it's part of the story. When Victoria explains her relationship with her mother, she could take an example from her own life, but instead she uses *Autumn Sonata* because that, too, is part of her life.

Many people say I take fewer risks than I used to. I think I take just as many, if not more. The difference is I'm working with different materials. A scene where two people talk and discuss Bergman's film in order to understand each other is risky. It could easily be ridiculous. Victoria has three pages of dialogue about *Autumn Sonata* and through them explains her relationship with her mother. Before shooting it, I told Victoria the monologue could kill the film. We did fifteen takes. I wanted to shoot it in one master shot in order to allow Victoria to perform the entire text. The scene gives an indication of her talent, her self-control and her extraordinary judgement. She played it very movingly, step by step, following my directions. It was very impressive. There was complete silence on set. It was like

and *Autumn Sonata* (Liv Ullman and Ingrid Bergman).

Opening Night: 'It contains all the elements I like.'

watching a play in a theatre. The whole crew held their breath. I've never felt such an intense atmosphere on any of my films.

For the opening night party you gave in Paris for High Heels, *you had Victoria Abril and Marisa Paredes perform the scene on the stage of the Salle Wagram. It was very convincing and everyone held their breath, as you say. When I visited the set of* Kika, *you were shooting a long scene which was rather similar. This time, two men were confronting each other and your first idea was to do it in a single master shot. The master shot is the natural and spontaneous evidence of a temptation to theatricality. We discussed this earlier in relation to* Women on the Verge of a Nervous Breakdown, *but in* High Heels *you push this theatricality even further.*
No, I think *Women on the Verge . . .* remains my most theatrical film. As for *Kika*, I had wanted to shoot that scene in one shot but in the end that wasn't possible, mainly because I wasn't confident enough either in my crew or my actors. It's very difficult to make sure everything's in place for the whole length of such a shot. I don't often shoot that way; I'd like to, but I rarely have the patience. It can also create a dangerous problem: you can lose some of the actors' reactions and therefore some of the audience's too. Ideally, I'd like to use a shot where the camera moves a great deal; in other words the opposite of a static master shot which is often what one ends up doing.
 It's true when I rehearse a scene in its entirety, it can seem very theatrical. But after this initial rehearsal, I automatically cut the scene up into several shots. What's theatrical is the way I present the scene to the actors, the directions I give them. But a theatrical *mise en scène* isn't necessarily uncinematic. Quentin Tarantino's *Reservoir Dogs* is a very theatrical film, but one can't imagine it on stage. Its theatricality comes from its use of space and the division of the scenes.

And High Heels *is a very unchoppy film. In general, the rhythm of your films stems from what's inside the shots – the actors' performances, the pace of the dialogue – rather than the way the scenes and shots are intercut. How important is editing for you?*
Editing is the process I'm most interested in and amused by. You're quite right when you say the rhythm stems from what the scenes contain, the energy of the dialogue and the performances. For example, *Kika* is a film of almost mind-boggling pace but that doesn't mean the shots are short or that there are many cuts. It's wrong to think that pace comes from a profusion of shots. A shot must first have its own internal rhythm. Each shot must either

contain new information or raise new questions. Therefore, each shot must tell you something. That's the key to the rhythm of a film.

I'm fascinated by editing and I've been lucky having the same editor on all my films, José Salcedo, who's excellent. He concentrates particularly on what we call here *el afinado*, the little details, the tiniest corrections in editing which entail the greatest subtlety.

But the editing of my films is dictated by the work done before, even by the way I shoot. Now I have more money and I'm much more aware of the dangers of shooting, I shoot many more takes. Normally, I shoot several different versions of the same scene, different in terms of tone mainly – the scale of the shot rarely changes. I also try to shoot the scene from the point of view of each character within it. This supplies me with more possibilities during editing. The story, the structure of the film are already dictated by the script, but the way the narration develops comes from the editing.

Shooting more takes is particularly interesting as far as the work with actors is concerned. Sometimes, I get a crazy idea about how an actor should say his lines. Before, I couldn't allow myself to devote an entire take to a crazy idea; I wouldn't know what the effect would be. Now, I can shoot the scene in a serious, conventional way and then go on to try the crazy idea I may have had. I did this on *High Heels*. When we were editing I almost systemically chose the conventional takes, the most serious ones. But with *Kika* it was the opposite; we opted for the takes that were all the most wild and exaggerated.

For High Heels *and* Kika *you started editing with José Salcedo while you were shooting. Is this a new method and what made you choose it?*
I've always worked like that. For me, not editing while shooting would be like flying blind. It strikes me as far too risky to shoot everything then edit it and see whether everything works the way one wanted. If you edit the film while shooting then at least you can adapt. During editing, I have my first objective view of the characters. They've become real and sometimes they're not entirely what I wanted them to be. But there's still time for me to guide them in the direction I want them to go. You can also see the rhythm of the film. While shooting you can deal with all the problems that the editing confronts you with. Shooting for me's a very tiring experience. I go to the editing suite after each day's work and I sleep very little. But one week after I'd finished shooting *High Heels*, the film was cut. Post-production's therefore much easier and shorter.

I saw you working on the set of High Heels. *You were playing the scenes*

yourself in order to explain them to the actors. Is this something you often do?

Yes, very often. In fact, I have the reputation of being a good actor. What's true is that while I'm shooting I feel as if possessed by each character, I want to play them all in the clearest and most expressive manner in front of the actors. But I couldn't do this in a film like a real actor. I don't like seeing myself photographed and I don't like being filmed in that kind of situation because for me acting is something very intimate. Agustín, who's perhaps one of my greatest admirers, would like to shoot a 'making-of' of one of my films to show the way I work with the actors. But I'd be ashamed. The actors are naked in front of a director. It's the same thing for me when I'm acting. I see nothing; nothing exists apart from the character I'm playing. When one returns to one's normal personality it's rather embarrassing.

The musical sequences in High Heels *are perfectly integrated into the drama. In your previous films, musical scenes had more of a documentary feel, such as when you sing with McNamara in* Labyrinth of Passion. *They could also be an entertaining interlude between dramatic points in the story as when Loles León sings in* Tie Me Up! Tie Me Down! *In* High Heels *the music and the songs have become part of the story. Was that your intention?*

High Heels: The musical sequence in the jail.

Absolutely. The story of *High Heels* shines through every note of the songs. I listened to an enormous number of songs to find those I'd use in the film. I finally chose two I liked, 'Piensa en mi' and 'Un año de amor'. They became hits in several countries. But my quest for the songs was hardly scientific, I fell on them by chance. I had to find songs that would correspond to a singer such as Becky del Paramo both at the start and at the end of her career.

'Piensa en mi' is a very famous song in Mexico. Lola Beltrán sang it. It was composed by Agustín Lara who was once married to Maria Felix and is a kind of national hero over there. But no one knew the song in Spain. I had several versions and the one I liked best was by Chavela Vargas who's the last in the line of singers like Billie Holiday or Edith Piaf. In fact, you can hear her in *Kika*, she sings 'Luz de luna'. 'Piensa en mi' is a very rhythmical song, but when Chavela sang it she took out all the rhythm and turned it into a *fado*, a genuine lament. That's the version I copied for *High Heels*. 'Un año de amor', which Femme Letal sings in playback during his show, is a French song by Nino Ferrer. I knew the Italian version sung by Mina, a great singer.

For the film, choosing the songs was like working on the script, all the more so because I looked for them well before making the film because I wanted to record Spanish versions. Once I'd chosen them I had to find a voice for Marisa. I had her trying on different voices in the same way as I did her various costumes; to see which would hang best on her body. Luz Casal's fitted very well. I asked Luz to sing the two songs – which was a little strange, rather like asking Johnny Halliday to sing a nursery rhyme, because Luz was famous as a rock singer in Spain. She accepted and the two songs became her biggest hits.

From film to film, you've made famous many songs which are now associated with your style: two compilations of La Lupe who sang 'Puro teatro' in Women on the Verge . . . *have come out in Spain. One is called* La Lupe al borde del ataque de nervios, *the other* Laberinto de pasiones.
It's a homage on the part of her record company because *Women on the Verge* . . . made her famous here. This is the case with almost all singers in my films. It's a little unfair because Los Panchos in *Law of Desire* Lucho Gatica in *Dark Habits*, Los Hermanos Rosario in *High Heels* and Chavela Vargas in *Kika* all sing in Spanish and even if all these singers come from South America they should have been discovered earlier. But there's a real prejudice against this type of music. In Spain, it's long been considered old-fashioned and over-sentimental. I'm very happy to have helped these singers to be recognized artistically and commercially. People look at a singer of *bolero* in a different way now. They're even becoming a little too fashionable.

· *What makes you choose the songs?*
My heart. They're always songs I like and which speak of my characters.
They fit quite naturally into the world of my films.

Yes, as with 'Soy infeliz' and 'Puro teatro' in Women on the Verge . . . , *each
song shines light on the story. There's also the scene in* Law of Desire *where
before committing suicide Antonio Banderas makes the director he loves
come to see him. The song playing is 'Lo dudo' by Los Panchos. The words
are roughly 'You'll never find a love as pure as mine' and they take the place
of dialogue. Instrumental music in your films rarely fulfils the same narrative
function as songs do. Even if the music has been specially composed, it
doesn't have such a precise or important role to play.*
Music plays a very important part in *Kika*. Kika herself is associated with a
certain type of music, Andrea with another, each character has his own
musical genre. I came upon a percussion piece by Perez Prado, the king of
mambo. It's a very primitive, savage, arid, violent and abstract piece of
music; perfect for Andrea. I also used some other mambos by Perez Prado
for Kika, but the lighter, tenderer ones.

The film is divided into narrative blocks. In turn, each of these blocks is
divided into subsections. I don't underline the movement within each block,
but rather its beginning and end. I use the music like the heading of a chapter
in a novel. Ramón is resurrected the first time, then meets his father-in-law
two years later. The music plays in the scene the following morning when all
the characters are getting up. From the morning till evening when they go to
bed, when Kika is on the terrace listening to the music, it's another chapter.
Then there's the block containing the rape which ends when Andrea goes on
to Kika's balcony, looks at the town and points her camera at the buildings
like a gun. Then I go straight to night; night becomes the moon; the round
moon becomes the door of the washing machine which contains the clothes
Kika was wearing during the rape. We pass from one block to another and
the music serves as a guide or a link. In the fourth and final part of the film,
which, because it belongs to another genre from the others and operates
somewhat independently, I use the music in a completely different way. This
block begins when Rossy de Palma walks off alone in the street. I use the
music Bernard Herrmann composed for Hitchcock's *Psycho*, music that will
bind together the discovery of the hidden crime through an extract on the
TV of Losey's *The Prowler*, and Andrea's entire nocturnal search through
the videotape.

Of all cinema composers, I consider Bernard Herrmann to be the best
manipulator of an audience. Even if only film buffs will understand this, I

allude through the music to another story of a man obsessed by his mother, just like Ramón is in *Kika*. It's an amusing parallel. When Ramón enters the Casa Youkalli to speak to Nicholas, he seems unhinged. The house smells of a dead woman. Of course, the body of the woman played by Bibi is lying dead in the house. But Ramón believes he can smell the perfume of his mother whose suicide he never accepted. That's where I use the theme of Kurt Weill's 'Youkalli'. It's a French cabaret song from the Twenties. The words, which we don't hear, describe an idyllic land where love is always shared: 'Youkalli, land of my desire, Youkalli, land of happiness and pleasure . . .' The end of the song is rather different: 'But it's a dream, a fantasy, there is no Youkalli.' It's a tragic, pessimistic song. It's highly significant that Ramón's mother called her house after a paradise which doesn't exist. It gives some indication of her character. Most people don't know all this, but that's why I used Kurt Weill's music. When Ramón approaches the bathroom where his mother died and where there really is another body, the music throws a kind of shadow of maternal gloom across the scene. It's also very moving.

For the end of the film, I chose another mambo inspired by a very famous tango, 'La Cumparsita'. The version's for an electric band and gives enormous impetus to Kika's exit. It's an optimistic mambo, but hard, not light like the others. It's dynamic music which forces one to act, which is precisely what Kika does.

You could have used the words of 'Youkalli' to bring out the meaning of the music more clearly.
I intended to. If the film had ended as in the script, with Ramón and Kika reconciled in the house, I would have used the version of 'Youkalli' sung by Teresa Stratas. It was perfect for the epilogue. But I couldn't use it the moment I made Kika leave the house and take to the road. It's a shame, because I would have liked the public to hear the song. At least it would have allowed me to develop an explanation of the meaning of the film . . .

Did you have the idea of casting Miguel Bosé in High Heels *because he was a famous singer in Spain and South America?*
No. I screen-tested him like any other actor. His character is complicated; he has several facets and fulfils several functions in the story. Physically speaking, it wasn't easy to find an actor who could play him. The actor had to be believable both in drag and as a judge. Miguel Bosé was the only actor I saw who could do it.

Rossy de Palma, one of your pet actresses, was also a singer before becoming an actress.
Yes, she was in a band called The Worst Possible. They were very underground. She was also a waitress in the bar they played in. But the band no longer exists.

The other pieces of music on the soundtrack of High Heels *are all credited to Ryuichi Sakamoto, but there are very few of them in the film. Why is this?*
I didn't like them. It's very difficult to find a composer capable of writing music which will fit perfectly into a film. There's very little time to write and record, three weeks at the most, between the editing and sound mixing.

For the title sequence and Rebeca's second confession in *High Heels* I used pieces composed by Miles Davis in the Sixties, pieces inspired by flamenco. They're very strange. Miles Davis is the only musician who's captured the power and essence of Spanish music. The first piece, which we hear while Rebeca's alone waiting for her mother, is called 'Solea', meaning 'solitude' in Andalusian. After her second confession to Judge Dominguez, when Rebeca goes to the cemetery to throw a handful of earth on her husband's coffin, we hear the second piece, 'Saeta'. During Holy Week processions, penitents sing for the Virgin Mary. Their cries are called a *salta*. It's a cry of pain, recalling the death of Christ and sung *a capella*. Miles Davis recaptured with his trumpet this form of the human voice. It's an extraordinary achievement. Such a musical cry of pain is perfect for Rebeca.

But there are other sources for the music in the film. I stole two themes composed by George Fenton for *Les Liaisons Dangereuses* without anyone noticing. You can hear them when Rebeca leaves prison and goes home and when she returns to prison in the van. I love the idea of stealing music composed for one film and giving it another meaning, a new life in another.

Why did you ask Ennio Morricone, whose work has always been classical if not sometimes conventional, to do the music for Tie Me Up! Tie Me Down!, *a film which is neither?*
I'm not crazy about what he does, but I like his music for Westerns. He happened to be free when I needed a composer for the film – which wasn't the case with Miles Davis whom I'd originally wanted. I only used half of what Ennio Morricone composed for *Tie Me Up! Tie Me Down!* As you say, his music was far too conventional for the story of the film.

I'm always confronted by this problem when I commission original music. I listened to other pieces by Morricone and realized all he'd done was copy himself. The main theme of Polanski's *Frantic* is almost identical to that of

Tie Me Up! Tie Me Down! I don't want to do these composers a disservice. They have so little time to work on a film, it would be unfair to judge them just on that. When I sit down to work, I do so in the hope of creating something new. However, with so little time, a film composer inevitably comes up with things he knows already. Musicians who've composed music which can stand on its own – Georges Delerue, Nino Rota, Bernard Herrmann – are rare. I'm also very fond of Goran Bregovic. I asked him to compose the music for *Kika*. But when Goran came to Madrid, we'd already finished editing the film and I knew exactly what kind of music I wanted. He didn't have anything to do; I'd already chosen the pieces I wanted to use. It was a shame.

The music for *Kika* is very eclectic, like that of *Law of Desire*. I didn't have a composer for *Law of Desire* so I used a mixture of pieces I already knew. The result's very pleasing, but it's a rather complicated way of working because of the rights.

When Becky del Paramo says she was once a pop singer and has now become a grande dame of song, is this an aside to the critics you mentioned earlier when speaking of your evolution as a film-maker?
The line's very ironic. Becky's laughing at herself when she says it. At forty, you can still be a pop film director but not a pop singer. Pop's a juvenile form; past a certain age a singer becomes pathetic. She must change genres and like Becky become a *grande dame* of song. Otherwise she'd be grotesque. But that isn't the case with cinema.

Nevertheless, High Heels *seems to aim for a more classical form of cinema. There's something Hollywoodian about the film.*
Out of all the ways of treating a melodrama I chose the most luxurious. I could either have made an arid, pared-down melodrama like Cassavetes or one like Douglas Sirk in which the luxury and artifice are as expressive as the characters. And the latter was precisely the kind of Hollywood aesthetic I chose. It has to do with the way I see the story. I also feel it brings me closer to the audience. As I said, what I like in cinema is the artifice, the representation of reality. I adore *Opening Night*, but I'd never be able to shoot that story in such a radically naturalistic style. I can admire it, but I can't imagine working that way.

When I started making films I took cinema to be the representation of something else, a kind of game. It's this game which interests me most as a director. In it you can see an artifice which belongs essentially to Hollywood, most of all to the melodramas of the Forties and Fifties,

made during the birth of colour. To use this Hollywood aesthetic seemed logical – especially since the mother is a singer, a showbusiness character whose story recalls the stories of certain Hollywood stars. The film alludes both to the films made by Lana Turner and Joan Crawford and to their lives, to the relationship between Lana Turner, whose lover was killed by her daughter, and to the tumultuous relationship between Joan Crawford and her daughter Christina. In this way, glamour is part and parcel of the world of the film.

It's a very logical choice, given the characters of the film, but in relation to contemporary cinema one could say it was old-fashioned, passé.
And precisely what I like is that no one makes that kind of movie today. I like showing that the public can still be interested in films like *High Heels*. If you want to be modern, you mustn't worry about it. You must tell the stories you like in the way you like. We spoke earlier of the end of the century and the eclecticism which makes you look back and refashion the things which appeal to you. If you remain sincere, looking back to the past will inevitably become a personal style. You mustn't worry about the originality of your work, but be sincere within the aesthetic and the language you have chosen to work in. The more sincere you are, the more modern you are. Of course, you need talent as well. I really believe if directors made the kind of films they really wanted to make, they'd be much more original.

The present dearth of great melodramas can perhaps be explained by the fact that directors fear a genre which has been so debased by television. Perhaps they feel they can no longer save it from its decline and may even be dragged down with it. Did you also share these anxieties?
Yes, it's one of the dangers. Melodrama is the genre which has most suffered at the hands of television. It's been massacred through countless idiotic television series. When one makes such a film one naturally takes the risk of being associated with the sad image melodrama now has. But it's a prejudice one must fight against, precisely in order to renew the genre.

The scenes which take place in prison work extremely well. They also introduce a brutal, realistic element into all this luxury and artifice.
And the dance number with its frenetic music also creates the kind of distancing effect I use in all my films. The prison scenes are very realistic. At the same time they're the most kitsch part of the film. There are allusions to famous musicals shot in fake prisons like *Jailhouse Rock* with Elvis Presley and recently John Waters' *Cry Baby*.

High Heels *provoked different reactions in different countries, both among the critics and the public. How do you explain these mixed reactions?*
Various things happen to my films. Sometimes it has to do with factors outside cinema. But I'd like to analyse why my films do better in some countries rather than others.

High Heels was enormously successful in Spain, but the reviews weren't good. Spanish reviewers tend to talk about me as if I were a phenomenon outside cinema. They never tackle my films head on. Throughout the world my films appear more in fashion and design magazines than in film journals. But in Spain they don't even discuss the aesthetic or the colours of my films. I don't mean I'm not appreciated, I am, but because it's my native country I'm looked at cursorily, not seriously. No one is a prophet in one's own country. *High Heels* was very successful in Italy and the reviews were both heartfelt and moving. In France, too, I'm considered with more objectivity and more freedom than I am here.

The film did less well in other countries such as Germany and the States. In Germany, language was the main problem. The film came out in a dubbed version. Any of my films loses sixty per cent of its value if it's dubbed; it loses even more if it's dubbed in a language as far removed from Spanish as German. In Germany my work also runs counter to a certain mentality. All the questions I'm asked there start with the word 'why?' My films move very freely – not irrationally but freely – and to understand them one must simply allow one's intuition and sensibility free rein. For example, I'm sure if I'd made Peter Bogdanovich's *What's Up Doc?*, where the whole story revolves around four characters with the same suitcase, the Germans would have asked me why I used that particular make of suitcase, weren't there any other types in America? It's impossible to discuss with Germans certain conventions which are part of cinema. I've never been asked so many irrational questions as in Germany.

High Heels was less successful in the States than my other films. One of the reasons, although it's the least important, was the recession; Americans go to see far fewer foreign movies. Like *Tie Me Up! Tie Me Down!*, *High Heels* was especially attacked on moral grounds, notably by certain women's groups. Also, what was considered my audience, the 'modern' audience, believed I'd betrayed them, that I'd stopped making 'modern' films and was trying to join the mainstream. A rather stupid reaction, I think. What's more, Miramax, our distributor, hadn't understood the film at all. They had no idea what to do with it. A few years ago in the States my fans belonged to radical groups. The films were talked about in the radical press and the reviews were much more generous than they are now. Nowadays the films

get a much bigger release and the reviewers come from the national papers; they're the most conservative breed one can imagine. I am still a figure of the underground, I'm an independent film-maker, my films may not be as underground as they once were, I now have more money, but they're still not mainstream. So in the States I'm in a rather difficult position, stuck in a sort of no man's land.

But America launched your international career. America was where the Almodóvar phenomenon was born and it's via America that your films came to be released in France.

France is an extraordinary country for cinema, but also a follower of American trends. I tried to reach the French audience before any other, but French distributors only decided to take an interest when they saw how well I'd done in America.

This was the time of Dark Habits *and, most of all,* What Have I Done to Deserve This? *Was your relationship with America very different then?*

Yes, that was the honeymoon period. I interested the most 'modern' audience, which is both an advantage and a disadvantage. It's a very 'intellectual' audience in inverted commas, a very capricious, fickle audience. The moment I reached a bigger audience, they began to reject me because they prefer to keep their pleasures to themselves. They're a very snobbish audience, highly informed and interesting, but also very cruel because they're the ones who lead the fashion.

On the other hand, one must also take into account the broader changes occurring in American society. The return to reactionary values hardly favours me. I'm considered a scandalous phenomenon, almost a danger to the American people. I think it would be better for me to remain a minority interest in America. At least I wouldn't have to bear the judgement of the majority, a majority that's always conservative. This creates an unpleasant atmosphere. When I go over there I always get the impression I'm laying bare their contradictions. Without wanting to, my sense of freedom brings out the lack of freedom in American cinema. And the absence of prejudice in my characters only serves to show the enormous prejudice extant in America. Over there, my cinema creates a lot of conflict, it has an almost revolutionary power which it doesn't have in reality. And since I haven't kowtowed to my 'modern' audience, I'm stuck in this no man's land. The 'moderns' can no longer bear me because something in me criticizes that particular audience. In reality, I'm a mixture of things but in the States they'll only accept one facet of your personality. If you're a member of

the underground, you stay underground. If you're homosexual, that's all you are.

I've never wanted to be ghettoized in this way. Nor have I campaigned on behalf of one single aspect of my persona. I'm even critical of the militancy of certain groups I'm supposed to be in sympathy with. For example, I don't take part in the gay movement in America. I much prefer a mixture of things. Homosexuality is a genuine problem in the States, but the reactions of the gay community towards a film like *Basic Instinct* smacked of an extremism redolent of their opponents. The reactions of some small groups against certain films seem exaggerated and don't help clarify their objectives. Homosexuals protesting against *Basic Instinct* seems as absurd as hoteliers campaigning against *Psycho* because the murder takes place in a motel.

In Spain, your status as a popular and at the same time iconoclastic film-maker, a man who remains faithful to his own world, doesn't seem to cause any problems. Is your position better understood?

Yes, it all happens much more naturally. But you're right, it's a strange situation. My films stay personal and I'm very surprised they're such a popular phenomenon here. It shows a certain equivalence between my evolution and that of the Spanish audience. We changed at the same time. The Spanish working class has developed at a much faster rate than anything else here, faster even than the films made here, and much faster than the political class.

Before shooting Kika *one of your projects was an adaptation of* Live Flesh, *a thriller by Ruth Rendell. Is your wish now to tackle all the genres, systematically? Melodrama, musicals, thrillers?*

I don't know. When one looks at things with a contemporary eye, it's clear much has to be changed. Melodrama is a manichean genre. It was used to set one social element against another, to defend one thing and denounce something else and it continued to do so until Fassbinder re-invented it. There is no such manicheism in *High Heels*, unless one considers the two heroines to be bad, or at least not very good. In the same way, my excursions into musicals and comedy totally contradict the basic rules.

I don't know which genre I shall turn to next, but I know I won't entirely respect its rules. Only the studios and the large corporations respect genres. And then it's only to make films like *Indiana Jones*, which is a very calculated way of dealing with the adventure genre. A film-maker who wants to make personal films cannot respect all the rules of a genre. As time passes, we inevitably see stories a different way. Nowadays, it's no longer important to say who is bad and who is good, but rather to explain why the baddie is

the way he is. Genres force you to view characters in an elementary manner. I don't think that's possible any more. It corresponds to the mentality of another age.

So it's less the genre but the story and the form you can tell it in that interests you?
Yes. *Kika* comes from the first chapter of Ruth Rendell's *Live Flesh*. I liked it a lot and wrote my own version which was completely different and eventually led to the script of *Kika*. There are many genres present in *Kika*, but in a much more dangerous mix than in my other films. It's like a poisonous sweet. Three quarters of the film is a sugared almond, the rest is pure venom.

Kika

The humour of everyday life

Reality Shows

Collage

Older women

Sets

A handicapped basketball player

The media

FRÉDÉRIC STRAUSS: Kika *is a film which looks both back and forward. In a totally new form, it shows the encounter between your studio work since* Women on the Verge of a Nervous Breakdown *and a character, Kika, who's highly reminiscent of Carmen Maura in* What Have I Done to Deserve This? *Although surrounded by people, Kika is a deeply lonely character living in a very brutal urban environment. As it happens, Veronica Forqué, who plays her, had a small part in* What Have I Done to Deserve This? *Your vision of urban life in* Kika *is much less realist, less social, more futuristic than in the earlier film. But to compare the two seems justifiable. Do you agree?*

PEDRO ALMODÓVAR: One can't speak of realism in relation to any of my films, although *What Have I Done to Deserve This?* is the closest to a kind of neo-realism. From that point of view, *Kika* is very different. The heroines of both films are indeed solitary women. But Kika's world is clearly far superior socially to Carmen Maura's. This could give the impression that her life is more comfortable, which in reality it isn't at all. Both women are surrounded by a version of hell. But the hell of *What Have I Done to Deserve This?* is instantly recognizable in the concrete elements, the details of her daily life: hell is her husband, her children, her mother-in-law, the neighbours, the street, work. Hell in *Kika* is something much more abstract

and therefore harder, more aggressive because it can't be defined. The tension lies in the heavier atmosphere – heavier precisely because the film is much less realist and puts forward ideas rather than characters and situations. *Kika* is about the sickness of big cities. I wanted to show this sickness as if it were something one breathed in the air. Which is why I hardly ever show the city in the film, in the same way as one never sees Los Angeles in *Barton Fink*, even though the film is about the hell the lead character experiences living there. You don't see any streets in *Kika*. When you do see the city, it's only a representation of the city, such as in the set of Andrea's reality show. But the aggression is there all the same, in spite of it not being expressed in concrete form.

Kika (Veronica Forqué): a deeply lonely character.

You obviously no longer want to shoot in the streets.
Nowadays in Madrid it's very difficult, even impossible. People in apartment blocks form groups to ban shoots in their street; you can hardly get a permit to stop the traffic from the council because the traffic's already bad enough as it is. One can steal shots on the fly, as I used to when I worked in Super 8, but the minute one has a crew things get complicated. The city of Madrid is not interested in film-makers. The Mayor's Office no longer even grants authorizations to shoot. In a studio you can put your camera where you like,

you can put up walls, take them down, you're free. What's more, for *Kika*, for its atmosphere, shooting in a studio proved perfectly logical and fruitful.

What's interested me most in my studio work since *Women on the Verge . . .* is the possibility of using all the artifice that comes with it, creating all the sets inch by inch. I'm now interested in the opposite: assembling an exhaustive and detailed archive of naturalistic locations, exteriors and interiors. I don't know what my next film will be, but I've already decided to shoot it on location. It's something I'm going to study very closely. I'm sure the physical reality of things will prove to be very surprising. No prototypes exist for the interiors of houses, but I think I'll come across some very amusing – not to say inventive – things which will be as surprising as what I imagine and certainly more surreal. I want to go on a kind of safari through people's houses.

How are you going to do this?
Like a market researcher, going from door to door in different areas.

In Spain?
I don't know.

Getting back to Kika, *it's a film of many narrative components, but also one where your dramatic construction has never been freer, so free it's almost baffling. The film's coherence springs from what seems a mass of incoherence which, if one doesn't watch the film with a mind rid of pre-conceived notions of conventional narrative, might seem terribly confusing. It's almost as if the film posited a new genre.*
I'm hardly the one to say whether I've invented a new genre or not. Perhaps I simply made the film in a different way. *Kika* is perhaps my least classifiable film. Even though *Kika*'s recognizably part of my work, it's very difficult to compare it to the other films I've made.

One of the problems Spanish critics had with it was that they approached it with an almost Stalinist orthodoxy, when the film couldn't be more heterodox. The film has the structure of a collage or of a very radical puzzle. This doesn't mean the edifice is any less rigorous, but that communication occurs through the doors, windows, the different floors of the building. In this universe, there is neither past nor future, only the present, an objective, almost concrete present. For example, when I do go back to the past via a flashback it's through the use of a very intimate diary, something concrete, belonging to the present. Of course, there's a background story to the relationship between Nicholas and the woman played by Bibi but I don't want

to tell it, I only tell what the characters see, which is their present. I wasn't at all interested in telling the story of a serial killer in South America. It's the kind of choice Spanish critics find very confusing.

Being confused can be a pleasurable experience for an audience. In the case of Kika *the pleasure's abundant. It's a film one can play along with as long as one accepts the logic of the puzzle and its kaleidoscopic variations of character. One can also view it as three-dimensional object, a very amusing ideogram. It contains as many stories as there are ways of looking at it.*

What I found surprising is that, unlike you, cinema professionals, connoisseurs, critics, just didn't see this. Only the public did in Spain. But this is a subject we'd better avoid. What's happening to me in Spain feels more and more like a lynching. The day of *Kika*'s première I was afraid the audience wouldn't understand the film because it's a very personal work, full of purely cinematic concepts. I love to pick over the guts of a film with someone, but a film should be able to stand on its own without explanations. Before the première, I wasn't sure *Kika* would be able to do this. When I work I think only of myself as a man and film-maker, but when the time came for the film's release, all I could think of was the market.

I have no desire to become the kind of megalomaniac, capricious director who spends vast amounts of money on personal projects. I don't mean I don't admire certain megalomaniac exercises such as Coppola's *One from the Heart*, an exercise in style which fascinates me. But I don't want that to happen to me. I don't want to bankrupt anyone. What Coppola did was fantastic, but the situation he was in would frighten me. Normally such stylistic exercises are doomed to incomprehension, even if later they become vital to an understanding of the history of the cinematic language. But I don't want to make expensive films and *Kika*'s the most expensive film I've ever made. I risked a lot with *Kika* and I would like to go on taking risks, but with not so much money. I'd feel calmer and freer that way.

In order to visualize the narrative structure of Kika, *I amused myself by drawing a kind of diagram describing the relationships between the characters. One of can see very clearly that Kika lies at the centre of a kind of circle with all the other characters acting both upon her and the story.*

Yes, it's true. I was aware of this when I was writing the script and wasn't sure whether it would be a good idea. Kika's at the heart of the story, but doesn't drive it. It bothered me a lot because it goes against the canons of conventional storytelling where Kika would normally be the engine of the story, instead of a passenger. What's more, this passiveness runs against the

One from the Heart: 'An exercise in style which fascinates me.'

grain of her character; she's so spontaneous and energetic, always ready for anything. On the other hand, her complaisance, though energetic, can also make her passive.

Before visiting the set I read what was almost the final version of the script. It was the seventh draft. Did you work a great deal on the story?
Yes, I wrote and rewrote it repeatedly. The changes I made in each version affected all the characters and made me understand them better each time. *Kika*'s a film where all the doors and windows are open, where all the characters are open even though they all have something to hide. Therefore, anything can happen at any stage of the story. I finally had to make some choices because the proliferation of narrative possibilites was beginning to drive me mad. Each character had its own narrative line, any of which could have become a film in itself. Out of all the versions I wrote I chose the most daring because it was the one I found most exciting.

What remains in the film is that each character is related to a specific cinematic

genre. But there again Kika herself doesn't have her own genre; she belongs a little to them all: comedy, thrillers, suspense . . .

Yes, it's a problem. She's the most passive and undefined character. It also makes her a victim because she's the only character who has nothing to hide, to the extent that everyone, even Ramón, knows about her relationship with Nicholas. This expresses her innocence, her total incapacity for intrigue. But I can just as easily conceive of her as the centre of the story, the main protagonist. She reflects everything around her.

In that light, the end of the film works very well. In retrospect, when Kika says she needs direction, her place in the story becomes limpid; lying at the centre of the romantic intrigue, she also embodies its many ramifications. At the same time, she lies somewhat outside all this; she's the only character who doesn't lose herself in it; she's the only one who learns from her experience.

Yes, that's very important. I'm very pleased I put her on the road at the end of the film. The white line on the tarmac shows her the way. It's an image which expresses her openness very effectively.

But the last part of the film caused me countless problems. The scene between Andrea and Nicholas was far too lugubrious. I couldn't see how I'd get Kika, who represents life, to come to this house full of corpses and then get her to leave. I wanted to save both Kika and her brand of optimism from the horrifying reality of the story. Striking a balance between all these elements was very difficult. Kika had to react to the tragedy round her without losing either her naïvety, her innocence or her spontaneity. For Veronica Forqué this meant acting the part totally differently from the way she had been up to that moment. Veronica understood at once what I wanted. She has the air of a little girl lost among the horrors; a little girl who stays an optimist in spite of it all, but a poor little girl nevertheless.

I've enjoyed all the stories you've told me which you haven't made. I'd be curious to know about the earlier versions of Kika.

One of the versions was much less drastic and resembled more a conventional comedy. In this version, Nicholas was much less important and the story of Paul Bazzo and Juana much more developed. For example, when Juana sees her brother escape by climbing down the rope which was used for moving Nicholas's furniture, she remembers she saw her brother flying through the air once before. This sets off a flashback to their childhood.

They're both in their native village. Juana – in pigtails, she already has her moustache – is pushing Paul on a swing. He's shouting, 'Higher! higher!' So

she pushes him so hard he flies up into the air and eventually hits his head against a rock. From then on, Paul's no longer quite right in the head. On the other hand, his body develops at an incredible rate. He is sexually precocious, he rapes all the animals, the local housewives, even Juana. Although she's already a lesbian she lets her brother do it so he'll leave the village in peace.

When Paul is fifteen, Juana, who's a practical girl, decides to take him to Barcelona where he can become a porn actor, because that seems to be the best solution to his problem. She becomes his agent and Paul quickly becomes a star, mainly because when he's screwing he can't tell the difference between film and reality; he's doing it for real. The problem is he can't understand why the actresses, who were so passionate while filming, suddenly don't want to see him afterwards. He starts hating them and tries to kill them. Paul becomes a very dangerous man. And that's the end of the flashback.

Then, when Juana sees Kika's rape on the television, she rushes off to phone Andrea to offer her an exclusive, a film showing her making love with her brother. But she doesn't say who she is. The two women arrange to meet in a wax museum where she knows the police, who are looking for Juana because she's Paul's sister, won't find her. Juana arrives disguised like Morticia, the Anjelica Huston character in *The Addams Family*. She becomes

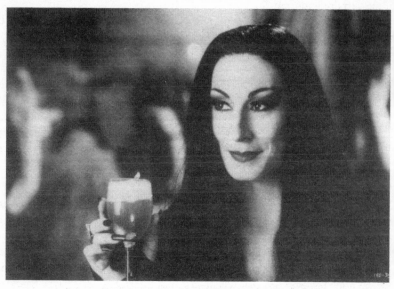

Morticia (Anjelica Huston) in *The Addams Family*.

another wax figure in the museum. She discusses the arrangements with Andrea who also wants to interview Paul. Juana accepts, goes to fetch him and comes back with him to Andrea's.

When they arrive, Andrea is filming Kika's apartment. She sees Kika with the policeman, her boyfriend. Andrea's furious, her desire for revenge becomes uncontrollable; not only is Kika living with Ramón, her ex-boyfriend, but it looks as if she's trying to seduce the policeman, her present lover and professional partner. In fact, it's the policeman who's trying to seduce Kika but Andrea doesn't know that. In a jealous fury, Andrea asks Paul to go back to Kika's, rape her again and, if possible, kill her. Obviously she'll film it as it happens. Juana then realizes Andrea is totally mad and lets Paul slap her. Andrea faints, Paul rapes her on the spot, Juana records it and keeps the videotape.

It's very different to the film you have now. How did you come to abandon such a good idea?
It was a story-line which only worked as comedy. I changed my mind when, during the rape scene, one sees a chest being lowered down the rope Paul uses to escape. I suddenly became obsessed by the idea that there should be a corpse inside the chest. This changed the rest of the story and made Nicholas much more important.

Kika is also a film about appearances, on the proximity of death which is something never seen, just as no one can see that the chest is in fact a kind of coffin containing the corpse of a dead woman. Hundreds of tragic events take place around us without us even realizing. I don't know why, but that interests me. I'm sure that if I'd followed the comic version of the script, the film would have been more commercial, but it struck me as too easy. Luckily, I didn't tell the actors about it, otherwise Rossy de Palma would have insisted on going to the wax museum dressed like Morticia. Rossy has a very Anjelica Huston quality. In fact, they're great friends. When they're together, you'd think they were sisters.

Kika is a strange mixture of physical types and often very abstract images. Was this simply the result of a concatenation of different ideas or was it intentional?
It's the vital mixture which makes the film credible. This is a general rule. My great secret, if I have one – the key to my work – is that, whatever the situation, however crazy or eccentric it may be, cinema is always objective. The image is made of real, concrete elements and must therefore be sustained

by naturalistic performances. This is what makes a scene both credible and convincing.

This is why I systematically surround my characters with objects which have a multiple use; not only do these objects reflect the aesthetic of the film, but also give the audience clues as to the nature of the characters. For example, in Kika and Ramón's bedroom, on the left hand side of the bed, Kika's side, the dressing table is covered in little objects. They're Kika's mascots: statues from Holy Week, her favourite animals, photos of her friends, things which reassure her and at the same time remind her she's alone. I don't shoot an insert of these objects – there are hundreds of objects I don't show very closely in the film – but it's there, Kika's shrine. The other side of the bed, Ramón's, is much more spartan and cold; one or two statu-ettes of more or less naked ladies, some crystal, an icy, glass ashtray, a picture of his dead mother with two small vases of flowers. The only two things which might awaken our sympathy are two robots Ramón used to play with when he was little. I chose these objects very carefully. Even if they don't elucidate the characters, at least they suggest something about them. Thanks to these elements and the naturalistic performances, the scene becomes much more believable while allowing a mixture of abstract and physical components.

Such as when Andrea stays impassive while reading horrific pieces of news. It endows the bloodthirsty reality of what she's saying with an almost abstract dimension. Or when Kika stays detached while Paul Bazzo rapes her. The rape scene is at the heart of the film. How did you approach it?
Indifference, which in Andrea's case is a symptom of her cruelty, becomes with Kika an indication of her optimism, her sunny disposition. In another version of the script, Kika idealizes Paul; she reads the paper over breakfast, sees a picture of him and goes to sleep. She dreams she's making love to him and wakes up to find him inside her. I abandoned the idea because it was too ambiguous. Showing a girl fantasizing about her rapist was risky, even if, cinematically speaking, the scene would have been interesting.

In the film as it stands, Kika starts by resisting Paul, but the second he puts the knife at her throat she becomes practical and tries to persuade him he has a lot of problems she can solve. This doesn't indicate any pleasure on her part; it shows her optimism. It demonstrates the strength women can call on in difficult, not to say critical, situations. Kika and Juana negotiate with the rapist in order to find a solution. I wanted to show this because it's a femi-nine trait I admire a great deal. It's also what makes the scene funny. If I'd written only half the scene it would have stayed merely violent. You have to

imagine that it doesn't last twenty minutes; Paul Brazzo is on top of Kika for three hours, the situation has time to develop. The horror of rape becomes irrelevant; a thirteen-stone man is on top of you and after a while you want to scratch your nose, have a pee, you think of the shopping, the phone calls you have to make, all kinds of domestic worries spring to mind.

Humour always arises out of everyday life. In cinema, situations are usually brief, one plays a lot with ellipses. However, actions which are conventionally and arbitrarily brief and which one makes longer always end up being surprising. Hitchcock proved the point in *Torn Curtain* during the murder, which is no longer a murder typical of cinema, but a long scene which shows how difficult it is to kill someone. Time passes, the man resists, the scene becomes something else. The Coen brothers do the same thing in *Blood Simple* with the man who can never decide when to die. It ends up being very funny.

Torn Curtain: showing how difficult it is to kill someone.

The rape scene also exemplifies the strange fact that physical pleasure in Kika is something never shared. Characters take their pleasure at the expense of others. Such a dark and disillusioned vision of pleasure seems surprising on your part.

Kika: non-communication in sex.

There's no reciprocity in the film, it's true. Non-communication in sex is even more terrible than anywhere else. All the characters live individually. This is horrifying, but it's what came about in the film. A lot of things in the films forced themselves on me even though they're what I like least in life. I was forced to keep them; I tried to make a positive film, but what came out was a representation of everything I hate, I couldn't avoid it. But one's being as sincere by keeping the things one doesn't like in a film as when one glorifies the things one does. Obviously I prefer the latter, although *Kika* dictated the former. When one makes a film, writes a book or paints a picture, one can correct reality, improve on it. But at a certain moment one can't avoid reality imposing its own rules and taking its place in one's work.

Reality in Kika is also Andrea's horrific and spectacular reality show. This aspect of the film is equally surprising. Not only do you insert in your story a televisual genre which already exists, but you develop it too. Suddenly we're faced with the more recent phenomenon of what the Americans call 'stringers', people who videotape violent events then sell the tapes to TV. Such personal initiative is very much part of Andrea's character. She goes beyond the normal scope of a news presenter. Do you know any 'stringers'?

Not at all. The whole thing's very curious, although predictable. People are going to spy on each other. It's what the market demands. Andrea doesn't only represent television, but also television's capacity to corrupt and provoke the most unthinkable actions. It doesn't just entail voyeurism, the pleasure of watching the unhappiness of others, but also a turn of mind, a kind of terrifying, denunciatory atmosphere of a police state. It's a very dangerous phenomenon.

Kika: 'Andrea (Victoria Abril) represents television's capacity to corrupt.'

Two years ago, when I started writing the script of *Kika*, reality shows didn't exist in Spain; they started this year. What shocked me and directly inspired Andrea's character was a show I saw in America relaying real trials. The trial I watched was that of the Kennedy boy accused of rape. The very fact of filming the trial is ghastly; if the man's guilty, it's terrible for him; if he's innocent, then it's terrible for the girl. But the programme went even further. At one point, the camera zoomed in on a piece of evidence, the girl's underpants on which were supposed to be traces of sperm. The image struck me as even more humiliating than the rape itself.

I gradually realized these video images would become an enormous market for television. In a way this is logical, given that many people live more and more shut up at home and their only link with the outside world is the

television. For me as a film-maker, reality shows are an interesting phenomenon. But they should be controlled and humanized, otherwise it all becomes too ghastly for words.

Andrea's character is a radical development of Rebeca's in High Heels, *also a news presenter. Victoria Abril uses the same voice in both films, the same serious, impersonal tone. The voice creates a double distancing effect given the tragic contents of the information. Andrea is inhuman but you treat her like a character, not just as a transmitter of images.*

Yes, there is something hard and distant about her, all the more so because what she recounts in *Kika* is so tragic. Her character, the way I wrote and described it, is one of the biggest risks I take in the film. She's someone who evolves amid images. But I was more interested in making her live through her voice rather than through pictures. There were two options: either tell her story from her point of view by using the subjective, tragic, violent images she shoots with her video camera, or tell it from my point of view by limiting the use of these images. I much preferred telling her story myself through her voice, which is hardly orthodox, given she's a girl who works entirely with images. But since I'm the narrator I can tell her story with an actress and hence with words. I preferred to hear her reciting the tragedies, rather than seeing them on screen. It's more theatrical but also, I think, more powerful. Using images would have been more spectacular, but as a film-maker I wanted to work on Victoria's tone and movement. It also goes to prove how much I detest TV. When I'm almost forced to use its language, I instinctively reject it.

Seeing Victoria Abril in Kika, *it's curious to recall she once played the sensual girl in* Tie Me Up! Tie Me Down! *Your work with her seems to be replacing her softness, her physical warmth with a much nervier expressiveness. Her presence is becoming much more abstract. How did this evolution come about?*

Andrea was the hardest part for Victoria to play because the character is effectively so abstract. Andrea belongs to another culture, totally alien to a European way of telling a story. She's also an absolute monster, deliberately inhuman. Sustaining this through a performance can make an actress face terrible things which leave her nothing with which to identify. So Victoria had to become a kind of instrument. This is very hard for an actress, especially when the instrument represents something so unsympathetic. But Victoria's work is splendid. What interests me most about her is her ability to play with anger and tension. She doesn't always like it. She often asks me,

'Pedro, why don't you write me the part of a nice, sweet girl?' But my dream is to see her become the new Bette Davis.

Andrea's a monstrous character, but in the last scene she's finally a touch humane. Her desire to film Nicholas's confession before he dies becomes moving. She expresses it as if a profound instinctive need were taking her over.

Kika: The confession scene (Victoria Abril and Peter Coyote).

She isn't indifferent to the situation, but it's not his death which concerns her. The scene shows how she becomes the victim of her own predatoriness. Nicholas is a very intelligent man, immoral certainly, but totally in charge of his life. During the whole of that terrible scene with Andrea he says nothing. The only thing he allows her to film is the crime she herself commits. This is my present to Nicholas. Television is a savagely competitive world. Andrea is ready to kill or die to get an exclusive. She's utterly mad. There's no television presenter like her, but it's a profession where, without realizing, one could very quickly become like her, like a spinning top whirring in a vacuum.

This happens almost literally when her camera continues whirring while

recording Nicholas's silence. At this point Andrea becomes pathetic and moving.

Yes, it's only at the moment of her terrible failure that I show her becoming human. I deliberately shot the scene as a moving one. When she says 'Nicholas, we haven't much time left', she almost becomes a friend. She lets slip a word of sympathy. Even though her motives are execrable, she becomes a heroic character at that point.

Veronica Forqué has had a very successful career in Spain ever since What Have I Done to Deserve This?

Yes, she has. Veronica's become one of the biggest stars in Spain. But she was already known before *What Have I Done to Deserve This?* She'd started in films very young. Her father directed her. But she'd only been offered very conventional, dated parts. After working with me, she started doing new things.

She's also, I believe, younger than Carmen Maura when she starred in Women on the Verge of a Nervous Breakdown. *There was no discussion of age in that film but in* Kika *age is very important. Kika wonders whether she's too old to marry Ramón, who's her junior. This preoccupation with age seemed somewhat surprising given her insouciance. It's also very moving.*

Carmen's behaviour in *Women on the Verge . . .* was that of a mature woman, although she's spontaneous too. Kika is thirty-six and behaves as if she were sixteen. This makes her more vulnerable, more sympathetic and funnier precisely because we know she's no longer young. Characters like Kika are always played by very young girls because life tends to blunt one's optimism. Kika, however, is as optimistic as ever. It's almost surreal.

In that sense, Kika is also a character which stands apart from the other women in your films; almost all of them are mature women in the style of the parts played by Carmen Maura. Young girls don't seem to interest you.

Candela, the character played by María Barranco in *Women on the Verge . . .*, resembles Kika a little. But you're right, most of my female characters are mature women, Victoria's in *High Heels* included; even though she seems young, her personality is fully formed. Crises are much more interesting to examine when they have to do with women who are no longer adolescents. These women face their lives with a greater awareness; it makes everything much more intense.

It's revolting to see how female characters are disappearing entirely from American movies. In *The Fugitive* there is only one scene for the woman;

Renee Russo, who's an excellent actress, hardly exists as a character in *In the Line of Fire*; Barbara Hershey in *Falling Down* is reduced to a mere supporting part. It's a great shame. As long as, in *The Age of Innocence*, Scorsese has been faithful to Edith Wharton's book then the most interesting character should be Michelle Pfeiffer's. I haven't seen the film, but Scorsese is the perfect example of a brilliant film-maker who has no idea about how to deal with women. He doesn't know what they are, how they can function dramatically.

We've spoken a lot about the sets of Kika. *They work extremely well and are a revelation in spite of all we already know about your inventiveness in that field. How did you come up with them? Did you do the kind of research you mentioned in relation to locations?*

Yes, I did. But it's a long process which advances by gradual stages. Only gradually do you see the full picture – rather like a painter faced with a blank canvas starting to organize the components of his picture. He may have thought they would all fit together, but realizes soon enough he has to change some of them.

Although there's a conscious, systematic element to this work, instinct plays the greatest part. This is why the sets cost so much money. I don't decide once and for all what I want; I work in several directions at once and reject or retain certain ideas as I go along. Before an armchair ends up on the set, I consider it in different colours and shapes. I'll study the effect it has in reality. One can only judge the effect of some sets by building them. For example, for the literary programme in *Kika* I had the furniture designed with letters and the set painted black and white like the pages of a book. It was a clear and highly conceptual idea. But when I decided to have my mother play the presenter, I realized the set was far too sophisticated for her and clashed with her personality. So I scrapped the original set while it was being built in order to build a new one around my mother. We went to La Mancha, where I and my whole family were born, and photographed the façades of the local houses. We turned these photographs into the vast posters which decorate the set of the programme. We also put in a table laden with local produce: chorizos, manchegos, local cheeses and piles of books. As you can see, I arrive at a set from several directions at once. It depends on the actors and the characters.

How did you get the idea of making your mother play the presenter? Was it simply a way of making her appear in the film like your brother Agustín? He has a small part in all your films.

The initial design for the literary programme.

No, it wasn't the same thing at all. The function of the literary programme was to show the cynicism of Nicholas's way of working. A scene must transmit information, but when it does that and nothing else it's no use. You must find another reason for the scene; you must give it another life. The information must be communicated through something which has a life of its own. Written, the scene was simply informative.

Knowing this and trying to find a way of giving the scene a greater autonomy, I had the idea of getting my mother to play the part. From that moment on, the scene became interesting. First, because the characters, a widow and a widower, discuss solitude. Secondly, the fact that the part was played by my mother made it much funnier. It alludes to the fact that anyone at all can have their TV programme. Often it's that person's non-professional side, their human qualities, which justify their presence. I'm alluding to Carmen Sevilla's programme on Spanish television. She's an old actress who retired twenty-five years ago who's now become famous again for a programme she presents where she constantly makes mistakes. She either uses the wrong word or forgets what she's saying. What may at first seem a weakness has become the *raison d'être* of the programme. The audience love the programme because they love her mistakes.

Your mother appears in What Have I Done to Deserve This?, Women on the Verge of a Nervous Breakdown, Tie Me Up! Tie Me Down! *and* Kika. *Each time she's very convincing and natural. Do you direct her?*

Kika: Almodóvar with his mother as the presenter.

She's an actress without knowing. But I do direct her. In *Kika*, when she puts her notes down and starts talking about the long winters in her native village, she learnt all that dialogue, none of it is improvised. She has a marvellous gift: a great spontaneity and a total lack of respect for the camera. She doesn't believe acting to be a serious undertaking. Which is why she's so good.

Has she seen Kika?
No, she doesn't need to see my films, she doesn't care. In fact, I think she acts for the money! She always asks me how much she's going to get paid and she wants her money when she finishes her scene. It's wonderful! While we were making *Kika*, a chauffeur would pick her up in her village where she still lives, and bring her to the set. She'd behave to the crew as if they were neighbours at home. She'd tell them to look after me and feed me up. That's another thing that makes her a character for my films. She has a very active rural life, her neighbours are almost all widows, but she's the only one who's

worked in movies. It's a bizarre situation, but very real. I'd like to make a film about a character like her.

In the other TV programme in Kika, *Andrea's reality show, the sets are much more substantial and elaborate. How did you arrive at such spectacular results?*
The sets and the costumes associated with Andrea are inspired by her character. By definition, reality shows shouldn't have any sets at all, but for Andrea's, which depicts what's worst about city life, I had to have one. To begin with, I asked for a backdrop of huge photographs of real city buildings. But the result didn't please me; the pictures didn't have the weight I wanted them to have. I also wanted Andrea to be as big as the pictures, like a sort of King Kong, an image which fits the character perfectly. But creating a three-dimensional horizon of skyscrapers turned out to be very difficult. In spite of my enthusiasm, I had to abandon the idea.

Instead, I imagined a city made up of panels, the sort of panels used to build sets. But these panels would be dirty, scuffed, and I'd only show their backs, the side which shows how they're built, not the painted front audiences usually see. One therefore has the constant impression of looking at the city sideways as well as seeing what's behind the walls of the buildings. I used a lot of second-hand materials and rubbish, but the result's very sophisticated. The floor of the set is the potholed tarmac typical of Madrid streets. There are also two cranes typical of towns nowadays. My idea was that the cranes would frame the set and turn it into a theatrical stage. Reality shows also always have video walls which provide the link with the reports. In spite of hating those things, I had to include one or two TV monitors. So I hung the monitors from the cranes.

Kika is a lonely woman, but Andrea is a woman who lives alone like an animal, the way people with power can live alone. For me this kind of solitude is related to the baddie in films like *Superman* who always lives alone in a remote, Gothic hideaway; Andrea is a baddie to cap them all.

When Andrea's on set she faces an auditorium of empty red seats. I realize this was intended as a significant image, but I haven't yet worked out its meaning.
It's the kind of idea I have while I'm shooting. When I saw the red seats, I thought they looked much prettier empty. More importantly, the image expresses a contempt for the public; the public isn't even worth representing. But Andrea's contempt for the public isn't any worse than any other present day programme's. People are treated like furniture. Andrea's almost more

The initial design for the Reality Show.

respectful; at least she uses canned applause rather than ask the audience to react when a red light comes on.

I imagine the sets in a theoretical, logical manner. But there's a considerable journey to be travelled between the initial idea and the set which is actually built. It's this journey I find most interesting; during it I discover what I want to do and why I want to do it. No doubt it's the kind of thing you can do only when you are your own producer. The process has nothing to do with doubts, although an outside producer may see it that way. In those circumstances, making changes right up to the last minute would be impossible.

Having invested so much energy, time and money in a set such as the one you've described, it must be very tempting to shoot a great number of scenes within it. But you didn't do this.
It's the kind of temptation one must be wary of. You must never fall in love with your ideas. I'm very cruel to myself. I always listen to what the film

demands. This isn't as abstract as one might imagine. You have to take drastic measures. The aesthetic intuition entailed in the conception of a set stimulates but never overtakes me. I try to fit what I like visually into the dramatic structure of the film; I try to marry the needs of the characters with my own desires. I'm not capricious. I'd never impose my preferences for their own sake.

In terms of their apartment, one could say Ramón and Kika are the kind of comfortably off couple who like Almodóvar movies.
Very much so! In fact, a lot of the objects in the set belong to me. Yes, they are comfortably off, but Kika and Ramón could hardly be described as passionate; they radiate no warmth at all. This is the reason why, for the first time ever, I painted the walls grey. There are very cold parts of the set, the living room notably, while the Caribbean bar area is much warmer. There's also an obsession with tiles and frames. It was intuitive on my part, but I thought about it later. Personally, I don't need an explanation for them, but since I'll probably be asked about it, I may as well have an answer ready. That's always the problem with interviews; they force you to be aware of what you've done. After much reflection, I arrived at my explanation for these tiles: they're a direct visual metaphor for a television screen. What do you think?

It's not the most obvious interpretation.
Yes, it's rather extravagant. But it's also related to my obsession with symmetry. Symmetry reassures me. Asymmetry unnerves me. Which is why I always buy things in twos. It's a mania. I don't mind mess, I can easily handle chaos but, as far as films are concerned, I need symmetry and flat planes. The need's almost part of my nervous system.

Some film-makers, such as Peter Greenaway, are similar, but in their case it's often a question of architecture. For me, it has to do with my initiation on Super 8. No one explained to me what a camera angle was. The rules of lines and angles are some of the few complicated rules in cinema. The best way of avoiding problems with angles is to shoot face-on – which is what I always did in Super 8. Therefore, I never had any continuity problems with the line of a shot. Sometimes you can cross the line by moving the camera or the characters. This can be very rewarding. Orson Welles was particularly brilliant at ignoring these rules. Talent is also knowing how to take the greatest liberties. You can't possibly know whether it works before you edit the film. The choice of angles also depends on the kind of story you're telling.

Describing Ramón and Kika as we have also underlines the danger that you can be identified much more readily from the sets than from your characters.
Yes, it's true. I choose the set and what goes in it. Which is why, in my next film, I'd like to escape from myself and enrich my world a little with outside influences. I'd like to avoid having such a concrete trademark; I'd like it to be more varied.

In general, such a change in aesthetic is more typical of painters. Their forms and colours change according to certain periods.
Yes, it's very much the province of art and architecture. But the aesthetic of certain film-makers doesn't just spring from lighting but also from the objects they choose, the particular world they create. David Lynch is clearly a pictorial artist. I don't know at what level it operates, but his images are composed pictorially. There's also Tim Burton. But the summit of this approach is Fellini. Josef von Sternberg was trained in design. He was a set designer before becoming a director. His films are highly stylized and essentially visual.

Curiously, all these directors have had something to do with art – Fellini's a very good draughtsman – but I never have been. For me, it's something instinctive. Everything I've done is related to my life. Things manifest themselves chaotically, by chance. Also, intuitively. For example a kind of baroque Caribbean aesthetic was present in my films long before I actually went there. When I did go to the Caribbean, I realized my roots lay there. I'd used the colours without knowing they already existed there.

Is it this artistic construction, the preoccupation with space and form, which you admire in Hitchcock's work? He's one of your favourite directors.
Yes. And I forgot to mention him! His work is visually the richest in the history of cinema. I discovered Hitchcock when he started shooting in colour. I was an adolescent at the time and simply considered him an entertaining director. Later, when I studied his films, I started to understand the genius operating behind each picture. Aesthetically, he's a great innovator. All the elements of design in his work are deliberately artificial. Hitchcock used backdrop effects a great deal and couldn't care less if they were obvious. His painted exteriors are the same: he doesn't try to hide their artificiality.

Were you thinking about Rear Window *when you were making* Kika?
Yes, the sets in *Kika* have the same significance. They're a portrait of the town. Whenever one shoots in a studio, one's main aesthetic reference is Hitchcock. This applies to everything and everyone. But I haven't yet

reached the point where, in *Marnie*, there's an entire port painted with boats next to Tippi Hedren's house.

Your heroines could almost belong to Hitchcock, but their personal neuroses and their often complex relationships with men resolve themselves in a playful and positive manner, even if it's by means of a crime, as with Rebeca in High Heels.

Yes, the way I deal with my heroines is less neurotic than Hitchcock's. His female characters are very neurotic, but behind them there's a man whose relationship with women was just as highly neurotic. You don't need to read Tippi Hedren's or Vera Miles' memoirs to understand this; it's blindingly obvious. Hitchcock used the scenes of his films as a way of relating to his actresses. His difficult relationships with women enriched his female characters and inspired the most memorable scenes of his films, even if they also end up giving a rather negative image of the men. I haven't such a complicated relationship with women; it's much more generous and limpid. Hitchcock's talent was so enormous I'd prefer not to judge him as an individual. But he was a hell of a character. For example, he forbade Vera Miles to get pregnant because he wanted her to play Kim Novak's part in *Vertigo*. I can't forgive him that.

Your relationship with women, the way you treat them, is as affectionate as Fassbinder's.
In a sense it is. We're also both fascinated by melodrama; we share the same interest in women as dramatic subjects. We also defend women. In the same way, our partiality for a baroque form of melodrama is a spontaneous defence of the outsiders in society. In Fassbinder's case, his interest was more intellectual; in mine, it's more a question of social origins. But the basic difference between us lies in his way of denouncing injustice. He's manichean. He always explains very clearly who is bad and who is good. And the baddies are real monsters.

Kika excepted, I've never considered my characters in such a manichean way. The characters I defend, I defend from within their contradictions and complexities. For example, it's obvious I defend the role of the mother in *What Have I Done to Deserve This?* But I'd never paint the portrait of a perfect, self-sacrificing mother. The mother in *What Have I Done to Deserve This?* has no time for self-sacrifice. She's irritable, she's very hard on the rest of her family, her grandmother and her children. She's no exemplary mother. I defend her, but I also want to explain her complexity. She's heroine, but not a model one.

Kika: an interest in women as dramatic subjects (Veronica Forqué and Rossy de Palma).

When did you discover Fassbinder?
When he started. I was in Madrid at the time. I can't remember which film I saw first, probably *The Bitter Tears of Petra von Kant*. We also have theatricality in common. All his films have been shown in Spain. I very much liked *Fear Eats the Soul*, *The Law of the Strongest*, plus his more underground films like *Satan's Brew*.
(That day, Almodóvar arrived in the El Deseo offices apologizing for being so tired: he'd stayed up the previous night to watch the end of a tennis match with Arantxa Sanchez.)

I'd never have thought you were interested in sport.
Sports people have a fantastic physique for cinema, the physique of people who've suffered and struggled. Sport also represents a pleasure I can't have. As I'd like to experience all pleasures, it's both very fascinating and frustrating. But women's tennis is the only sport I'm interested in as a spectacle. I don't know why.

Do you have favourite players?
Arantxa Sanchez; I'm a nationalist. But I also like Monica Seles, even though

on court she's a kind of devil. Everybody's against her; it's rather impressive. What both fascinates me and terrifies me in tennis is the fact that the players work in front of the public and the public's response to their work is so immediate. I find that attractive because it's precisely what doesn't happen to me when I work. No one sees me. I'm being a little self-contradictory because I like working alone. But I'd also like a film to depend on what I could do before an audience.

I'm writing a script at the moment, the adaptation of *Live Flesh* I hadn't finished before. Practically nothing's left of the book, but at least it helped stimulate me. One of the novel's characters is a policeman who's been paralysed by a bullet in the back. I made him become a basketball star who triumphs at the Para-Olympics. I don't particularly like sport, basketball doesn't appeal to me more than anything else, but the game becomes something more with a paraplegic. It's not a matter of feeling sorry for a player in a wheelchair, but ever since I decided to make him a basketball player his character's become much more interesting and furnished me with lots of new ideas. I'm very fond of the story. Once again I can't control my creation.

Will it be a funny film?
No, but there'll always be some humourous touches. It's a project in the style of *Law of Desire*, a film which is tragic though occasionally very amusing, where emotions are stripped bare, where everything is related to physical desire. I'm going to finish this script because it's already well advanced. It'll form part of a dyptich. In the last few days, I've already made notes for the second film.

The project also recalls Trailer para amantes de lo prohibido, *where a paraplegic athlete was also the object of forbidden desire.*
Yes, the film will be a sort of dance of desire for five characters: Fleetwood, the handicapped basketball player; Claire, his physiotherapist and girl-friend; Victor, the young man who shot him by accident and spent nine years in prison for it; plus another policeman and his wife, Diane. Desires flow between them, sometimes reciprocated, sometimes not; it's a very fluid situation.

The story's set in London. Claire, the basketball player's girlfriend, works for the social services. She's the kind of person born to do good. For her it's a compulsive need. Making love to a paraplegic doesn't particularly excite her, but since she's a woman who cannot conceive of attraction outside her desire to do good, she can only express herself in a relationship with someone handicapped. Claire and Fleetwood are very much in love. Apart from

being a great basketball player, Fleetwood is also blessed with the most wonderful hands and tongue. The rest of him doesn't work.

The man from the other couple is an inspector, Fleetwood's superior when he was in the police force. This man ordered Fleetwood to go up to the first floor of a building where a supposedly dangerous man was waiting. Fleetwood was reluctant because, like all English bobbies, he was unarmed. That came from the book. What I invented was that the inspector deliberately sends Fleetwood to his death. At the time, Fleetwood has a girlfriend who wants to run off with the inspector. In fact they later marry. So the inspector very rationally sends Fleetwood to his death. Fleetwood, however, ends up paraplegic. After the accident, Diane leaves him anyway, just as she'd planned to do so before.

Victor, the young man who shoots Fleetwood by accident, is a rapist in the book. I didn't like this idea so I simply turned him into a mixed-up boy with psychological problems, who suffers panic attacks and so on. A poor kid. The dance of desire begins when he's released from prison. Victor used to write to Claire from his prison cell. He'd seen her on TV watching a basketball game Fleetwood was playing in. He'd also seen her present a programme in which she gives psychological advice to the handicapped. Victor follows her advice because, in a way, he is handicapped too, not physically, but psychologically. More importantly, he writes to her to explain that what happened was a terrible accident, an accident of which he was the principal victim, having spent nine years in prison; Fleetwood, after all, has become a basketball star. When Victor comes out of prison, someone's writing Fleetwood's biography. This person wants to interview Victor. That's how Victor meets the couple and falls passionately in love with Claire. Claire and Fleetwood's sexual relationship is limited to the use of the mouth and hands. The relationship between the inspector and Diane is breaking down because of her terrible guilt complex. She regrets having left Fleetwood.

At one point, the four characters have dinner together and, in the kitchen, Diane discusses with Claire all the ways women can have sex alone. Diane says her situation is no different from Claire's; often, she uses a banana which she covers with a condom to make it more human. It gives her as much pleasure as anything else. Claire says nothing, but realizes Diane used to be Fleetwood's mistress.

Diane runs an antique shop. Victor sells her the furniture he inherited from his dead parents. Diane buys the furniture, but makes clear she'd like to buy him too. Victor has very little experience of women because he was imprisoned when he was twenty. He tells her with great sincerity that he's in

love with someone else. He doesn't say who. Diane suggests paying him and a purely erotic relationship ensues. In this way, Victor learns how to give pleasure to a woman. As far as he's concerned, this knowledge will help him in making love to Claire.

Victor befriends Fleetwood who always needs a helper, someone to push his wheelchair. Fleetwood has become something of a miser, loving money and always wanting more. He accepts Victor's help because Victor doesn't want to be paid. Claire's very ill at ease because she knows Victor wants to sleep with her. Fleetwood and she have a tacit pact; she is occasionally allowed to sleep with another man whose cock's still in working order.

Victor starts helping Fleetwood train, throwing him the ball and so on. One afternoon, they're getting changed in the locker-room and Fleetwood sees Victor's cock for the first time. He's very affected by it; not only because of its size, but because it reminds him of all he's lost. Fleetwood then tells Victor that it's Claire's birthday. However, Fleetwood won't be able to spend the evening with her because, like all sports stars, he has a sponsorship contract and he has to feature in a commercial being shot that night. It's his way of telling Victor to sleep with Claire during his absence.

Sure enough, Victor goes to see Claire and together they spend a night of unbridled passion. This is Fleetwood's birthday present to Claire. But while he's making the commercial, he suddenly realizes what he's done and can't bear the idea any more. He comes home much earlier than planned. Victor's still there. Hearing Fleetwood come in, Claire tells Victor to leave, but instead he hides in the bedroom cupboard. Claire quickly gets back in bed. Fleetwood comes in and wants to make love to her on the spot. He starts as usual with his tongue, but she's made love so many times already she gets irritated and pushes him away. So that Victor, who's watching all this, doesn't get any ideas, she tells Fleetwood she made love all night to Victor. She tells the truth. She knows an affair with Victor will be much more dangerous than those she's had with other men because he possesses something more than them.

From that night on, Victor is convinced Claire belongs to him. He causes all kinds of problems for the couple. He pursues them, pesters them obsessively on the telephone. It's not only disagreeable, but becomes a terrifying nightmare.

At this time, the inspector kills his wife where she usually meets Victor. Victor's fingerprints are everywhere. The inspector tells Fleetwood about the murder without telling him he did it. Instead, he says Victor was having affairs with both Claire and Diane and that they should get rid of him. Fleetwood agrees to take part in the plot, the same plot in which he ended up

being the victim nine years earlier thanks to this very inspector. Both men decide to accuse Victor of Diane's murder.

This disgusting last-minute pact between the two men fascinates me. The ending's still open. I realize it's a film that will drain me completely, like *Law of Desire*, because it's a film where everything's pushed to extremes. Everyone who made *Law of Desire* was opened up and cut in half; it affected the very core of their beings. Such an experience is very painful, but also very liberating. To arrive at it, all the crew, the cast most of all, must reach the same stage of incandescence. But there are moments when one doesn't want to show one's innards and expose oneself to that extent. I shall have to ask myself whether I want to do this again, but I rather think I will.

Will you set this film in England?
Yes, the main reason being that the police there are unarmed. In all other countries the police wear guns. The fact that Fleetwood is unarmed must be credible for the beginning of the story to work. You must also realize that this dance of desire is played out within a very hypocritical, English society. Which amuses me a lot. There may not be many secrets, but appearance is all. Setting the film in Spain would be very different; there would be a greater element of sincerity. A society which tries to preserve a façade makes the story much more powerful. On the other hand, I certainly don't want to hide the fact it's me who's telling the story. Everything will be seen from the point of view of a Spanish film-maker. The atmosphere will be so intimate, so profoundly human and physical, I'll hardly be able to hide my own feelings.

Was it then for this film you mentioned your search for locations?
Yes. Of course, I'll have to do considerable research with someone who knows London. Tackling English society will be the second phase. What I won't do, because it bores me, is recreate this society in a routine, naturalistic manner. Actually, I've already done this kind of naturalistic research for *What Have I Done to Deserve This?* But, beyond the problems of language and culture, making a film in London will allow me the chance of working with English or American actors. And there are many I admire.

Coming back one last time to Kika, *Kika lies at the centre of the story; she is both passive and active. She organizes the movement of the characters, a movement she is caught up in herself. She also has the power of resurrection. It seems to me the role is metaphor for the power of the director.*
Absolutely.

The interpretation isn't vital for an understanding of the film, but it enriches it none the less.

Naturally if one is conscious of everything we've discussed, then the pleasure of understanding the films increases. But what worries me – and I certainly don't intend to continue in that direction – is the danger of becoming a cryptic director, someone who must be deciphered. All the decisions I made for each of my films have a reason, but I also want to become transparent as a director. *Kika* is a very opaque film. Yet it's very much the film I wanted to make, in spite of the apparent contradiction – wanting to be transparent and not being so; I see myself in it. The film's the sum of my present feelings.

In a recent interview in the weekly supplement of El País, *you speak of your desire to break out of your present solitude and join in the lives of others. This also seems to be Kika's intention.*

It's a natural one for her; it's her way of existing. For me, Kika represents an ideal mode of behaviour, but I neither have her lack of awareness nor her innocence. If I want to do good, as vicars say, I don't do it so spontaneously. I think about it, organize it, I prepare for it consciously. In reality, if I'm good to other people, it's because I'm good to myself first. I'm neither nasty nor calculating, but I'm aware. Kika's good spontaneously, she doesn't think about it. I'd very much like to be like her.

Not being like her also tells me my entire life for the last fifteen years has revolved around cinema. The fact one devotes all one's time to something so concrete denotes a certain egoism; almost everything else falls by the way-side. Perhaps this is merely the egoism and solitude of being an artist, but it weighs on me; I now need to break out. Sometimes, the idea frightens me. I wonder whether this desire to break out has more to do with me as a film-maker than as a human being. It can simply mean I need to tell other stories. But to tell these stories one has to live them.

It's surprising how much the interview in El País *was concerned with you as an individual, as if the mystery to be solved, the main object of interest, was not your films but you.*

It's one of my biggest problems as a film-maker. It's also very unfair to all the other people who take part in my films. I didn't want to, but I've become the centre of attention; the others, the crew, the actors, all get forgotten. I need more and more not to be the centre of attention, to escape it. But for better or for worse, I'm the main target at the moment. It's not good for my films. Perhaps it explains why my films are better analysed outside Spain. Abroad, I'm not a personality but a film-maker.

It might also be the price you pay for your talent. You've often said in interviews that your cinema is instinctive. Bearing this in mind, it might be logical for people to be interested in you, in your own instincts, in your deepest personality.

That's the most positive way of looking at it. I tend to think people are interested in the opposite, the exterior image, the gossip. It would be nice if you were right.

The Flower of My Secret

Emotions

Solitude

Locations

The religion of pain

La Mancha

A family portrait

Harry Cane

FRÉDÉRIC STRAUSS: The Flower of My Secret *is a surprising film, different from all the others you've made, most of all from* Kika, *which was a film about conflict, where humanity itself seemed under threat. Here, however, you seem to celebrate the beauty of the human sensibility. Leo, the heroine of* The Flower of My Secret, *is another woman in crisis, but for the first time the crisis isn't expressed in terms of hysteria, but through depression and fragility, through an inner anxiety and a very moving prostration. And the emotion generated is more serene than before. Do you agree?*

PEDRO ALMODÓVAR: I don't know whether the film is more serene or not. But it's certainly more austere, sober and cohesive. One doesn't necessarily have to talk of a woman in crisis in terms of hysteria. And if you want to compare *The Flower of My Secret* to *Kika*, then, yes, they are complete opposites. *Kika* went in several directions at once. It dealt with ideas rather than characters. *The Flower of My Secret* is a film about characters and has a highly linear narrative. *Kika* was a film of artifice; when you saw the town, it was a representation of the town, not the real thing. *The Flower of My Secret*, by contrast, was shot on location. Also, even though it's a drama, it's a much more optimistic film than *Kika*. The characters in *Kika* are often nasty, none is here. Of course, the characters in *The Flower of My Secret*

occasionally commit a *faux pas*, make mistakes and hurt others, but they never do so on purpose. There are many other differences too.

Leo's has a feeling of the blues, a kind of sadness, wistfulness – emotions new to your work.
It's more than sadness, it's a great hurt. Sadness strikes me as a weak way of explaining what Leo is experiencing. It's like confusing melancholy with

Leo (Marisa Paredes): a woman alone.

suffering. Leo's suffering is like that of an animal being disembowelled. And her suffering becomes so great that at one point the only way she can escape it is by killing herself. Even when she returns to her native village and her mother tells her how she was born, she experiences something terrible. Her mother tells her that she came into the world almost asphyxiated. Leo realizes she's been fighting to stay alive since that very first day. Her reaction is far from nostalgic.

Within the couple formed by Chus Lampreave and Rossy de Palma, two women of fiery temperament, it is not hysteria that wins in the end, but emotion, an emotion which is highly surprising.

I'm very happy with these scenes. For me, it's an authentic family portrait. Leo belongs to a different social class, but, when she goes home to her mother and sister, we realize their roots are the same. We experience the way these two women live with the daughter's husband and children. The relationship described by Chus and Rossy is typical of certain Spanish families. Mother and daughter adore each other. When they part, it's a disaster, they weep. But the second they're reunited all they do is say terrible things to each

Rossy de Palma and Chus Lampreave: two women of fiery temperament.

other and argue all the time. And it goes on all their lives. It's funny, but it's also terrible.

You concentrate on emotion throughout the film. Even the way you use commercials becomes a source of emotion. It's an obsession which seems to have guided the writing of the script as well as your direction.

Yes, the basis of the film, its roots, are very simple emotions. I show Leo's drama through small things, recognizable things certainly, but trivial none the less. Leo is a lonely woman, and her solitude has made her enormously fragile. Her fragility wasn't born yesterday; years of solitude have led to years of fragility. I show this at the start of the film in a very simple way: Leo is wearing ankle boots which are too tight. The first time she wore them, her husband had to take them off for her, but he's no longer there. Usually, the maid helps her, but it's her day off and when Leo calls her there's no reply. This woman is so alone that she has to cross town and interrupt a friend at work to help her get her boots off. And, when she finally reaches her friend with her change of shoes in her bag, she can't bear it any more. Her solitude is terrible. I built the whole film on emotions. It's not facile but risky. If the audience doesn't empathize, my failure is total.

This work on emotion creates a very expressive portrait of Leo – which is hardly surprising from you – but it's also very delicate and subtle. Never before have you described a character in such depth, a character whose fragility renders her vulnerable to all kinds of feelings.

I can see very well what you're getting at, but it slightly embarrasses me to talk about it. What all this means is that *The Flower of My Secret* is a mature film, more mature than all those I've made so far. And it's true I'm now over thirty and I don't like thinking about it. I hate saying it's a mature film, but it's obvious and what can I do? Perhaps only geniuses never mature.

Leo's solitude bursts open in the suicide scene, most of all during that almost black, very impressive shot where the mother's voice is heard countering death with the power of rebirth. Such moments demonstrate the breadth and maturity of the mise en scène.

The mother's voice brings Leo back from the dead. The voice is like the aroma of a delicious meal simmering in the kitchen which drifts down the corridor to Leo's room and wrests her from her final sleep. Leo hears her mother on the answering machine saying she feels ill, that her blood pressure is high, and she thinks, if I die, my mother will die too. This is what makes her react. The voice has saved her; the voice of Life. I'd initially envisaged a rather complex *mise en scène* for this scene, but I soon realized there was

a very simple way of shooting it: framing Leo's face in profile against the pillow, her mouth obscured by the shadow cast by her shoulder and fading to black. It's a trick as old as cinema, but it explains better than anything else Leo's slide into death. Then, over this terrible darkness, I bring in her mother's voice and the shot of Leo, whose face jumps and whose mouth appears out of the shadow crying, 'Mummy!' This is perhaps why you call the film serene. My way of shooting this scene without camera movements, for example, results in a very sparse style. For me, the challenge was to find solutions such as this in order to film the script. I'm seeing more and more clearly how to communicate emotion. The serenity of the film is not Leo's, but mine.

Solitude is also expressed by a Miles Davis piece, 'Soleá', which you had already used in High Heels *and which accompanies a very beautiful and disturbing dance between mother and son.*
Absolutely right! That scene is a perfect example of the sparseness I was describing. At first we had prepared a backdrop for the show, but I chose not to use it and instead shot the dance against a bare wall. The only colours are red and black: the floor, the wall, the son's clothes are all black; the mother is in red. The cameraman used a red light which made the redness of her dress even more intense. These two colours make the dance very tough and dramatic.

When Leo goes back to the village, her mother uses a strange phrase, which I found both funny and poignant in relation to her solitude: 'You are like a cow without its bell.' Where does the expression come from?
I thought of making it the title of the film: 'Like a Cow Without Its Bell'. It sounds great in Spanish, but it's an expression only really used in La Mancha, where it's very common. To be like a cow without its bell means being lost, without anyone taking any notice of you. I borrowed the phrase from my mother. For a long time now she's used it to refer to me. So Leo's mother tells her, 'You're as lost as I am, I too am like a cow without its bell. I no longer have a husband.' And she adds: 'But at my age, that's normal.' She explains that a woman must return to her birthplace in order to rediscover the purpose of her life. It's also the reason why the mother never stops asking to go home: she wants to rediscover herself too, it's not just a whim.

The mother also recites a poem. It's one of the most beautiful moments in the film. Where did you get the idea for this scene from?
It happened because one day BBC2 was making a documentary about me

and interviewed my mother. The journalist asked her to talk about me, so she started from the beginning and described my birth. For her, talking about her son meant telling the story of his life! Then she wanted to recite a poem, which was a very kitsch idea. She recited it in a way that moved me terribly. She said it in exactly the way I would have asked an actress to do so: without accenting the rhymes, making it sound natural, in a modern manner. My mother's forgotten who wrote it, it's called 'The Hamlet', but she writes poetry too. If she sees a beautiful bird she'll write a poem about it. A couple of months ago, when I gave her some flowers for Mother's Day, she dedicated a poem to the flowers.

The relationship between fiction and reality, between the real and the imaginary, has been omnipresent in your work since High Heels *and* Kika. *This time, it occurs through the contrast between the reality of Leo's existence and the subject matter of the romantic novel. But the questions posed by this part of the story seem resolved by the* mise en scène, *which uses exteriors or locations in a very simple way. Was the desire to abandon the artifice of the studio very important to you?*
Shooting on location was above all an aesthetic and visual decision. *The Flower of My Secret* reflects my conception of neo-realism. This doesn't mean my next films will be naturalistic – which is something different again, and a genre which doesn't attract me anyway. When I talk of reality, I think of something which exists, which one can show as well as transform – a representation. Reality interests me in so far as it is something which can be represented and used as an element to build a fiction. It's true that the emotions one provokes in this way are linked to an irrefutable reality – to our own existence, our own sensibility – but for me a film will always be representation, and representation always means artifice. When one talks of reality, one also talks of manipulation.

How did you conceive the scene of the medical students' demonstrations? It's one of the most surprising in the film and the closest in spirit to a documentary.
First of all, I decided to feature medical students because they'd be dressed in white. So, in the shot Leo would be the only person wearing a colour – her blue jacket – so her isolation would thus be expressed visually. When Leo arrives in the street, she has just escaped death and life seems to her absurd and incomprehensible. But the life out on the street is youthful and effervescent; the young people walking in the opposite direction to her fill the air with energy. That is the function of the scene, a function which relates to the

cinematic language, and indirectly to the story. Those are the two main reasons for the scene, then other reasons appear and they're just as valid. The students' demonstration places the film in a historical context, in a particular moment in Spanish reality. All the aggressive slogans against Felipe Gonzales clearly express the dissatisfaction of the Spanish with their present government. It endows the scene with great power, but it's only a secondary, unexpected effect; my deeper motivation was much more frivolous or, rather, more artistic.

While you were shooting the film you said to me that locations stimulated your imagination. How so?
A location forces you to conceive the *mise en scène* in a specific manner. You are forced to accept the geography of where you are. In a studio-built apartment no one would have imagined building a huge corridor like the one in Marisa's apartment. I had to find a way of using this corridor in the film. That meant doing things I would not otherwise have done. The scene, for instance, where Leo and her husband are reunited, a key scene, starts in the vestibule, which was very narrow. To give an impression of space in a location like that, one always puts in a mirror. I didn't invent the trick, everyone knows it. But instead of a large mirror, I imagined using lots of small mirrors to film the kiss between Leo and her husband. Their image is therefore fragmented, which says everything: from this moment on the couple are in pieces. I would never have thought of that working in the studio. To shoot the scene I would simply have moved the wall back. In the same way, when Leo's husband leaves her, I would never have made the shot of her last so long. The location made me want to film Leo's look as we hear her husband's footsteps going down the staircase.

Are you in your element shooting on location?
Yes, even though it's very difficult to shoot in Madrid. My ideal would be to be able to shoot in locations which I could rearrange in my way. One must always improve on reality. Which is, in fact, what I do when I write. The first line of a story or a scene is dictated to me by reality, but the second line and the next have to be written by me in order for this reality to change into something I want to see. By 'improving on reality' I don't mean making it better, but making it resemble as much as possible what I want to see and film. For *High Heels*, for example, I was in a bar and I saw a newsreader on television, a woman, announcing the death of a man. That was the first line, the line directly from reality. The second line I wrote: the newsreader says she knows why this man died, how and when, because she killed him.

In The Flower of My Secret *there is a nice balance between the principal character, Leo, and all the more or less secondary characters. As usual, several stories criss-cross, but with a greater fluidity than before. Did you have to control yourself a great deal to achieve such a result?*

No. I wanted to prove that I could tie up all the strings of a story when and if I wanted to. There's always a way of doing this. It's a less choral film than the others. The structure resembles that of a novel with chapter headings. I nearly gave a title to each major section of the film: 'Leo's Solitude', 'The Family', 'El Pais', 'The Husband's Visit', 'The Suicide', 'The Return to the Village', 'The Return to the City'. Of course, Leo shares each chapter with the other characters. But the narrative is linear because everything relies on her, the other characters appear only in relation to her journey, which avoids any kind of diffusion. Leo unites them all; her story describes a circle which ends where it begins. Not only does she gradually close her circle, her story, but also the stories of the other characters. For the audience it's a much easier film to follow. But this advantage was merely due to the chance of inspiration; it doesn't mean I won't use another form of narrative in another film. This particular form was demanded by the story. A story always has its own laws. In this case, the story corresponded with the actual demands of the audience – and here I'm talking of the popular audience – which doesn't want to be distracted by multiple storylines because they require too much effort. Luckily, when a non-linear narrative works, the public salutes it, as in *Pulp Fiction*, where a character dies then reappears without shocking any-one at all. Nevertheless, it remains a challenge which I'd like to take up, but with another subject.

Marisa Paredes is extraordinary as Leo: she seems absent from herself, as if she doesn't know who she is until the end of the film. It's a very original performance, and a courageous one, too.

Marisa did wonderful work, and it was indeed courageous and original. Any actor in such a part would be tempted to exaggerate their performance. Marisa knew very well how to express what I wanted to say about Leo's character; her every emotion was sincere. If one can understand the deepest and most intimate nature of the character, it's thanks to Marisa. Sometimes she makes me think of Garbo, especially when she's in the café wearing the hat. She cries a lot in the film, but they're never the same tears. You could say there was a menu of tears: the tears after her husband's departure, the tears with her mother at home, tears of nostalgia, weakness, impotence, emotion. Marisa worried a great deal about this. She'd say, 'Pedro, are you sure it's not always the same thing?' Because when she'd cry, of course, she perhaps

Marisa Paredes (with Chus Lampreave): 'Sometimes she makes me think of Garbo.'

couldn't feel the difference. I confess that there is no spectacle which fascinates me more as a director than that of woman crying. What fascinates me is everything leading up to the tears, the journey the woman has travelled before crying. But this time, there's such an overdose of tears I've promised not to film any more in my next film.

Nevertheless another reason why The Flower of My Secret *is so original is that it isn't a lachrymose movie.*
Not at all. And I did everything to avoid that. The tears are very natural. I remember walking around Madrid one day with another Spanish director and we passed two boys sitting on a bench and one of them was smoking a cigarette and weeping. He was crying in the most natural way imaginable, without dramatizing or underlining what he was doing. This is what I wanted to do in the film, to distance myself from sentimentalism, from anything underlined. I'd define *The Flower of My Secret* as a feel-good movie, though I know the term is dangerous. Normally a feel-good movie automatically makes concessions to sentimentality, but here there are none, either in the *mise en scène* or in the performances. As the shooting progressed, I pared the *mise en scène* down to the bare essentials. It's a drama,

not a melodrama, even though it's a drama with songs. I have nothing against melodrama, but as a film it's very different from *High Heels*. *The Flower of My Secret* is a film about pain, about a pain of almost epic proportions. But it isn't an epic film about pain. This pain is the pain of abandonment, a pain which I believe one feels as physically as a death. No matter that for the rest of the world the person who has gone continues to live. For us, the relationship is the same as if they had died. Perhaps the serenity you spoke of arises from the fact of filming pain. When I film pain, I see it in an almost mystical fashion, as if I were genuflecting in front of the altar of pain in order to pray. Perhaps this is the feeling that comes across in these images, a feeling of contemplation. Pain moves me, it's like a religion to me, a religion which allows everyone to communicate, because everyone knows what pain is.

Is Chavela Vargas, who sang 'Luz de luna' in Kika *and who sings in this film an incarnation of this?*
Chavela is the grand priestess of this religion! The poncho she wears actually looks like the vestments a priest would wear to celebrate mass. And there's one thing she does very well, better than most performers – opening her arms as if miming a crucifixion. Chavela also has the face of a primitive god. In the film, she assumes the role of an intercessor. In her song she tells what is really happening to Leo. When Leo comes back to life, she isn't well at all, and amidst a completely absurd outside world – such as the TV report about the yearly shouting competition in a little village – arises an image of Chavela speaking of abandonment, speaking of what she is feeling. It's like an hallucination! That is the emotion I wanted to express.

The solitude at the heart of the film is perceived in the most intimate manner and reminded me of the solitude you described in relation to your own childhood, a solitude that was part of existence. Is there a link?
Possibly. But if there is, it's unconscious on my part. There is a part of my childhood which is clearly evoked in the film; for example, in the way Leo discovers literature and writing by reading her neighbours' letters and writing replies for them on the patio of her childhood house. That's a personal memory. My childhood was very solitary, but I filled the solitude with things which nourished me a great deal; I was a child who spoke a lot, even if it was often in long monologues! I don't like giving the impression that I was a solitary child, with everything that entails, even if it is true. I don't see myself like that.

Talking of the scene in High Heels *where Marisa Paredes returns to the house where she was born in order to die, you told me you got the idea from the story of your father's death. Here Marisa Paredes is at the centre of a film which is even more personal. Is there something in your relationship with her which leads to confession?*

Quite probably. But to tell the truth I hadn't realized it. Many things were the result of improvisation, especially in the section in La Mancha. Filming the countryside of La Mancha and the village women singing, were ideas which came to me while we were shooting. The minute the film arrives in La Mancha, it acquires a charge which is very moving for me and which I didn't expect. I was born in La Mancha, and I lived there for eight years. These years taught me that I didn't like the place, that I didn't want to live there, and that everything I would do in life would be contrary to what I saw in La Mancha: the way of living, thinking, of actually being these people. But, having made the film, I also discovered I belonged to La Mancha, even though I no longer go there, even though my life represents the opposite of that of an orthodox Manchego. The white streets of the village, the white-washed walls move me a lot. They were the first streets I saw. And the fields of La Mancha have always touched me – a vast flat redness without interruption which meets the sky on the horizon. It's the reason why artists from La Mancha are so imaginative; they have to fill this empty landscape. My childhood is also the neighbours' voices on the patio, telling ghastly stories like the suicide of a woman who threw herself down a well. I've always thought the water of the well, both crystalline and dark, was the last mirror a Manchego looked into before dying. All these stories are ghastly, and I've genuinely fought against them all my life, but I come from there, and even if it embarrasses me to say so, I admit that the film is a confession, an evocation of my roots. Returning to the scene you mentioned in *High Heels*, oddly it represents the same thing: Marisa returns to die in the house where she was born and, if possible, to the very bed in which she was born. In *The Flower of My Secret*, she returns to the bed and the house of her childhood, not to die, but to rediscover the origin of life. And to regain the strength to face the future. There is a certain nostalgia in the film, it's true. But I never go back to my childhood village, I've never even shot there. It's a neighbouring village in the film. But there is a kind of idealization of place.

One piece of good news about The Flower of My Secret *is that you are reunited with Chus Lampreave!*

Chus is marvellous and the tenor of her performance is different from that in the other films – it's denser, drier. I'm very pleased to have worked with her

again. To think I hadn't worked with her since *Women on the Verge of a Nervous Breakdown*! She's part of my family.

You told me Chus Lampreave wasn't available for a part in Pepi, Luci, Bom *. . . or for another part in* Labyrinth of Passion *because she had to undergo operations on her eyes. Here she plays a woman who is awaiting an eye operation. Was her real personality an inspiration for the character?* No, now you remind me of the story, it's funny, but it hadn't occurred to me. In fact, the eye business came from my mother, who inspired the character played by Chus, just as Rossy's part was inspired by my two sisters. It's exactly their way of living and talking. My talent here lay simply in condensing hours of conversation into a few minutes. Everything that Chus and Rossy do comes from my mother and sister, even the apartment set is faithful to their lives. I had them come over to the set when I was shooting the scene. It was a rather strange situation. I was obsessed by the idea that their seeing a somewhat parodic version of what they were would upset them. Naturally, they recognized everything, but without entirely recognizing themselves and it all went off well. When Chus was rehearsing the scene where she refuses to have an operation, my mother, who wears the same big dark glasses because of her eye problems and who also refuses to have an operation, said to Chus: 'Chus, an operation is like a melon, you don't know whether it's good or bad until you open it.' It made me laugh a lot and I added the line to Chus's dialogue. It was very funny to have at the same time and in the same place both the original and its copy, and in such a natural and lively way. Obviously, it was an advantage having the model there to work from.

Leo is a writer, but the film starts when she is no longer really writing, as if the status of writer allowed you to go somewhere else, perhaps towards this confessional sub-text that's suggested in the film.
Yes, the fact she's a writer isn't of primary importance. Not only is she having a crisis with the rest of the world, but with words too. When she repeatedly types the same words, I was thinking of the Jack Nicholson character in *The Shining*, who fills page after page with one single word. Leo's literary activity is yet another element, but not the most important one. Most important for me in the film is the sum of all the elements that compose the portrait of this woman. Through her weakness, Leo also manages to face herself. She is so weak she can no longer pretend; she no longer has the strength to tell stories or to write fictions she no longer feels. I don't want Leo to be taken for an intellectual. Her favourite writers are of a minority interest, Janet Frame, Jane Rhys, Virginia Woolf, Jane Bowles, Djuna

Barnes, Dorothy Parker. All these women are considered intellectuals, but what unites them most of all is the emotion in their work. They awaken feelings like a bolero, that Cuban feeling which endows the dancer of the bolero with such importance. For Leo it's the same. She is as moved reading a book by a woman as she is listening to a bolero. This is the subject of the essay she's writing – 'Pain and Life'. If she changes the tenor of her novels, her aim is not a greater intellectualism but a greater authenticity. There is no prejudice against the romantic novel. But there is, through the evocation of the romantic novel, a veiled critique of the denial of reality. It's particularly relevant to movies from the American studios, which are becoming so infantile that they refuse to accept even the most basic realities such as the fact that people go to bed with each other. The public can bear this, but not the Motion Picture Association of America.

The Flower of My Secret *reminded me a little of Woody Allen's recent films in its capacity to integrate many characters within a modest scale, in its family spirit and in the very personal motivations one can find within it. But there is also another reason which may well not please you: like Woody Allen you're ageing with your characters, and with both of you it's very moving.*
It doesn't please me at all hearing it, but you're right. I very much admire Eric Rohmer's ability to continue making films not about older, but about younger and younger characters.

The Flower of My Secret *is a very sincere film and while watching it I thought of something you said: 'I believe that if film-makers really made the films they wanted to make, they'd be much more original.' The film's originality arises from its sincerity.*
What I meant was that everyone has a story to tell, sincerely, and if everyone could tell that story, it would be truly original and full of life. This applies therefore to film-makers. But it also means that no film-maker has two stories to tell. All my films are sincere. This one perhaps more than others, or it hides it less. It depends on what one touches on. If I summoned up my most artificial side, the film would be as sincere as the others, but with a baggage of visual elements. It would be another image entirely. In being a film about the simplest, most immediate and spontaneous emotions, the film is sincere in a much more obvious way.

But, as you say, to make such a film means being able to open oneself up, to give of oneself. And sometimes that's hard. When I was writing *Law of Desire* I knew exactly what I wanted, but it was an enormous effort for me.

But the more time passes, the more I think of my work in those terms, as an exploration of what is strongest and most real within me. For me, cinema is more and more a way of opening myself up, of showing myself as I am, while in life I can hide, cut myself off and, because I have the time, present an image of myself composed of different pieces. But with cinema I have to be what I am. This time, because the exploration was in part unconscious, it was less painful.

The theme of a double life, central to Leo and the story of her pseudonym, seems to be dealt with in a very particular manner in the film. It's not so much the double character that interests us but the idea that one may have another life while already having two. Leo wants another life and, thanks to her, Angel finds another life. Often they both compare their situations to those of fictional characters, thus transporting themselves into still another life. Being able to identify with very different characters is also the principle of the romantic novel. Even the first scene of the film deals with this: using the organs of a dead person for a transplant, for a new life. I believe it's the real theme of the film, it's very beautiful: a new life.

It's an attractive interpretation. There is something hidden in each character. They all have a hidden facet and want to do something else. Leo writes under a pseudonym which no one knows, and her inspiration is changing; Angel becomes a writer; the maid is a dancer; Betty is the husband's mistress but doesn't say so; and the film starts with a scene which is a representation, a fake. It isn't so much a question of a double life, but of the double possibilities of life. The important thing isn't really to have access to a completely different life, but rather to arrive at a change of nuance, of tone and colour.

Seeing the film one imagines that you may yourself have wanted to take on a pseudonym to make your films.

Many times! It's very tempting. To take a pseudonym is an effective way of fighting against time. You start over again, which is what I'd like to do: to reshoot an earlier film, with all the freedom that implies. I'm very free when making my films nowadays, but it's a freedom I've acquired by staving off various pressures. When you make your first film, there are no pressures: you have no line, no style, no audience yet, you're starting out. So I thought of taking a pseudonym. I found a name: Harry Cane. Because if you say it quickly it sounds like Hurricane, a typhoon! But my brother has forbidden me to use a pseudonym. We now have our own company, it took us long enough to get where we are, so we're not starting again!

Leo (Marisa Paredes) and Angel (Juan Echanove): finding another life.

Another life could also be expressed by the phrase 'turning the page', which suits the film very well. Is the phrase applicable to your present state of mind?
It's very accurate about the film. But as for me . . . turning the page isn't an absolute necessity. I need novelty, but nothing radical. I don't know . . . It's a very difficult question to answer on such a hot Saturday afternoon.

Live Flesh

Liberation

The power of literature

The power of cinema

A story of men

Motherhood

Body landscapes

Guilt

Politics

FRÉDÉRIC STRAUSS: *Let's begin, like your film, at the very beginning. The title sequence to* Live Flesh *is extremely pared down. That's something of a surprise.*

PEDRO ALMODÓVAR: There's hardly any title sequence at all, we go straight into Victor's story, at its point of origin. For the title I came up with the idea of having the letters look like a red-hot cooking rack on which to grill meat. Flesh, fire and voracity! *(laughs)*

Seen in that light, that's very much you. However, the starkness of this title sequence also suits Live Flesh *very well. It's a film in which you make less of an effort to resemble yourself, you free yourself of the image people have of you.*

I never stop freeing myself of my image! That's not something I have to strive for – for me it's a must. Which is not to say that I repudiate the work I've done until now; I just feel I have more freedom in the way I approach new projects. I don't want to have a style so recognisable that it becomes a registered trade mark – though the people I work with have rather a

tendency to see things that way. When I'm on a shoot, I keep getting brought furniture and accessories in line with the image people have always had of my films. I have to turn it all down because it's too me and it's not me any more! That said, I think audiences will recognise me in this film; I do. But it's true that the progression in my work seems to be causing a fair amount of confusion around me. Whether or not this new phase will interest people I don't know. I sometimes get the impression that, with me, audiences like to laugh but not to cry or to feel other kinds of emotions. Being independent means I get to make the films I want to make – not the ones other people want me to. But I'm not conscious of any of that while I'm working. I'm only in a position to talk about it once the work is over.

It's striking how close you appear to be to the five main characters in Live Flesh. *The script isn't so very different to the one you told me about over three years ago, when the film was still at the early draft stage. Did all that time allow you to get better acquainted with your characters?*

This is one of the scripts that took me the longest to write. So I did get to know my characters well. I also had a very precise idea, as I wrote, about how each of the characters would act. The hard part lay in advancing a story in which the slightest development affects all five of them simultaneously. As I clearly couldn't repeat the same piece of information five times over, I had to resort to a narrative structure that was full of ellipses, almost within individual scenes. That was complicated. The structure of the film, its inner flow – was far harder to achieve than the construction of the characters. For example, everything was clear to me up until Victor comes out of prison. But once he was released I, as the narrator, had to have him find all the other characters as quickly as possible, and in a way that was credible. You can't imagine how long it took me to come up with the idea of having all their paths cross in the cemetery! The finale was just as complex, because for all the characters everything starts to happen so fast. I didn't want to have the screen split in two or five, as they used to do in the 1970s, nor did I want to simply keep cross-cutting. It's always easier to take a single character and follow them through all that happens to them, like I did in *Women on the Verge of a Nervous Breakdown* or *The Flower of My Secret*, the scripts I wrote the quickest. On *Live Flesh* it was my knowledge of the characters, Francesca Neri's in particular, which helped me, and that was the most important. Now the film seems so transparent, so simple to me, that I have to ask myself why it was so hard to write!

You told me, before filming Kika, *that this film was based on the first chapter of Ruth Rendell's novel,* Live Flesh. *What was it about that novel that so stimulated your imagination?*

I don't know if it was the novel that really led me to want to make a film, or if the novel just happened to coincide with things in me which were waiting to be expressed. I very much like the first chapter of Ruth Rendell's novel, perhaps because it reminds me a little of the last scene in *Law of Desire* when Antonio is in the apartment, surrounded by the police swarming in the street below. The first chapter of *Live Flesh* describes how a young man who's a rapist, a sort of rapist, runs off after having attacked a girl, who was saved by her friend. He then suddenly turns up in another woman's bedroom, even as the first victim rushes to report an attempted rape on her to the police, and a neighbour of the second victim, having heard noises, also gets in touch with the police. The police put two and two together and arrive on the scene. All of a sudden, the rapist shows himself at the window, he's got the woman and is threatening her with a gun. The street is packed with people, exactly like in *Law of Desire*. The older police officer tells the younger one to go inside the house. The younger one replies that it would be madness, the man has a weapon, whereas he, like all English policemen, is unarmed. His superior orders him up to the room all the same, saying that the weapon is bound to be a fake. The younger policeman has to obey an order, and then gets shot in the back by the rapist, which leaves him paralysed. Looking at this chapter more closely, I first of all asked myself what would happen if someone, a kind of voyeur, witnessed the scene through a telephoto lens – which is fairly plausible these days, what with everyone looking at everyone else. That gave me the initial idea for *Kika*, and I then forgot the book, which had simply helped to stimulate my imagination. When I returned to it to try and attempt a full-blown adaptation, I realised that first chapter is full of artifice and holes, and unanswered questions. Why does the police officer send his subordinate up to get killed? Ruth Rendell says nothing of his motivations, which didn't interest her. But when someone does something like that, it's because, for one reason or another, they want revenge. So I imagined that David, the younger policeman in my film, was having an affair with the wife of his superior, Sancho, who wanted to make him pay. Another question: Why does someone who has just tried to rape one woman take refuge in the house of a second woman, and wait for the police to come and get him. It was much more convincing for him to know the girl in that house already. In the novel she makes no further appearances, whereas for me the fact she has a crucial place in that first chapter immediately made her an important character. When this girl sees herself caught up in the tragedy and

Almodóvar with Javier Bardem and José Sancho

Two different weapons: The young man's revolver; the young woman's eyes
(Liberto Rabal and Francesca Neri)

realises that in one fell stroke she's unwittingly ruined the lives of two men – the poor kid who's going to end up in jail and the policeman who'll spend the rest of his days in a wheelchair – she's overcome by a guilt she knows she'll only ever be able to escape by marrying one of the two men. I also included in the scene an idea I like a lot: when the younger cop, who'd been afraid to go inside the house, sees this woman, Elena, he's suddenly very pleased to be there; he wants to become a hero in her eyes, and they immediately fall in love with each other. There and then, he becomes the victim of two different weapons: the young man's revolver and Cupid's bow. Elena looks at him with immense desire, her eyes tell him 'I want to go to bed with you, I want to do everything with you'. He is so struck by this look of hers that he wants to go on delighting in it and, not knowing that the danger lies with Sancho, he turns his head to hold on to Elena's gaze. That's what causes the tragedy. In Spain, we call it 'losing the eye of the bull' – the *torero* must never take his eyes off the bull. Even when looking at the spectators, he has to keep one eye on the beast. This scene talks the language of bullfighting. So everything derives from the novel, but at the same time it has all been turned into something different. It was the first time I tried my hand at adapting someone else's work, but my approach was never going to be standard. Once I'd decided that Victor wasn't going to be a rapist, that the cops would be armed, that David's wife would be the same woman who was in the first scene – which is more interesting, bearing in mind in prison Victor thinks only of her – and that David would become a Paralympics basketball champion, that was the story I had to go with – no longer the one in the book. But the book gave me that initial spark, which in my other films comes from my own life, my memories, from something I heard or saw at the cinema.

Aside from this book by Ruth Rendell, do you have a particular interest in crime fiction?
Yes, I like genre fiction in general, particularly crime novels. Of Ruth Rendell's work I very much liked *The Ceremony*, which is a far better novel than *Live Flesh*. Rendell is always very imaginative, she has a real talent for coming up with intriguing situations, which she narrates in a way that makes for a pleasant and vivid read. However, with cinema, that kind of narrative doesn't easily work: in a film you have to show how one thing leads on to the next, how the characters gradually evolve. Not that you can't lie with images. On the contrary! The master in this regard was Hitchcock. But in a novel, in the space of a couple of sentences, you can hint at an infinite number of things merely by setting in motion the reader's

imagination, which does the rest. That's not trickery, that's the power of words. Cinema doesn't have that same power of suggestion as literature, even if people tend to believe the exact opposite. When I hear it said that cinema is the language of dreams, I completely disagree: in cinema you have to show things, their logic. The magic realism of García Marquez, or of his imitators such as Isabel Allende, is a literary genre associated with the world of dreams, but in the cinema it doesn't work, and ends up seeming cheap and artificial. What cinema can translate and convey are hallucinations – and more than hallucinations, psychedelic sensations, such as those produced by drugs. Literature has a far greater power of suggestion than cinema, whose power is hypnotic – which is different. I've sometimes found myself completely hypnotised by a film only to realise, as I left the cinema, that I hadn't liked the film at all. That kind of thing doesn't happen with a book. As a reader, I adored the first chapter of *Live Flesh*. Coming back to it as someone wanting to translate the story into pictures on screen, I said to myself, 'My God, it's riddled with holes!' So when I write a script, I approach my own imagination with a great deal of caution; I don't trust it. I always need to give myself explanations which no one else would ever ask me for.

In Live Flesh, *there's a clear sense that you like the stock characters of crime fiction – the good cop, the cop who's an alcoholic, the delinquents, the women over whom men fight. Yet at the same time, the whole film shows that these basic elements of crime fiction are not enough for you.*
What I've retained of the thriller genre is its iconography – external elements such as the night scenes, the weapons, that opposition between those who represent the law and those outside the law. To begin with, they're little more than clichés, or at least the most emblematic aspects of a thriller. I start off telling the story of two cops, as in any cop thriller, except here one of the cops has a death wish and is intent on killing himself together with his wife's lover. In fact, it's on this night so typical of film noir that I insert the keys to a tragedy that will play out a long time later. In my other films, *Women on the Verge of a Nervous Breakdown* for example, the police were always archetypes. Here, they become characters in their own right. As the story progresses, the fact they're police officers becomes fairly incidental.

It becomes incidental because you manage to reveal in these men something much deeper; you're in there with them in a way you'd never been until now with male characters – ones that are so typically masculine. How did that come about?

Virility predominates: Javier Bardem and Liberto Rabal

I couldn't say. It was only once I'd finished the film that I realised it was told from the point of view of the male characters. I don't know why. What's certainly true is that not only do I not judge these men, I understand them perfectly. Even a character like Sancho, who on the face of it seems very negative. When he slaps Clara, then says that it hurt him even more than it did her – to me that seems true and moving. It's also perfectly understandable to me that David becomes a killer for the same reasons as Sancho: he's defending what little he has, what little he has left. I really got inside these male characters, more so than the women this time. The virility – in the sense of masculine identity – that predominates in the film is not simply an easy way of pitting two opposing images of men, one powerful in a sexual sense, the other now impotent and powerless. It's a way of saying that *Live Flesh* is profoundly a story about men. When Sancho aims his gun at Victor he aims for his balls, and when he repeats the gesture at the end of the film, we see him through the triumphal arch formed by Victor's crotch and legs. In Spain the word *huevos*, meaning testicles, represents about fifty percent of the average male's vocabulary. When Victor is doing his press-ups at home, it looks as though he's screwing the floor; and David appears in the space expanding and contracting under Victor's body. The only thing which manages to pull the two men apart when they have their fight is football, that very masculine

language. There's no particular glorification of heterosexuality in my film, but I did tell the story from a man's point of view.

But with these male characters that are so 'masculine', there's also a sense of something lacking, either emotionally or physically. Until now in your films, it was more the women who had faced this difficulty. Could that not mean that your view of masculinity is, even in this film, rather skewered or secretly twisted?

I don't know whether I've twisted things in this film or in previous ones. Here the male characters have a capacity for action, a moral autonomy, which was more characteristic of my women characters before. But perhaps these women were based more on masculine traits! They are, in any case, this time more passive. In a certain sense they're the victims of the men and events in the story – a story whose very masculine language they don't speak; whose very masculine vision of sexuality they don't share. When Elena spends an entire night having sex with Victor, it is Victor's feet that she caresses afterwards, not his cock, because what she misses most are powerful legs full of life – which her husband David no longer has because he is paralysed.

Javier Bardem at the Paralympics basketball match

The handicapped basketball players' games and training sessions are filmed in an almost documentary style. That gives a very strong sense – that exists in other scenes as well – of bodies in full athletic or sexual training. How did you approach that sport?

I imagined myself in the position of a film-maker asked to make a video clip promoting a team of disabled sportsmen. It meant I had to find the way to film them correctly. However, deep down, I also wanted to help these sportsmen by giving them some publicity, showing what an exciting sport theirs is, how it's even more entertaining than traditional basketball because the added difficulty requires far more spectacular skill. I also think an element of unconscious truth crept in as regards the body. For a few years now, physical activity has had a greater place in my life, and the film probably reflects that. The handicapped players' technique was also of rather personal, and felicitous, significance for me: it was a bit like intimately experiencing the feeling of early cinema; I suppose that the first travelling shot was done with the aid of a wheelchair. The wheels on those wheelchairs spoke to me of the earliest motions of cinema, the whirring of those first reels. In this film the progress of the story is also very circular, describing concentric circles, like those on a target. I intentionally placed a round carpet with concentric circles at the entrance to Elena's apartment, as if to get the characters on the target. I would have liked Clara to also be present in the same scene – that would've been perfect! That carpet may seem a slightly ridiculous idea, but it's the kind of detail that helps to position a camera, to arrange a scene.

Unlike in your other films, the women in Live Flesh *don't share a strong bond, except very briefly in the opening sequence. Doesn't this also open the film up to a new sensibility?*

I think that here the female characters are far sadder than the women I had previously had in mind. Clara moves me immensely – so too does Angela Molina – for she admits from the outset that she will pay a very high price for her affair with Victor. Antonio Banderas' character in *Law of Desire* felt the same way, but he was a character that overflows with happiness – even when he tells his lover that he is going to die, he is full of joy. Clara doesn't have that kind of happy excitement about her, she's more of a character from tragedy. She accepts that she will soon disappear, just like Victor's condemned neighbourhood will disappear, for her relationship with Sancho has turned her into something of a zombie. Her dead marriage has sucked her dry. The most important relationship of her life – which I don't describe, but can be guessed at through the film – was the one which led her to marry her husband. And that relationship has been a tragic failure. The female

characters in my work have often been erratic, but never as pathetic as the ones in this film. The women in *Live Flesh* are orphans. They've reached their limit, they've no strength left. It's true that they don't share a bond – it's funny that. They're too alone to form a bond.

They escape their solitude only by becoming adoptive mothers, Elena through her work, and Clara in her relationship with Victor. In Women on the Verge of a Nervous Breakdown, *it was by becoming a real mother that Carmen Maura escaped her condition of a woman who has been abandoned. But here it's far more forceful, because motherhood acts as a ghostly presence.*

At the very heart of the women in *Live Flesh* is an enormous need for motherhood. Their acceptance of tragedy is far more straightforward than in the case of my other female characters. When Clara arranges the bouquet of flowers on the tomb of Victor's mother, she can almost see herself in that dead woman's portrait; and, in fact, Angela has a slight resemblance to Penelope Cruz, who plays the mother. At that precise moment, it's as if Victor's mother were entrusting Clara with her son, along with the responsibility for taking care of him – which is the role Clara will play with Victor. Clara is a kind of idealisation of motherhood, assuming you can see motherhood without moral prejudice – Clara teaches Victor all the pleasures in life, starting with sexual pleasure.

What makes the relationships between the men and women in Live Flesh *very audacious, then, is that there's something incestuous about them. They're mother-son or sister-brother relationships in which sexual contact permits, above all, the reestablishment of a lost union, a fusion of common blood.*

That's true, though I have no idea what that suggestion of incest is doing in the film. Elena and Victor are both parentless, which brings them closer as it would a brother and sister. There's also something at a purely physical level about actors on set which can provoke a kind of incestuous excitement. Even if it's always up to me to control everything, bodies and faces bring with them their own particular qualities which I can never fully rein in; and which, in this case, I like very much.

The five main actors in Live Flesh *are working with you for the first time. That reinforces the sense of a very visible change in your work. As regards the younger of them, do they represent a new generation of Spanish actors?*

Oddly enough, several of them had already worked with Bigas Luna: Francesca Neri in *The Ages of Lulu*, Javier Bardem in *Jamón, Jamón*; as well as Penélope Cruz, who is wonderful in *Live Flesh* as Victor's mother. Javier

is a star in Spain. Pilar Bardem, who we see in the first sequence acting alongside Penélope Cruz, is Javier's mother. Both of them are from the family of Juan Antonio Bardem who made two very interesting films back in the 1950s, *Muerte de un ciclista* (*Death of a Cyclist*) and *Calle Mayor* (*Main Street*). Liberto Rabal is going to be what the Americans call the 'next big thing'. I was very glad to work with him because I greatly miss Antonio Banderas, and perhaps Liberto will be able to take on the roles that Antonio can no longer play. Liberto is very at ease with his body, like an animal. He's also very good with emotion, tenderness. And, like Antonio, he has a hint of madness about him.

When Elena spends the night with Victor, there's that very beautiful shot of their bodies forming a kind of original kernel. What gave you the idea for that image of a unity regained?
It was like a heart. I didn't quite know how to film that scene, as there aren't a huge number of places to put the camera opposite two naked bodies on a bed – not nice places, at least. It's the kind of scene that is always a bit heavy-going, and I didn't want to repeat what I'd done in *Tie Me Up! Tie Me Down!* Here what I was most interested in were the faces and noises. Faces in the grip of pleasure look very much like faces locked in pain; and cries of pleasure sound like cries of suffering. I tried to have the bodies look like moving landscapes. I spent a long time looking through the lens at the bodies, the way an astronomer might study a planet through a telescope; before deciding it was better to restrict the scene to a few very carefully chosen shots. What I wanted was for Elena to lay her head on Victor's legs as if they were a pillow, and for the sun to come up over the legs as if over a landscape. I put the actors into position and, when I saw those two bottoms joined in opposite directions, it was like a revelation. The effect was striking, it looked just like a heart, or a single bottom. Above all, you could no longer tell the difference between what was man and what was woman!

After she admits her infidelity to David, Elena slices an orange in half with a knife. I suppose that was a very deliberate image.
Absolutely! I thought it rather kitsch, but I wanted it all the same. It's quite straightforward, one half of the orange is the person you're with, and so here it's divorce. It's a pleasing image simply because it's so transparent.

But Elena herself makes things very clear!
She couldn't make them any clearer! Truth can be as cruel and as perverse as lies. When David tells Elena that he'll continue to exploit her guilt complex,

that's very crafty on his part, but it's her who provoked that reaction. Elena's great weakness is to possess the sort of fanaticism that leads you to try to resolve things in the most radical, least appropriate way. Her guilt complex has drained her. Francesca Neri's very pale, very white skin was very good for that. That guilt complex preys on her; it's also what makes her so sad. I feel compassion towards her, an emotion I hadn't felt for a character until now.

Guilt is a theme which is very present in Live Flesh. *At the same time, it's a feeling which the film profoundly ignores – and one which seems alien to you personally.*
Yes, but that's directly to do with my education. For Spaniards of my generation – of all generations for that matter – guilt was one of the central pillars of the educational system. In La Mancha, that kind of inculcation of guilt damaged an enormous number of lives; and for many turned out to be a punishment. But a year after my stay with the priests had ended, guilt was once more not in my nature. I recognise my mistakes, but I don't repent them. Repentance and guilt are Judeo-Christian inventions which I have no time for.

The link with guilt is also there in the extract from Buñuel's Rehearsal for a Crime: *the world as portrayed in that film and the world in* Live Flesh *correspond perfectly, including the theme of the body.*
That really was a lucky coincidence, one which I only discovered gradually. There are some obvious similarities, of course; for example, that moment in *Rehearsal for a Crime* when the mannequin loses a leg. My original idea had been to intercut between Victor and Elena on the one hand, and Archibald as a child with his governess on the other. But the result was more intense than I had imagined. Buñuel's film is after all, as you say, also about guilt: Archibald proudly – and very amusingly – accuses himself of murders which are in fact merely the result of chance accidents. Buñuel is making fun of guilt and of death. Laughing at the things which frighten us is a feature of Spanish culture. It's something I've done in my own films too. But there is also in Spanish culture a tragic sense of life; it permeates the very air we breathe, and the spirit of my films is much more in that vein.

The links with Buñuel's film heighten that sense of fate which hangs over Live Flesh, *and many of your other films.*
There were an enormous number of other things which didn't occur to me straightaway about Buñuel's film; odd things, such as the fact that Liberto is

the grandson of Paco Rabal, who was Buñuel's favourite actor, more so even than Fernando Rey. Buñuel was on family terms with Paco, who used to call him uncle. Also, it was in *That Obscure Object of Desire* that Angela Molina made her film debut. It's as if the hand of destiny were behind all that – not that I believe in destiny. But you're right, fate is present in all of my films. Chance too. On the subject of destiny and chance, I remember Paco Rabal telling me the story of Miroslava, the actress who plays the woman Archibald recreates as a mannequin and burns in the scene I include in *Live Flesh*. In order to shoot that scene, Buñuel used the mannequin and the actress in alternation, which makes the images all the more ghastly: as the mannequin goes into the oven it's the expression on Miroslava's face that we see. Well, it turns out that actress burnt to death in a car accident. That's fate and chance for you, right there in life's most tragic anecdotes. But I found all that out after I had made the film.

The scene where David ascends to the mezzanine in his wheelchair is fairly Buñuel-esque – half comic, because of that little squeaking sound the stairlift makes, and half tragic, because it looks as though he's ascending to the scaffold. Was that how you conceived the scene?
The scene wasn't planned that way in the script. I rewrote it when we found the location. That little squeaking sound wasn't prearranged either, but I loved it. I've spent a lot of time with paraplegic basketball players, and what's particularly typical about them is that when they're looking for an apartment and get shown round one with lots of obstacles, stairs or even an internal mezzanine, that's precisely the one they go for. They hate being treated like invalids and never stop wanting to prove themselves with all kinds of feats of physical daring and skill. David's apartment is exactly the kind an invalid sportsman might have. What I liked in that scene was the way David rose up into the room staring only at Elena's genitals. Unfortunately, the mezzanine level was rather cramped and so the bed couldn't be very big, whereas in the script David literally crawled across an enormous bed towards Elena's genitals, like a snake. Visually, that made it a very powerful scene, and said a lot about the character David.

Let's return – in conclusion – to the beginning of the film: the opening to Live Flesh *is one of the elements which clearly doesn't come from the Ruth Rendell novel. In its reference back to Spain under Franco that opening sequence places the story in a political context. Previously it was a period you had always refused to allude to in your films. What changed?*
Yes, I had never made reference to Franco's Spain before, and do so now

very explicitly in this film. I wrote that opening under the impulse of narrative and dramatic ideas. But, in the end, I think there were also things which I had to say; for instance, what leads me to invent a character, to show a certain colour or object is always the narrative, though I suppose it all inevitably gets contaminated by my own life. I wrote that prologue as I was finishing the script. Until then, the film opened on the night of the tragedy. However, I read in a newspaper about a woman who had given birth on a bus; how afterwards the mayor made the baby an honorary citizen of the city and the director of the bus company had presented him with a travel pass for life. I was very taken by that incident, because from the outset I'd thought that Victor should be a very inopportune kid, one dogged by a kind of bad luck. What could be more inopportune than being born in the street? As for the bad luck, it was while I was calculating Victor's possible year of birth that I had the idea of bringing him into the world on the night a state of emergency was declared in Spain. A night all Spaniards remember. Hence that striking political event found its way into the story for narrative rather than personal reasons. I began to research it further, to listen to speeches from that period, and what most astonished me was that the minister who'd announced the state of emergency was Manuel Fraga, a man who today is still President of the Regional Government of Galicia and standing for re-election. It was Fraga who formed the Popular Party now in power. It shocked me that the person who announced such a monstrous act is not only still alive, but still involved in modern-day Spanish political affairs. It is his voice, his horrible voice – he speaks very badly – that we hear in the film, and Spaniards too will be in for a shock when they recognise it. From that point on, my interest in that scene was based on personal reasons. I wanted to highlight that at the end of the film, in order to remind myself, and Spanish audiences too, that there came a day when I stopped being afraid. It was a day of great joy for both me and my country. Things change over time. Twenty years ago, you smoked a joint to get stoned. In *Live Flesh*, David and Elena smoke one to relax before bed! *(laughs)* Twenty years ago, my revenge against Franco was to not even recognise his existence, his memory; to make my films as though he had never existed. Today I think it fitting that we don't forget that period, and remember that it wasn't so long ago. I like the two births in the film – the first in a desolate city living in fear, the second in a city full of people and joy, a city which has forgotten its fear. And for me, that note of optimism, following on from a story that has more than a hint of tragedy about it, comes as a breath of fresh air.

All About My Mother

Mothers

Families

Transplants

Solidarity

Ellipses

First Interview

FRÉDÉRIC STRAUSS: *What's remarkable and comes across very strongly in* All About My Mother *is how you seem to have put in all the things you love: literature and writing, the life of the stage and the dressing room; women and actresses, a mother and her son, the world of the transvestite . . . One senses that everything you show in the film is close to your heart.*

PEDRO ALMODÓVAR: Yes, those are all elements that I feel close to. All, from start to finish, are things which I hold dear and which, for me, go very deep. *All About My Mother* is a film about artistic creation, about men, women, about life, death. It is probably one of the most intense films I have made. I'm not suggesting my other films contain any sequences that are banal, but in this film I wanted to get to the essentials of each sequence through the use of ellipses. That gives the film its sense of intensity, one that at times can even get a little overpowering. Literature, the theatre, a love between two women, a wounded mother who struggles on, prostitution, the world of the transvestite, in this case Agrado – all are subjects I have dealt with before, but this time I treat them very differently. I think that even with the same elements and the same characters you could make a thousand different films.

Penelope Cruz's character, Sister Rosa, is probably the one we could most directly place in your universe, as she recalls the nuns in Dark Habits. *However, the mise-en-scène has changed, and the tone is not at all the same.*
Even though I have never written in a parodic vein, the nuns in *Dark Habits* were a conscious borrowing from the world of kitsch. In those days, my references came mainly from cinema. I had in mind Sara Montiel in her roles as a nun, and also a certain type of Spanish pop cinema where nuns could be seen rescuing or educating young women. Those films were a kind of musical comedy, and were used to further the careers of promising young actresses, such as Marisol or Rocío Durcal, who were set to become stars. *Dark Habits* is a nod in the direction of that religious pop cinema, and the treatment of the characters depended on keeping a certain comic distance. Nowadays, when I create a character who is a nun, I have in mind real-life nuns who do charitable works, and my points of references are largely articles in *El País*. Penelope's character might still seem just as exaggerated, but she belongs to a reality which is, in a way, the exact opposite of kitsch. The inspiration for Sister Rosa came from an article about a group of nuns who devote themselves to working with transvestites, trying to offer them a way out of prostitution. As always when I write, I tried to find out more about

Penelope Cruz as Sister Rosa: 'very original and very intense'

what these nuns did; I was very curious to learn about relations between the transvestites and the nuns; but our request for any closer contact was turned down. In the end what is different about Sister Rosa is that, unlike the nuns in *Dark Habits* (who were trying to save girl sinners), she is no longer trying to save anyone. She's no longer sure about God or anything else; she's losing her faith, and herself. Penelope brought something very original and very intense to this character.

Similarly, the character of the mother in All About My Mother *is both new and familiar. Manuela is different to a mother as portrayed by Chus Lampreave in* The Flower of My Secret, *or also to Becky del Paramo (Marisa Paredes) in* High Heels.

The mother in my films has always been a woman similar to my own, even when it was a younger mother, like Carmen Maura in *What Have I Done to Deserve This*. And she was always a woman from the same social class as me. Here, she's a mother with nothing in common with mine, and nothing in common with the type of traditional mother we'd become accustomed to with Chus Lampreave. Manuela is a young, Argentinean single mother, hence also very different to Becky del Paramo, who was inspired by Lana Turner, and Rocío Durcal, the singer I mentioned, who went off to Mexico and became a star over there. There's a Mexico-Madrid axis, just as there is a Paris-Barcelona axis.

Is that Lola's path in life in All About My Mother?

Yes, I've met a lot of people that used to live in Paris, had their breasts done in Paris, and then, like Lola, came to work in Barcelona. The character Lola is inspired directly by a transvestite who had a bar by the beach in La Barceloneta. He lived with his wife and would never allow her to wear a miniskirt, although he himself went around in a bikini. When I heard this story, it struck me as a perfect illustration of the utterly irrational nature of machismo. I made a mental note, thinking it might come in handy one day. It was while I was in Barcelona doing some research for the character of Lola that I came across more incredible things. There I met a transvestite who was 45 years old and on the game, along with his son of barely twenty, who was also a transvestite. For the son's birthday, his father and mother had paid for him to have his breasts done! In fact, the more outlandish scenes in *All About My Mother* are all drawn from real life, but have been toned down.

The title of the film plays on the word 'mother'. One could initially think it refers to your own mother, before discovering the film is entirely fictional.

Yet in the end, having seen the film, that first thought returns. There's something both deep and touching about the relationship between Esteban and Manuela. It's a very particular take on the mother-son relationship, and evidently has a personal relevance to you.

I thought hard about those brief scenes in which the two of them are together. They're what required the most work – especially as Esteban dies very early on, which meant that everything had to be just right. I quite like what I filmed, but those scenes I rewrote a dozen times. What was clear to me, on the other hand – and this is slightly autobiographical – was that the mother had to read something to her son about the act of creation, when he is in bed. Whether it was Truman Capote or something else didn't matter. It was a personal whim, but it touches me to think of a mother revealing a concept as fundamental and as clear as what creating entails to a boy who, one day, will be a creator. Manuela explains to Esteban what it means to create so that he knows it, and she does so through the words of Truman Capote. At the same time, it's a typical mother-child scene: Esteban asks her to read him something before he goes to sleep, just as a small child might ask for a story. Even though it isn't very realistic, I'm glad it happens that way. The scene also comes from a project I had, which I am still intent on doing, to make a video film about my mother. I had wanted to sit her down in front of

Mother and son (Cecilia Roth and Eloy Azorín)

a camera and let her talk; simply have her talk as much as she likes – it's what she most needs these days. But since I'm a film-maker and can't keep that out of the equation, even when it comes to filming my own mother on video, I thought I would get her to read from certain books I like and want to have read aloud in her voice. That's why I shot that scene in *All About My Mother*. It's the mother who brings you into the world; who initiates you into the mysteries of the world, the essentials, the great truths. Maybe I'm idealising them, but the mothers who appear in my films are all initiators. Angela Molina in *Live Flesh*, for example, behaves like a mother to Liberto Rabal when she teaches him how to make love properly. She initiates him into something very important – the physical act of love.

All About My Mother is also about wanting to be a mother, or wanting to become one again. It reminded me of the song you wrote and sang with McNamara back in the days of the Movida, Voy a ser mama *(I'm Going to Be a Mother). That song's title could be taken literally here, couldn't it?*
Yes, those were my lyrics! (*laughs*) *All About My Mother* is about motherhood, about the pain of motherhood, not just Manuela's but Rosa's too. There's also the relationship between the two lesbian characters, played by Marisa and Candela, which is practically a mother-daughter relationship. But more than anything, the film talks about what it means to bring a new life into the world, about a motherhood which becomes a fatherhood and vice versa. I hardly dare use either of these two words for Lola. The film also says that irrespective of personal circumstances, there exists an animal instinct in you inciting you to procreate and to defend your progeny, and to exercise your rights over that being. It's what Lola represents, and is perhaps what is most scandalous about the film, although I show it as natural. Lola changes her whole way of being, her entire body, yet something inside her remains intact. That moves me, I couldn't say why.

The scene in which Lola appears is very curious. Did you hesitate about whether or not to show this character?
The arrival of Lola, her eyes hidden behind her dark glasses, provokes a very strange impression; but it was essential that I showed this character. It's the arrival of death, rather like the white-faced man dressed in black in *The Seventh Seal*. I see it as a death that is grand and elegant, disguised. Never before had I imagined a character that represents an abstract idea in such concrete terms. Lola makes quite an impression in that setting, descending

the stone stairway of the cemetery as though a model on a fashion shoot. Lola's reappearance is very important for Manuela, because she's come to Barcelona to find her and tell her of their son's death. They are simply two beings who suffer enormously, and the pain they share as a couple excuses Manuela from the reproaches she would otherwise direct at Lola. For both characters it's a necessary exorcism, one that goes by way of Rosa's death and Lola's reappearance. Lola's presence was equally important for the second and last scene she has with Manuela.

The Manuela-Lola couple is clearly an unusual one – the father has become a woman. Yet in this second scene, where they are together with the second Esteban, everything is actually very straightforward.
What's important about Manuela and Lola as a couple is that the hatred between them has gone. Faced with this new child, they understand one other; Manuela has understood that nothing could be more natural than for a father and son to know each other, and that it does no good to resist this. I wanted the audience – even if it may seem a touch forced – to see this trio as natural. Not for the audience to tolerate it but to see it as something natural. Lola, Manuela and the second Esteban make up a new family, one that attaches importance only to essentials, one for whom external circumstances are of no importance. That's why Lola, dressed as a woman, can say to the child: 'I'm sorry to leave you such an awful inheritance' and ask Manuela if she can kiss Esteban. 'Of course you can, girl' replies Manuela, talking to Lola in the feminine with absolute naturalness. For me this very atypical family evokes the whole range of families that are possible at the end of the twentieth century. If anything is a feature of our end of century, it is precisely the break-up of the traditional family. It's now possible to create a family with different members, based on different types of biological, or other, relationships. A family should be respected whatever its make-up. What matters is that the members of the family love one another.

But your characters have always had a different notion of the family. One of the nuns in Dark Habits *starts a family with a priest and a tiger. And in* High Heels, *the Victoria Abril character was expecting a baby by the man who dresses up in drag to perform on stage as her mother.*
I forget my films. But it's true that I've always seen things in that light: variously configured families based on affection.

That couples and families form freely in the film is initially because there are parents who lose a child – first Manuela, then Sister Rosa's mother. I don't think your films had ever spoken about that, the death of children.

Having Esteban die was a very painful experience for me. I hesitated over it for a long time while writing the script. The pain that death causes was also something new to me. It's a pain everyone can understand. Until now, the pain I had dealt with in my work was the pain of love lost, of loneliness, or of uncertainty in love. I don't want to establish a hierarchy of pain – though perhaps one exists – but nothing can compare to the loss of a child. It's a pain that can drive you mad. In the film, for Manuela this pain entails a kind of re-initiation into life. She is a devastated woman – as damaged as if she'd been struck by lightning, ravaged by fire. And it's because she is so utterly desperate, a zombie, her soul gone, that she starts to relive. From the depths of her despair Manuela is more open to others, for her own life is no longer of interest to her. She no longer has anything to fear, because she doesn't have anything more to lose. Which is why, as she passes an actress' dressing room and sees that the door is open, she goes inside. And when this actress asks her if she can drive, she answers: 'Yes, where do you want to go?' Manuela acts out of sheer despair. It's what allows her to, little by little, start to feel human again and have feelings once more. From a dramatic point of view, it's a wonderful state of mind for a character to be in, because anything could happen.

In All About My Mother *the family is also the troupe. Does that aspect of the film relate to the 'El Deseo family', the team that surrounds you?*
It has to do with the fact I'm a film-maker and work in a team, with many others. I also happen to like that idea of a family – people working together and having an emotional bond that unites them. Your well-being comes from the people you have around you, I think. They make you feel less alone, and that work group ends up becoming your family. However, that wasn't uppermost in my mind when I was writing the film.

Did you have in mind Fassbinder and his way of establishing a family of collaborators, of mixing his artistic creation with his personal life?
I depend far less on the people around me than Fassbinder, who was a bully to those he worked with. At the start of this year I was staying with Caetano Veloso in Rio. There I met Daniel Schmidt who told me several times that I reminded him of a friend of his; I then found out that he was referring to Fassbinder. That surprised me because I find I don't at all resemble Fassbinder – and I think Daniel was referring to Fassbinder's best period, before the drugs got to him. The picture Daniel painted of Fassbinder's final years was a chronicle of chaos, the portrait of a man who was very difficult to live with for those around him. My idea of working in a group is different.

In fact, when I refer to my production team as a film family, I'm talking mostly about the future. I have a lot of respect for the people I work with today; as the director I'm on my own, and even when I need them I don't ask too much of them. What matters most is that we develop a relationship which will become a family in a few years' time. But I have no desire to be the boss, to be constantly making demands simply because I'm in a position to do so. In that sense, I'm not at all like Fassbinder. But I did think of him when I came to write about *All About My Mother*. It was a piece about acting; about actresses and their ability to fake it. In it I make reference to *Veronika Voss*, where Fassbinder explains very clearly the relationship between light and an actress' face. *All About My Mother* is dedicated to those actresses who've played actresses on screen, which is practically a genre in itself. Those films would make a great idea for a retrospective to be put on at the Madrid or Paris Film Institute.

Marisa Paredes is perfect in the role of an actress.
Marisa is the quintessential actress. She epitomises the kind of actress who can both act in front of the camera and can dominate a stage. That's something you either have or you don't. The way Marisa walks across a stage, or moves about a set, is majestic. It can't be learnt.

Marisa Paredes: 'the quintessential actress'

The section concerning the transplant of Esteban's heart is emotionally raw as well as fascinating. Perhaps, in part, because it returns as a kind of obsession following on from The Flower of My Secret, *which itself already featured organ donation. Are you fascinated by the idea that a heart can continue to beat inside another's body?*

It holds the same attraction for a narrator as it would do for a mother. In Manuela's case, though, wanting to find out who received Esteban's heart is the quickest way of succumbing to madness. But it makes very inspiring subject matter for a sentimental or a horror film, one along the lines of Franju's *Eyes Without a Face*, which I like very much. As it happens, the character Manuela was there already in *The Flower of My Secret* and even had the same name. She was the nurse who did a simulation with the doctors, one of those role-plays to teach doctors how best to break the news of decease. In *All About My Mother* I wanted, almost for moral reasons, to show why such doctors do simulations. It's because they have only a few hours to get a donor organ from A to B, knowing that a transplant patient can sometimes live very far. Near-military measures therefore have to be put in place, with planes ready to come and go carrying the surgical ice-box – all of which is very cinematographic. It was also so that people realise that once authorisation for a transplant is given, there's a whole strategy brought in to save a life. The people in Spain who do this told me how grateful they were; they're very pleased that I showed all these different aspects of their work.

The character Esteban puts me in mind of a film director not dissimilar to yourself. He's someone who likes writing, who likes actresses, and whose heart beats to a story that is no longer about him but one in which he is secretly present.

That's a fine description of cinema. And I completely agree. Whenever I'm asked which of the characters in the film is most like me, I say that it's Esteban. I can see myself by his side, seeing what he sees, reading what he reads, keeping his mother company. When Esteban sees the scene in *All About Eve* where the women are talking in the dressing room, that for me is the root of all storytelling. Although I didn't add a line of dialogue to make it explicit, what goes through Esteban's mind at that moment is that a group of women talking is where fiction starts, the origin of all stories. That's my feeling too. I grew up and I started writing while listening to women talking out in the courtyard of my house in the village. The link between fiction and life is an important one for me, and I wanted it to exist for Esteban as well, at a subliminal level.

Cecilia Roth as Manuela: '*A Streetcar Named Desire* marked my life'

The references in the film to All About Eve *or* A Streetcar Named Desire *act like transplants: they're no longer quotes, they become an integral part of the characters' lives.*
Yes, it would be wrong to see them as film quotes. *A Streetcar Named Desire* or Truman Capote are not cultural signs, they're simply things which form an intrinsic part of the story. I chose *Streetcar* not only because it was a perfect play for showcasing Marisa's talents, but also because of that line Stella says with her child in her arms, and which Manuela will say while playing that character: 'I'm never coming back to this house.' It's the phrase Manuela pronounced as a teenager in Argentina; she then says it again in Madrid, and she repeats it once more on a stage in Barcelona. She says to Marisa: '*A Streetcar Named Desire* marked my life', and it's as though she'd said 'Four times I've been gored by a bull in my life. But this play of yours has hit me like a streetcar.'

I think that at one stage you had planned to put A Streetcar Named Desire *on at the theatre.*
I don't know really. There are things of Williams' that I've always liked – *Streetcar*, of course, and *Cat On a Hot Tin Roof* – but I've always had a problem with the modern relevance of the questions raised in his plays. That

sexual urge, those characters who repress themselves – I'm not sure that's very contemporary. It appeals to me because it's what makes the characters' desires so strong. But it's something that in Spain no longer exists. What would be more interesting would be to have some of the female characters as men, which is what I think Tennessee Williams had in mind. I can quite see, for example, the part of Blanche DuBois being played by a man – Stella's older brother arrives, broke, perhaps just out of prison, and Kowalksi, the brute who constantly makes fun of him, ends up going to bed with him. For a male, Blanche, such a sexual encounter would pack a real punch. I could stage the play from that perspective. I don't know, however, whether we have the right to touch the madness of Blanche, a theatrical icon.

Opening Night *is another type of 'transplant' in* All About My Mother: *the story told in Cassavetes' film has an echo in Manuela's, but it's in the way you film the scene where Esteban dies outside the theatre that the link becomes clear.*
No, if you remember the film, it's not filmed in the same way at all. In *Opening Night*, the scene is shot at eye level, which is very disconcerting because we see practically nothing, except for backs, and only get to hear a lot of commotion. The fan who asks Gena Rowlands for an autograph kneels down in front of her and she's very direct, she goes towards the car and talks to her. Of course, there's the rain, it's night-time, and someone dies after asking for an autograph. Which is a lot of similarities. But in my film, it's first of all to do with a mother and her son waiting outside a stage door who, in the emptiness of the wait, suddenly exchange the most important words of their lives. Manuela talks of what an emotional experience it was to play the part of Stella, and tells Esteban she played Stella when she was young, and that the part of Kowalski was played by his father. Esteban is able to tell his mother how much he wants to know the whole truth about his father, how it's no longer enough to go on pretending that he died before he was born. So the scene has another meaning. Clearly, it comes from *Opening Night* – as I acknowledge in the tribute I pay to Gena Rowlands in the final credits. But in Cassavetes' film the actress played by Gena Rowlands realises what happened, and wants to know what became of her female fan. I preferred Marisa's character to drive off without being aware of what happened. As for the accident, I put the camera where Esteban's eyes would have been, hence it does several somersaults, until the moment Esteban lands back on the ground. We then see Manuela's high-heeled shoes as she rushes towards her son, she holds the camera up in her hands, as if it were Esteban's head. Filming it all was very trying.

There are many great artists tied in with the characters' story, but these characters themselves are artists in their own way: Esteban is a budding writer, Manuela has done some amateur theatre and become an actress of sorts at the hospital; Sister Rosa's mother employs her gifts as an artist to turn out fakes of famous paintings. That means there are first- as well as second-rate artists mixed in together. Do you like that combination?

It's like on the big wheel of life. Some people are higher, some are lower, but everyone's an artist. Sister Rosa's mother is an artist of fakes. She's another one of those characters that leapt out from real life, as in Barcelona there is an excellent school for forgers. The Chagalls they produce there are exact replicas of real Chagalls. The paintings are sold as imitations, but they'd qualify as fakes. I hadn't been aware of this mix of artists – that happened unconsciously. There are many things I haven't picked up on in the film. I wrote and shot it aware of the film language I was using, but unaware of all that that language was saying. I worked a lot on intuition.

Does this mixing together of artists correspond to the way you see art? There is no great or minor art?

No. It depends on the circumstances. A minor artist can be sublime, as is the case with Manuela or Agrado. But I rid these two of the selfish and frustrated side that such minor artists often have in real life. Neither of them have ambition, they're the opposite of an Eve Harrington. Agrado gets up on stage – as she's always dreamed of doing – but it's to talk about the most important thing she has done in life i.e. her life itself. That doesn't mean she will continue to go up on stage regularly. Personally, I have often been up on stage and met with success, but I don't feel the need to become an actor. The film is really the exact opposite of Eve Harrington's story, which is why I quite like the idea of starting with *All About Eve*, because it lays a false trail. In Mankiewicz' film, the bad guys – Addison de Witt and Eve Harrington (Georges Sanders and Anne Baxter) – are the most interesting characters, but I don't like them.

The plot of All About My Mother *plays out between the stage and life beyond, yet you don't use that world to suggest any easy illusion or magic. Sooner or later, each of the characters will have to face up to a harsh truth.*

Harsh, and at times amazing, such as when Agrado reveals what it cost her to be herself. The story moves continually back and forth between women who act in life and those who act on stage, but who all in the end are confronted with reality. Both Manuela and Esteban see the scene in *All*

About Eve where Eve Harrington, in a dressing room, makes a desperate attempt – she tells an absurd story – to lie her way in to the world of theatre. I also have a dressing-room scene, but a very different one. I turn the dressing room into a kind of female sanctuary and, when our Eve, Manuela, comes to tell her story, the story she tells is horrendous, but it's a true one. Stories told in films or on stage have their echo in life, but they never have quite the same ending. Originally, I'd wanted to make a film about a woman who knows how to fake it to perfection, who knows how to improvise and play a part and who goes on to hone this gift of hers in the context of her work. There are a great many jobs these days you can't do if you can't put on an act. What Manuela does on the National Transplant Centre training courses – which really do take place – is to simulate; it's how Esteban sees that his mother is a good actress. However, there's a situation Manuela role-plays with the doctors in which, when she has to live it for real, her acting is of no help, nothing happens the way she expected.

There's a certain purity about the characters in the film, not in any moral sense but in terms of an honesty which they have vis-à-vis themselves. Is that what you wanted to convey with that shot on Marisa Paredes facing us, practically defying us with her stare before she goes on stage?
Yes. She is a woman alone and suffering. That's how the women in the film are: they live alone or with friends, yet they are proud, beautiful; they live with their pain, they've learnt to keep that pain inside, and treasure it. In the end, Nina (Candela Peña) has gone, back to her home town where she's given birth to an ugly child, yet Marisa still loves her. What's important about that shot on Marisa is that she's facing up both to the feelings she has for Nina, as well as to the pain that love will cause her from now on. It's why there is still a photograph of Candela stuck up on the mirror. It's also a film about the solidarity that exists between women, but one that arises spontaneously in the course of life's trials – it's the glorification of a key line in *Streetcar*: 'I have always depended on the kindness of strangers.' In this film, the strangers are all female, and it is their natural kindness which saves them.

So solidarity is not an attribute that exists between men?
No. I don't see very many men – monks aside – trying to help each other out and joining forces. No, that would strike me as a grotesque aberration; I can't imagine it *(laughs)*.

At the start of this interview, you spoke of how concentrated the narrative is in All About My Mother. *Does that correspond to your idea of melodrama?*

It responds to a need to get down to essentials, to the heart of the matter. I wanted to strip out everything that wasn't necessary, especially in terms of the time sequences, and I'm glad I did. The transplant, for example: three weeks after the operation, the man who received Esteban's heart comes out of hospital, and Manuela is there, like a spy. I then close in on the man with the camera and the shot fades out on Esteban's heart. Straight away, Manuela is in her son's empty bedroom and, when her friend Mamen arrives, we realise that Manuela has broken all the rules by finding out who received Esteban's heart. The moment the dialogue with her friend ends, Manuela is on the train. We don't see the station, we don't even see the train, only her face looking very sombre. We follow her line of thought: Manuela is remembering the day, seventeen years earlier, when she arrived in Madrid with her son, after fleeing Barcelona, and now here she is going back to Barcelona to announce her son's death to his father. On comes the music, we see the tunnel – a real one but obviously the tunnel of memory – and then cut to that aerial shot of Barcelona, the city opening its arms to Manuela and the audience. We understand now that a new chapter in her life is starting; there's no need for us to see Manuela renting an apartment, settling in, finding her old memories. Straight away she is out looking for Lola. I did more ellipses than I had ever done before, and I find the result very evocative.

It's a very particular, almost paradoxical, approach to melodrama, isn't it?
Yes, it is paradoxical. It's very dense, very dry, and the style of acting is very pared-down. Cecilia, in particular, is very understated, except when she has that cathartic outburst of emotion. Her face is so expressive, because she does nothing, which is the best approach for an actress playing that role. I don't follow the rules of melodrama in this film, which may even be too austere for a drama, but that was the way I wanted to treat the story and the characters' strong emotions. I very much like cinema with emotion, although I'm not fond of sentimental films, especially the sort made in America. But I very much like *Breaking the Waves*, which is a purely sentimental film, but one that is true and austere, sincere and contemporary.

Last Interview

At our last interview, in April 1999, All About My Mother *had just come out in Spain. Its success was not yet assured. The Cannes Festival was still weeks away. It was a moment of uncertainty. As it turned out, wonderful things happened throughout that year. Did that come as a surprise?*

Yes, it's always a surprise. I'm not vain enough to believe that each one of my films will be an instant hit. Even when I'm pleased with a film I've just finished – as I was with *All About My Mother* – uncertainty is par for the course. But on top of the inevitable uncertainty, I had reservations about going to Cannes, or at least about entering the competition. I don't like the idea of films being seen up against each other. Of course, I can look back on it differently now.

What are your lasting memories of the festival, where you won Prize for Best Director and had been the favourite to win the Palme D'Or? What was your reaction to the controversy which greeted the decisions of the jury headed by David Cronenberg?
The festival was a wonderful experience. Not only because of the success of my film, but because that success was direct: I could see it, two metres away, in people's eyes. I was delighted to receive the Prize for Best Director and, at the time, the jury's decisions didn't strike me as unfair. But now after having seen the films that won and those that didn't, I have a different opinion. Those decisions were unfair. To think that the overall winner at the festival was *L'Humanité* is almost grotesque. *Rosetta* is an interesting but quite straightforward film; in cinematographic terms, it lacks subtlety and scope. David Cronenburg handed out prizes on the basis of personal envy and resentment. David Lynch, Jim Jarmusch, Atom Egoyan, Ripstein and I are all part of the same broad group of independent film-makers – even if we're not the same age and don't all live in the same place. All of us are eccentrics, strange sorts, strong personalities. We're therefore precisely the type of film-maker liable to come up in competition against Cronenburg. He saw us as rivals. On the night of the awards ceremony, I made a point of sharing the Prize for Best Director with Jarmusch, Ripstein, Atom Egoyan and David Lynch. Without even having seen their films, I knew that they'd be interesting from the point of view of the *mise-en-scène*. I wasn't wrong. *The Straight Story*, in particular, is a film of great depth.

The controversy centred mainly around the awarding of the acting prizes to non-professionals. What are your views on that?
Awarding a prize to a non-professional actor is always an option. But a decision to award a prize *ex-aequo*, as Cronenberg's jury did, should be to highlight two possible approaches, two different ways of being an actor. *Rosetta* was one choice: a young girl making her film debut and acting with little or no facial expression, a part which requires no more than that. But having gone with that choice, you had to go for its opposite: an actress

conscious of her technical abilities, able to do all registers, stretching the expressive range of her character. My film had several such actresses to choose from. The decision to give the prize to two young women, both of whom were beginners, seems to me a gesture of childish rage.

A doubt you had at the time of All About My Mother's *release concerned the film's numerous ellipses. In fact, they neither hindered the comprehension of the story, nor did they prevent the emotion coming through.*

Yes, I think those long ellipses may even have made the film easier to understand for the audience. I'm much happier and more confident about narrative now than when the film came out. I'm gradually discovering the force of what is not seen. I don't mean what is off-screen, but what is quite simply not shown, left untold. For example, in *All About My Mother*, when Manuela learns of her son's death, she signs the organ donor forms; but between that moment and her departure for Barcelona – a month, more or less – we see only two scenes: one at the hospital in La Coruña where she watches the man who received Esteban's heart; and the other back at her home, when she stares at Esteban's empty room. During that month, a great deal happens: Esteban's funeral, her trip to La Coruña, where Manuela spends two weeks waiting for the man who received Esteban's heart to come out of hospital; then her return to Madrid, completely shattered, her coming home and the corridor leading to Esteban's room seeming to her so long. All this I tell through the two scenes in which we see Manuela. Next we see her with her friend, and then directly on the train to Barcelona. All these choices, these ellipses, correspond to what some Americans call 'arty movies', arthouse cinema. But these days it's a very transparent and popular device.

Were these decisions which you took mainly during the writing, the shooting or the editing?

The editing was difficult because the film had been shot like that – with the ellipses. So we had no other choice. Plus the film was shot the way it had been written. I find it harder and harder when writing a script to include those brief technical descriptions: Manuela goes out into the street, she waits for a taxi, she arrives at the station . . . All those 'establishing shots' bore me, I want to get down to the essential right from the start. Choices therefore have to be made at every step of the way. But each stage in the process radicalises them. However, it's the shooting which remains the most crucial because of the whole question of the rhythm and tempo of the scenes: how long should Manuela stay by the door to Esteban's room for it to seem right?

That's very hard to say. You can't shoot three different takes and then expect to combine them in order to discover the right tempo. That tempo has to be there in the shots. The rhythm of the film, the breathing – these have to be found right from the actual shooting.

Is post-synchronisation a stage when you can still make or correct certain decisions?
No, I use it very little. I do all I can not to need to. For *All About My Mother*, we'd had a lot of rehearsals, and I did a lot of takes. The rehearsals were like those for a play. All the actors were present, even when the camera wasn't on them. There's a type of spontaneous acting style, close to natural-ism, which comes out of the theatre. For example, the sort of naturalism – or what passes for naturalism – you find in Mike Leigh's *Secrets and Lies* where everything seems so spontaneous, that comes from theatre. I've talked to Mike Leigh about it, and he confirmed what I suspected: every scene in his film had been very carefully rehearsed with the actors dozens of times. So the technique itself is hardly naturalistic. It's not 'Action! Just be natural!'.

What is it you don't you like about post-synchronisation?
Firstly, I'm claustrophobic. I can't stand spending hours in a studio in front of a screen. I don't have the same patience for that as I do on set when I ask for a scene to be re-done twenty times. It's a pity, because dubbing can sometimes allow you to do great things – to completely remake a film, rewrite it. Fellini made wonderful use of it; as does Berlanga, here in Spain, who sometimes starts shooting without a finished script. Dubbing is only interesting, I think, if it's the whole film that is being dubbed. It then becomes like working on a musical score. But as far as I'm concerned, nothing can match what comes from the body direct, the force of a live expression live. I've occasionally had to dub scenes because certain lines of dialogue weren't audible, but I always found it frustrating. I can never quite blend the voices recorded on set with those that are dubbed, which lack the same colour. Also, the actors don't really act when they're dubbing – they're not in a position to.

Post-synchronisation provided you with good ideas for a number of moving or comic scenes in Women on the Verge of a Nervous Breakdown *and* Law of Desire. *That's why I thought you would be likely to make frequent use of it. But it's for its dramatic potential above all that it has appealed to you.*

Yes, as a dramatic situation, post-synchronisation has interested me a lot. And also as a means of introducing one film into another.

The ellipses in All About My Mother *didn't handicap the film and may even, as you say, have rendered it more straightforward. Does that tempt you to become all the more audacious in the way you tell a story?*
Yes, though I can't be sure that audacity will always pay off. *All About My Mother* boosted my confidence, but at the same time I want to do things which I've never done before. I find that exciting, but at the same time worrying. At the moment, I'm working on a new script and making rapid progress – meaning, I've been writing fast for a fortnight after two years' worth of taking notes. I'd like it to be the script for my next film, only I can't quite work out if it's completely ridiculous or completely marvellous. Perhaps both. Everything will depend on the actual filming of it. What I do know is that the subject matter is very risqué. Last night it occurred to me that if I really want to make it into a film, I might do it under a different name. Everyone would know that it was me who made it, but under another name I'd feel I had more freedom. It would be less important to know whether it was ridiculous or not. I'm developing this project and another one at the same time. Both are risqué in terms of their subject matter, characters and what these say, as well as in terms of their narrative style and rhythm. In fact, the narrative style is the opposite of the one employed in *All About My Mother*. The time sequences merge, the characters talk a great deal, and there's very little action.

So it's not the adaptation of the Pete Dexter novel, Paperboy?
No, for the time being that project is on hold. The screenplay's good, but I don't feel the urge to go to America and film it. *Paperboy* doesn't inspire me with the same passion as the stories which I'm writing right now. Anyway, there's still some fine-tuning to be done on the script. It's crucial to have a strong script, one that's as polished as possible.

When you talk about doing new things, what does that mean?
It's hard to say because any film, even a remake, brings something new to a director. I'll tell you about the script which I'm in the middle of and you'll see what's new. The story is related entirely through the characters who talk at moments on the fringes of the action, passive moments. In fact, the story is told mostly in monologues which are almost anti-dramatic in that nothing is happening to the characters. At the same time, the narrative is interspersed with some wonderful moments. For example, the film opens on one of the

characters in the audience at a very moving ballet performance. In the next sequence, he tells the ballet to a girl who appears to be asleep in a bed. In fact she's in a coma. Two stories intersect. As that man – a male nurse – was watching the ballet, another, older, man was also in the audience and was equally moved, to the point of tears. The male nurse also mentions this to the girl in the coma, as he washes her hair, changes her clothes – all the things you'd do for a person in that state. The script takes shape around this daily cycle of hospital care and of conversation – everything the nurse tells this girl. He talks to her the whole time, mostly about dance shows and about films; he's a keen cinema-goer. This daily ritual is then interrupted by the arrival of the older man who cried while watching the ballet: he brings into the hospital a young female bullfighter who has been seriously injured and has fallen into a coma. She's his girlfriend. The young girl who is being looked after by the male nurse is still there, and she is gorgeous. In the course of her coma she has become a woman; when first admitted to hospital she was sixteen and now she is twenty. She has blossomed under the nurse's very eyes, with his words, and she is now a beautiful young woman. When the older man passes by her room and catches sight of this young woman lying naked on her bed, it's as though he has a vision, the most moving vision he has ever had. Come in, the nurse tells him. The two men get talking, and we find out that the older man blames himself for the accident his mistress suffered during a *corrida*. The nurse explains to this man that he can talk and say what he feels to this young female bullfighter. The man doesn't understand how, so the nurse tells him: women's brains are a mystery, even more so in a place like this. He says it in all seriousness, but it could either sound tender or ridiculous. In any case, the older man follows this advice and attempts to talk to his girlfriend. It's through the two men's monologues that we enter the women's stories – almost purely through narration. We also see extracts of the shows and films that the male nurse or the other man go to. The male nurse goes to see *Wonderland*, and afterwards tells the story of Winterbottom's film to the young woman in his care. He tells her about the characters, a young married couple with relationship difficulties. The young woman is pregnant, and on the very day that she is going to give birth she has an argument with her partner, who runs off. He doesn't come home, and she thinks he has gone for good. In actual fact, he's been knocked over by a car, and taken to hospital. She, too, now goes into hospital, to have her baby. In the last scene of the film, that's where they meet: she's in a wheel-chair, cradling her baby; he's also in a wheelchair, following his accident. The moment she sees him, she starts screaming at him. He tries to explain what happened, but what he wants most of all is to see their baby, a little

girl. They calm down, talk and decide to call their daughter Alice, after *Alice in Wonderland*, in the hope that she will have a wonderful life. All this the nurse tells to the girl in the coma, and he finds it moving for this girl too is called Alice. He tells her how, during the film, he thought about her, and about her father – another man who had perhaps dreamt of a wonderful life for his daughter. The whole film is a mixture of madness, loneliness, poetry, ridiculousness, mystery, and boredom as well, given that the characters are talking throughout. Yet there are spectacular moments – the images from the ballet, the images of the films that are described . . . I very much like the idea of two men getting on with their lives alongside women who can no longer talk but who, in a different way, are just as expressive as these men. It won't be easy, but it's exciting.

You've spoken on many occasions about the sobriety of All About My Mother, *in both the* mise-en-scène *and the actresses' style of acting. But the film also contains some stunning scenes. A similar kind of alternation of style seems to be at play in the script you've just described.*
In *All About My Mother* there are shots which, in visual terms, are more stunning, as we pass from one chapter to the next. For example, Esteban's death is presented in an original and visually striking way. Manuela's arrival in Barcelona – which opens another chapter – is equally spectacular. But within each of the chapters, when we're with Manuela and the other characters, the camerawork remains very simple. Which is not to say it's easy: whether in close-up, in medium, wide or reverse shot, in other words in a straightforward type of *mise-en-scène*, every detail counts, everything has to be got just right.

Is that kind of mise-en-scène *closer to the project which you've just spoken about and does it contrast with, say, the type of* mise-en-scène *we see in* Live Flesh?
Yes. In *Live Flesh* I'm in the thick of the action, alongside the characters; particularly as I'm directly present through the film's three male characters. In *All About My Mother* I tell a story which I feel passionately about, but I'm telling it from the outside. No character in the film represents me – the only possible one could be Esteban. But I am 'represented' by the film's overall sensibility, which is more important than being represented by one individual character. When I talk about telling a story from the outside, I don't mean that I am distant: I tell the story with all my heart. It has to do with where I place the camera, of course. The only time in *All About My Mother* I employ a subjective point of view is in the scene when Esteban is killed. But

at the time of shooting I hadn't realised what I've just told you. Another difference is that I made a great many changes to *Live Flesh* between the writing of the script and the final edit, whereas all the decisions in the first draft of *All About My Mother* remained viable right to the end of the film. I think that was due not only to the transparency of the story but also to the sobriety of acting style we spoke about earlier. Let's not forget that the storyline in *All About My Mother* is fairly preposterous, practically a screwball comedy. I remember that every time I tried to sum up the film I kept telling myself it sounded crazy. My idea was to shoot this crazy story as though it were a drama. It's a strange experience – like doing a remake of Mitchell Leisen's *Midnight*, the epitome of screwball comedy, and asking the actors to act contrary to genre i.e. in a way that's both dramatic and credible. I think that the success of *All About My Mother* is that despite the madcap material, audiences can watch the film, still feeling very close to it. Audiences are sensitive to what the film addresses at the deepest level: motherhood and what it means to give life, for a man. People accepted the image of a father with breasts; in the film they saw it without prejudice. That was my great achievement. That's why sobriety was so important. All the more so with the character of a mother who has lost her son. If I wasn't careful, it could have meant tears from start to finish. Therefore this mother had to cry only at certain moments, and at all others, fight back her tears.

Among everything that led you to All About My Mother, The Flower of My Secret *seems to me to have been an important film. It's in that inside-outside relationship with the characters and story that something gelled.*
Yes, *The Flower of My Secret* is like the mother-film to *All About My Mother*. Manuela's story is actually in *The Flower of My Secret*. What I achieved as a film-maker in *All About My Mother* is the continuation of *The Flower of My Secret*, bypassing *Live Flesh*.

Of the thirteen films you have directed to date, is there any sense in which some have helped you progress more than others, have freed up either your imagination or your way of filming more than others?
I know that *Dark Habits* made me feel that I had really got to grips with film language. Up until then, I'd been working with bigger budgets than I had in Super 8, but *Dark Habits* marked my entry into cinema proper. Confirmation of this came immediately afterwards with *What Have I Done to Deserve This?*, which felt like another step forward. Not technically – in that respect I had to limit myself a great deal. The film was shot in a studio where

we'd built a replica of the family apartment. Contrary to what I'd asked for, we couldn't move the walls. There was hardly anywhere I could put the camera. I did therefore face real constraints. I had to make the film using a stationary camera and just make the most of it. It ended up bringing out the apartment's sense of claustrophobia and allowed me to show clearly its origins. The progress I made with *What Have I Done to Deserve This?* was more on a personal level. I felt freer to tackle a subject that drew on my own life, family and social class. I also felt more confident and happier in my direction of the actors. I felt very sure about what I was doing with Carmen, Chus and Veronica. It was also in *What Have I Done to Deserve This?* that I really started to combine drama and comedy, which has practically become my trademark. Although there've been moments in my career when I felt I've made more marked advances than others, generally speaking, I think that my films show a coherent progression, each one completing what the previous one started. That said, *Matador*, which came after *What Have I Done to Deserve This?*, is probably the film that I'm most dissatisfied with.

I re-watched it recently, and I again had the feeling that it was a touch too mechanical and abstract, not fully brought into fictional life, or at least infinitely less so than Law of Desire *which you made right afterwards. As though your mind were already on that film when you came to shoot* Matador.

I wrote the scripts of these two films at the same time, and was impatient to make both of them. So for one reason or another I was perhaps inevitably preoccupied with *Law of Desire* while filming *Matador*. But I still think it was an interesting story, and there are countries, such as Argentina or England, where *Matador* is one of my most highly regarded films. I wanted to tell a legendary tale, something along the lines of Pandora's Box for example, but in a very sophisticated way. That's not to say I didn't put a lot that was personal into the film – especially as in it I talk about death, a subject of great concern to me – but in *Matador*, it was a certain aesthetic, a certain sense of alienation that I was most after. We didn't have the means to achieve this sophistication, not financially, but physically: the actors lacked that mythical dimension I was looking for.

What is your view today of Kika, *which was generally badly received, rejected even, by both critics and audiences?*

Kika has a lot in common with *Matador*. Visually, the two films stand out from among all those I've made. Both deal with concrete topics yet fail to resolve them due to problems to do with actors and technique; that said,

aspects of both these films still fascinate me. *Kika* earned me the worst reviews I've had in my career, but there's another reason at the heart of my dissatisfaction with the film. On set, I very quickly had to admit that I wouldn't be able to get much out of the two male leads, Peter Coyote and Alex Casanova. Neither was really cut out for the character he had to play. Alex Casanova's role was much more interesting in the script – a nice guy, but a swine at the same time. Alex Casanova was far too lacking in sensitivity to play it. I had disappointments on the technical side too. *Kika* was a film which could have allowed me to play with video, through the character of Victoria. I asked the director of photography for some new things, but none of the tests I was shown with video were good enough. I wanted control over the video image so that I could play with the light, and that turned out not to be possible. So I had to abandon a lot of ideas for the *mise-en-scène*, wasting a lot of time into the bargain. From a visual point of view, I found the film very frustrating.

On the other hand, the film which does gives the impression that you achieved precisely what you wanted and imagined, seems to me to be Women on the Verge of a Nervous Breakdown.
Yes, it probably is the film closest to what I'd intended and conceived before shooting. For me, but for different reasons, *Law of Desire* is an essential film. It's the kind of film I'd like to be able to make every ten years – one in which I can really open up the characters, look inside them, and I have the actors who want and can do that. To an extent, this sensibility laid bare is present in *Live Flesh*, and I'd really like not to lose that.

Through its main character, a film-maker, Law of Desire *provides a kind of definition of what a director is: someone who can obtain what he wants only by doing it himself. It's the inference that can be drawn when, for example, the film-maker writes his lover the letter which he wants to receive from him. Do you recognise yourself in that definition of a film-maker?*
I resemble the film-maker in *Law of Desire* in many ways, but we have an entirely opposite relationship to reality. The film-maker in *Law of Desire* wants to render reality perfect. He's also the director of his own life – as we see in the scene you've just mentioned. I make films which have their origin in real life yet are not naturalistic studies of manners. Reality gives me the first line of the script, but I invent the second. And this second line perfects reality only in a dramatic sense: it doesn't make reality better or more attractive, it renders it cinematographically more interesting. For instance, in *High Heels*, the first line of the script is taken from real life: a female TV

newsreader announces the murder of a man. The second line is invented: the newsreader confesses live on air that she is the murderess. From the first to the second is simply a greater dramatic intensity. The film-maker in *Law of Desire* wants the first line to already be perfect, better and more attractive than reality. But in the end the second line he writes, and which launches the film, turns into a kind of punishment: the story he's invented becomes reality and turns against him. It really is a different relationship to reality than the one I have. When writing, I rarely draw inspiration from anecdotes or situations I've experienced personally. It never works. For *Law of Desire* I actually wanted to give the film-maker traits that were even closer to mine, but the script rejected all these elements that came from reality. I don't know why.

But the film-maker in Law of Desire *gets what he wants only by doing it himself, wouldn't you agree?*
Yes, in that sense the film-maker resembles God. He makes things happen. But that prompts questions: how much control do we have over that which we've created? How much effort went into doing it? How painful was it to see the result?

You say that your scripts reject private anecdotes, elements that are too personal. Yet All About My Mother *is a film in which one does sense points of intersection, similarities with your own life, even if they don't take the form of autobiographical stories.*
Yes, my own sensibility is entirely in that film. In that sense, the film is as autobiographical as any about a director from La Mancha who has just won an Oscar. *All About My Mother* even talks about the way I became a spectator, and about how I became a film-maker. I like to think that my education as a spectator was formed by films adapted from works by Tennessee Williams, notably *A Streetcar Named Desire*. Desire – 'El Deseo', in Spanish – is the name of our production company; it's the key word in the title of one of my films, and desire itself is present in all the others. In the interview we did for *All About My Mother*, I told you about how I planned to make a film about my mother, one in which I'd simply film her while she was talking, purely for the pleasure of hearing her read certain texts I like above all others. One of the texts I wanted her to read was the preface to Truman Capote's *Music for Chameleons*. I included it in *All About My Mother*, where Manuela reads it to Esteban. That's one example of how present I am in the film. My desires, my vision of the world – it's all there, not as anecdotes, but as a sensibility. Lola's desire to

be a father is one which I've felt from the age of forty onwards. As I was saying just now, there is no single character that represents me, but I am there in all of them.

Your mother's death, barely a few months after the film came out, lent, it seems to me, even greater resonance to the story told in All About My Mother *, as well as to the title itself.*
I think the death of my mother, who everyone knew, had a big impact. It led people to see the film; it even led others to award it prizes. Her death allowed people's sentimentality – whether good or bad, it's not for me to say – to find an outlet in the film. As for me, I'm very glad I dedicated the film to my mother; it was something that I'd always been too shy to do previously. I'd wanted to dedicate *What have I Done to Deserve This?* to her because it was a film about a heroic mother, an epic maternal feeling, but I didn't as I wasn't sure she would like it.

You wrote a very moving text after her death. In it, you took up the last words of your mother, who had spoken, before dying, of a storm over Madrid, and for you these words re-evoked the world of the imagination, of fiction.
The text was like a letter charged full of reality, one dictated by a reality that my mother had just left. Everything I wrote in it was true. My mother really did talk to us about that storm, even as the sun was shining brightly in a blue sky. I wondered what storm she was talking about. As you say, that storm you can't see represents fiction; the fiction each one of us invents, which we give ourselves and give to others. That storm also represents the mystery of death, of a world we don't see. This letter took on an almost literary quality, yet I wrote it as a straightforward account of the events which took place in the twenty-four hours preceding my mother's death. Among all the things that happened, there were many that I hadn't known about until then. For example, I learnt how my elder sister had prepared my mother's body after she died, with a black veil and leaving her feet bare in the coffin – details they had decided together. My mother wanted to arrive in the next world dressed in black, like an official widow; she wanted to be barefoot because although she didn't know where she would arrive, she wanted to arrive there unencumbered.

Does religion have an importance for you too?
No. I believe in the rituals, but not in anything behind those rituals. On the day we buried my mother, we arrived in the village in the late afternoon, and

the priest suggested that we have a very brief mass so as not to get to the cemetery too late. But my mother had asked my sister for a mass with all the hymns, the works. We did as she'd requested. Afterwards, we received the entire village – another one of her requests – so that everyone could offer us their condolences. Such was the custom. My mother was a believer in the Spanish mould; religion to her was something very personal, not so much spiritual as material, practical; idolatrous rather than transcendent. My mother would often pray to Saint Anthony. She'd make him offerings, but she would also ask him for very concrete things, as matter-of-factly as you'd ask the cleaning lady to go out and buy bread. I showed that to an extent in *What Have I Done to Deserve This?*, it's something very much alive, and I really like that type of religion. Spaniards attend church, but their religious observance is essentially domestic, in the presence of the saints which they worship at home.

The return to the native village you describe puts me in mind of another: the return to their village that many of your characters make in their own life-time. Like Nina in All About My Mother, *whose return Agrado describes in the last scene of the film. What does the return to the village represent for you?*

For me, it represents a return to the officially normal life, after failure at life in the city. For a long time, it was an idea that filled me with horror. I was afraid that failure would take me back to the village, even if it wasn't very realistic to think so. Well, it was realistic during my first five years in Madrid – there was a risk that that could happen. Naturally, there're other circumstances in which you can return to the village: in *The Flower of My Secret*, when the character Marisa goes back to her village, it's to make sense of her life again, find herself, before then returning to the city. But for Nina, the return to the village really is a failure, a goodbye to her life as an actress, to the *dolce vita*.

You wrote the text we just mentioned at the time of your mother's death. More recently, in the lead up to the Golden Globes ceremony, you wrote a Hollywood travel diary which was published in Spain in the supplement to El País. *Does writing come into many aspects of your life – is it a dialogue with reality?*

Yes, it's a way of taking notes on the reality around me. It's sort of complementary. Like an artist's sketch. Only my sketches take a written form. Usually when film-makers talk about what gave them the idea for a film or the desire for a particular scene, they describe an image, the image that leads

them to the story. For me, initially, it's always words or a line of dialogue or a story which leads me to the images of the film.

Like the words of the TV newsreader which led you to imagine the story of High Heels – *that first line of inspiration you were talking about.*
Yes, that's the mother sequence of the film, although it's not at the beginning. Once I imagine this woman confessing on live television that she has killed her husband, I try to find out who she is, what led her to do it and what happened afterwards. It's around my initial idea that the film takes shape. Oddly enough, in all my films the initial idea is a scene that ends up in the middle of the film. For example, in *The Flower of My Secret*, the mother sequence is the scene where the character Marisa meets up again with her husband and they have an argument. I wrote that first. Then I asked myself how that woman had got to that point and how she was going to get herself out of it. I try to imagine the places where the character might have lived, the secondary characters who come into contact with her . . . It's like detective work: I follow the trails I myself invented. I think it works the same way for writers. It's a mysterious process, but generally speaking, for me, that's what happens. Sometimes it takes two months, sometimes four years. But the mother sequence always has to be powerful. It should be able to stand up as a separate film, a short. For me, it has to raise a lot of questions. I may not always find the answers to those questions, but I find other things I like, and I note it all down. It's only once I have a lot of notes that I can really make a start on writing the script. However, not all original ideas give rise to a film, no matter how powerful they are. I always have more stories than I can develop.

Will you one day publish the stories that you haven't made into films?
I've occasionally felt like publishing a book made up of the notes I take before writing an actual script, but it'd be a little too easy. I write when I feel the urge to, not in order to produce books. The idea for *Patty Diphusa* came from a publisher who wanted to bring together some texts which had never occurred to me could form a book. The text I wrote about my mother came to me at a very specific moment. I preferred to write it myself, to give my own vision of my mother's death, rather than let others do it. The same goes for my American diary: *El País* wanted to send a journalist out there with me, but I preferred to do it myself rather than have someone following me around the whole time. In the end, writing that diary turned out to be a far more intense experience than I had thought. It was a lot of fun, and it helped me to take a step back from everything that I was doing over there. A lot was

happening every day. Noting it all down allowed me to make fun of it and of myself too. My American diary is the chronicle of a professional prize-receiver. If you don't make fun of that kind of thing, it ends up turning against you and exploding in your face.

I've sometimes seen you use a small video camera. Is that also to take notes, make sketches?
If I were eighteen today, I'd start out by making films on video. It would be less interesting, though. Super 8 had all the features of 35mm. The same craft was involved: to edit the film you had to cut it; it had its own tiny magnetic soundtrack. The image you get with Super 8 is less flat than a video image, you can play with lighting effects. Although a video camera may seem ideal for taking notes, I prefer to use a photographic camera. As for location scouting, the visual notes I take are also photographs.

There are a lot of self-portraits among your photographs.
It's partly a desire to see how I'm changing, month on month. It also came about as a result of being on my own: I travel around quite a bit, but most often without anyone to take my photo, so I take my own self-portraits. It's now become a reflex action and I can't help noticing every shiny or reflective surface that I could use to take a photograph – car bonnets, the windows of apartment buildings, mirrors of course, television screens ... In any case, my photos are of no artistic value. The distinction between being a photographer and being someone who takes photographs still holds.

Oscar Mariné, who designed the poster for All About My Mother, *told me that you were concerned to have a poster that could 'work' the world over. Are you really concerned about entering into a dialogue with the whole world?*
I've always wanted my film posters to be the same in every country, but distributors have the right to change the original poster and almost invari-ably do so, for absurd reasons. I've always tried through my film posters to communicate with a wide range of people and, when I've been unsuccessful, it's been down to the bad taste of distributors. Luckily, for *All About My Mother*, they changed nothing.

Have you also thought that through your films themselves, whilst affirming a very personal universe, you could get through to a wide range of very different people?
I think so. But it's almost a miracle if a film is ever received in the way a

director intended. All of us are very complex; each one of us sees a film in terms of our own points of reference, our own personal story. Nevertheless, I think there are basic elements which everyone recognises and can understand and can relate to in my work. I don't want that to sound conceited and make out that I've achieved exactly what I intended, but there are important aspects of me which can, I think, be understood by everyone, and the world over. The high point in this regard has been *All About My Mother*, which provokes the same emotions whatever the country or language. I found that surprising, because I rely greatly on language as a means of expression, narration and characterisation. It's a very powerful ingredient, a fragile one too, since the spoken words of a film undergo all kinds of distortions once the film is on the market. Yet *All About My Mother* was able to overcome all these distortions, the dubbing and subtitling. That came as a real surprise.

When you received the Prize for Best Director at Cannes, and when you received the Oscar – in other words, moments of international recognition – you spoke of the Spanish public and dedicated each of these prizes to them. Was that a way of saying both that you hadn't forgotten your origins and that you had kept a sense of perspective?

At Cannes, I wanted to pay tribute to the Spanish public because they were my first audience; it's thanks to them that I was able to continue to make films. When I started out making films, Spain was becoming a democracy, so democracy is another element without which I could never have become a film-maker. As for the Oscar, I had a debt towards Spain: I could feel tremendous pressure had built up throughout the country, where everyone had decided, even before the awards ceremony, that my film was going to win the Oscar. I knew that half the country was up in front of their television sets at six in the morning Spanish time, and I wanted to acknowledge all those who'd got up at that time on my account. I also explained that I owed that prize to the campaign my sisters conducted. I wanted to show that I came from another culture; I thought it would be amusing to say to the people of Hollywood, the great experts in film promotion, 'Hey look at my sisters' campaign for the Oscar: a candle for every saint'. I began to list all the saints my sisters had burnt a candle to, but at that point the music came on and I don't think the audience got my drift. Anyway, I wanted to dedicate that Oscar to my two sisters as well, because I never usually mention them at awards ceremonies, only Augustín. I was very afraid of not getting the Oscar, not for my sake – I don't get worked up over that kind of thing – but because it had become such an obsession in Spain. Four months was a

long time to wait. So it was like a release: This Oscar is for all of you back home!

This year you'll be celebrating the twentieth anniversary of Pepi, Luci, Bom. *It's a happy occasion . . .*
Yes, it's wonderful. Especially since *Pepi* . . . was not a film destined to have the life it's had. It was never intended to have a worldwide distribution. It's a film made by someone who doesn't know how to make films yet, but who goes about it with all the joy and passion in the world. It could so easily have been condemned to obscurity, but it turned out to have an opposite destiny. I think that this anniversary will please a lot of people, in the same way I believe many people felt themselves rewarded by my Oscar for *All About My Mother*. It's an Oscar for a type of cinema that runs counter to the mentality of the mainstream. My films are on the edge, I don't mean that in economic terms, but in the sense that they bring together people who don't see the world the way the studios do. Everyone who doesn't think in terms of market could feel rewarded by the Oscar with me. Of course, that Oscar was awarded to a film that was doing well in America; but even so, the film remains a rarity, an oddity in American eyes. Through that Oscar there is something that goes out to all those who are 'special', the so-called freaks. Many people told me they had identified with that prize, people who want to keep working without falling prey to the market.

That commits you to staying true to that spirit . . .
I wouldn't want to say that, or else I'd end up setting myself up as an example, a moral example, and that frightens me. Though, actually, I already am a moral example, in spite of myself. This is my life to date: do what you want to do, have faith in yourself, be patient, don't sell out, and you'll get the best. But I didn't follow that path out of integrity or for moral reasons. I followed it because that was what I felt like doing, that was what I wanted.

Talk to Her – Bad Education

Fate

Angels

Secrets

Oscars

Chaos

Love and power

FRÉDÉRIC STRAUSS: Talk to Her *and* Bad Education *appear to correspond to a change in your work as a film-maker, or perhaps in your sensibility. Did something of that nature occur in the course of making these two films?*

PEDRO ALMODÓVAR: It's what many people said when *Talk to Her* came out: this is a whole new Almodóvar, one that needs to be completely reappraised. It *is* a different kind of film, as is *Bad Education*, I know that. But all my films are different, and all have something in common. Perhaps this time it's the overall tone that differs. These latest two give the impression of a simple, serene progression, whereas each one contains more than the previous films.

I'd say that they are, in any case, closely related. Are they linked in the way that you constructed them, wrote them?
Each of them contains elements that come from the past, things I wrote a long time ago. In *Talk to Her* it's the silent film *The Shrinking Lover*; in *Bad Education* it's a 10-page treatment that was the original idea for what became *La Visita*, the story written by the character Ignacio. The other link between them is that I drew on Patricia Highsmith for the construction of a character in both films. In *Bad Education*, Juan (Gael García Bernal) is based on Ripley as played by Alain Delon in René Clement's *Purple*

Almodóvar with the female bullfighter, Lydia (Rosario Flores)

Noon. He's a criminal entirely without scruples, which gives him enormous power. But he in no way resembles the criminal type as depicted in, for example, the expressionist films of Fritz Lang: Juan has an adorable face that betrays nothing of his true nature. In Patricia Highsmith's novels evil is never obvious. Her murderers know exactly how to blend into society, only their victims recognise them. Now there's a chilling phrase: only their victims recognise them! Juan has that amoral side of Highsmith characters, elusive creatures. He also represents a classic film noir character – the femme fatale. Which means that when other characters come into contact with him, he embodies fate, in the most tragic and noir sense of the word.

In *Talk to Her*, I quoted Patricia Highsmith through Benigno, who is also the exact opposite of a Highsmith character. In one of her novels, *This Sweet Sickness*, she tells the story of a man that organises his entire life around a girl who he has only met once. He buys a house for her; he embarks on an imaginary parallel life in which this girl has a central role. He's a psychopath, and his madness could present a danger to others. In *Talk to Her*, Benigno too constructs a parallel life with a woman, Alicia, with whom he has no real connection. This parallel world becomes the only one he knows. He can enter the world of other people – there are points of access – but every time he steps out of his own world it is with the sensation of having to make concessions. Benigno is insane, but he has a good heart. He's a gentle psychopath. His moral sense is different to ours, he's an innocent who, in his parallel world, has yet to reach adulthood. He's always looked after his mother and, when she dies, he looks after Alicia, who in a certain sense takes her place. But he falls in love with Alicia, and that changes him, literally. As it would a child unprepared to live an adult love. In *Talk to Her*, Benigno is a kind of angel. And in *Bad Education*, Angel – the name Juan wants to be known by – is an angel too, but a perverse one. It's obviously not the only parallel that can be drawn between the two films. Both stories concern men. *Bad Education* has no female character as such, and even though there're two in *Talk to Her*, neither of these women can talk or even move. All the same, they still provoke reactions in others, as if they really were alive. That was what interested me.

One of the most striking links between the two films is that both revolve around a secret. In Talk to Her *it's how Alicia fell pregnant, and in* Bad Education *it's how Ignacio died. For me, that sheds light on precisely what has changed in your work: it has become more secret, more intimate. Was this a conscious choice?*

No, I found myself face to face with this more intimate sensibility; it developed almost unconsciously. I find it very hard to explain, to put this more secret dimension into words – proof no doubt that it's there. In *Talk to Her* the secret conceals a miracle: Alicia comes back to life. In *Bad Education* the secret relates to a tragedy: Ignacio's murder. And, ultimately, both these events remained shrouded in a certain mystery.

The two films explore this intimate sensibility through a new narrative form: the story appears to fold and unfold, to deploy its logic with an enigmatic grace. Was mastering this structure the culmination of work undertaken in your other films?

For me, that narrative form was not only a challenge and a pleasure, but also the best way to tell the two stories. Getting it right was hard work.

That's not the impression they give.
It was hard for me – and that's fine – but that's not at all how it should be for the spectator. I'm still attached to that old idea according to which films should be, in Rossellini's words, transparent to the spectator.

Yet you told me that seeing Bad Education *second time round would be better than the first, and that's what I found.*
Yes, because in it there are an enormous number of stories which are not shown but have an echo. That echo is more audible at a second viewing. I realise now that in order to talk about the film I have to refer back to all the drafts of the script, or to at least the last ten of the twenty I wrote. I sometimes wonder whether I shouldn't have made a three-hour film in two parts, which for a while had been my intention. There were some interesting ideas especially in the first part which I had to drop and are now only present in the form of projected shadows. The film I eventually made is like the result of a chemical experiment in which the various elements are decanted down to a distillate. It's as though I had written the equivalent of the Andes, an entire mountain range, from the valleys right up to the summits. But in *Bad Education* only the outline of the summits remains. However, given that the base is very solid – because it's been set down in writing – I think it comes through in the film all the same. What I suggested to my brother Augustín was that we release *Bad Education* in two parts. The first would be the film as it exists today. The second part, to be released six months later, would also be *Bad Education*. People would go back to the cinema, only this time they wouldn't see exactly the same thing: they would discover the hidden part of the film.

We've talked about your sometimes radical use of ellipses in All About My Mother, *in which you cut straight to the essence. The same device is to be found again in your latest two films, but the moving back and forth between past and present adds a sense of depth.*
It's true that I appear to be specialising in this kind of narrative structure. I'm very pleased with the way the ellipses work in *Bad Education*. They correspond to the fade to blacks, and are what I think give that sense of depth. They're like black holes which, literally, add a depth to the film, a sombre depth. For the first time, I detailed these fade to blacks in the script since they occur at such precise moments.

It occurs to me that we could make a connection between this way of devel-
oping a story and the fact that several writers felt the need to write about
Talk to Her *and* Bad Education. *I'm thinking in particular of Juan Manuel*
de Prada, who in the Spanish daily ABC *drew a parallel – citing Poe and*
Kawabata – between Talk to Her *and the literary tradition of love for a*
woman who is either dead or asleep.

I was struck by their contributions. It's not something that happens very
often. One explanation may well be that in my last two films there's a kind
of celebration of storytelling itself. Or at least of what I personally consider
to be storytelling. In *Talk to Her* this celebration is there in the character
Benigno, who relates to Alicia everything he sees. He transforms the ballets
he attends into stories; and, in a first draft, I also had him telling her a whole
bunch of films. Storytelling is Benigno's way of surrounding Alicia with
everything she used to like before her coma, which as far as he knows was
dance and cinema. In *Bad Education* for a moment we think that we've
understood what linked Enrique's life to Juan's, but suddenly another story
begins, at which point we also pass to another narrative style, film noir.
That's what interested me – these transitions from one character to another,
from one story to another, to constantly be inventing. In the end, the type of
narrative style I employ resembles that used in *The Thousand and One*
Nights, where one story is interrupted by another story, which in turn stops
so that we're back with the first. I like these ramifications, this live develop-
ment of a story. Writers, of course, play a great deal with narrative, at
different levels; from that point of view, I completely see why certain of them
may have appreciated my latest films. That said, literary narrative is far
ahead of film narrative.

In Talk to Her, *Benigno, who turns every day of his life into a story to tell*
Alicia, is rather like a writer who doesn't write, isn't he?
No, he's not like a writer. That comparison would only hold true in the sense
that Benigno, like Ricki in *Tie Me Up! Tie Me Down!*, imposes his own
version of reality, brings it into being with as much authority as a writer who
shapes reality according to his will and vision of the world. However,
because Benigno does this in a society which has its own set of rules, he's
liable to be punished for the consequences this has. That couldn't happen to
a writer or to me. In Benigno's case, his love of stories is largely the sign of
intense loneliness. Either he invents his reality or else he has nothing. His
mother's death left him with a life in which he is not the master – that's what
she was for him. There was a dialogue I cut from the film in which his
mother asks him: 'What will you do when I die?'. He replies absolutely

Benigno (Javier Camara) finds something to love:

Alicia (Leonar Watling) with her dance teacher Geraldine Chaplin

naturally, neither tragic nor provocative: 'I don't know – kill myself, I sup-
pose'. The mother then says: 'No, you must go on living. You have to go out,
see the outside world, meet new people. You will see horrible things (she says
this because it's what she thinks of the society in which she lives), but you'll
find something that you love, something that you'll want for yourself and that
you'll fight to get.' And when Benigno goes to look out of the window, he
catches sight of Alicia dancing in the academy across the street. He realises
that his mother is right. That's how he comes to replace one with the other.

In Bad Education, *the homage to storytelling translates into the fact that
Enrique, the film-maker, receives Ignacio's story* La Visita *twice . . .*
In fact, he receives it three times: the first time from Juan, then from
Ignacio's mother, and finally, he is told it by Monsieur Berenguer, who
reveals to him the real story behind the two accounts he's been given. In
Spanish, the words 'la visita' denote not only the visit but also the visitor.
There're a lot of visitors in the film. Juan comes to see Enrique to bring him
the story, just as Ignacio brought the story to Monsieur Berenguer, and just
as Zahara brought the story to Father Manolo. All is refracted as in a game
of mirrors. But here Enrique is not so much a writer as a sort of private
detective. He's a film-maker and is at the writing stage, the pre-writing stage
even. In that phase, a film-maker works – or at least I do – in the same way as
a private detective, doing research into people and events. In order to move
from one character to another, from one scene to the next, you highlight
relationships of cause and effect that could exist, as in the deductive reason-
ing of a private detective.

It's also a question of solving a mystery, a secret.
That, for me, is truly what cinema is about. When making a film, you never
stop solving mysteries, making discoveries. Whether writing, shooting or
editing, even while promoting the film, you keep discovering new things
about the story it tells, as well as about yourself and others. For a film-
maker, that's certainly the unconscious urge: to glimpse life's enigmas, to
solve them or not, but at least to unveil them. Cinema is curiosity, real
curiosity, the kind that could power a great love story, a great film, or life's
big decisions. Enrique is a character who wants to know. He has the intu-
ition that behind what is happening to him lies a secret, one that goes far
beyond what I show. That's the reason why he decides to give the role of
Zahara to Angel. He wants to make a film of *La Visita* because it's the last
thing Ignacio asked him to do in his letter. It's as though he's been sent a
message from beyond the grave. He also makes the film in order to see how

far Juan will go, because Evil and Deception are themes which represent an obvious temptation for a film-maker. Mixed in with all of this is carnal desire. I don't know whether that's clear in the film, but for me it's physical desire above all that there is between Enrique and Juan.

Enrique wants to find out how Juan died. But when you want to unravel an enigma, you also sometimes have to be prepared for terrible discoveries. It's what happens to Enrique when he reads the typewritten message from Ignacio that says, 'I think I've succeeded . . .'. Enrique sees how these type-written words are followed by a smudged black mark, the kind formed when several typewriter keypads are struck together: the trace of Enrique's death. That makes the film pack a punch. However, we do find out at the end that Enrique eventually survived this dangerous affair with Juan, and that he's continued to make films with a passion. Ultimately, that's what counts: to survive and to go on with the same passion.

In Bad Education, *the progress of the story at times changes the status of the characters. For example, in the story* La Visita *Zahara is a fictional character, at the same time it's Ignacio as an adult. Does that also make Enrique a fictional character in the same section of the film?*
Through the character of Zahara, Ignacio is talking about himself. When he wrote *La Visita* it was in order to blackmail Father Manolo/Monsieur Berenguer. At the same time, however, his story is homage to his childhood love, Enrique. He also includes in it a reflection on himself, imagining himself as Zahara, a pretty young woman that now wants an operation to become even more beautiful. Ignacio is idealising himself in that passage, just as he idealises Enrique when he imagines him as an adult, married but still somewhat wild. It's then that Ignacio achieves his dream of making love to Enrique, without him realising. But the Enrique in *La Visita* has very little to do with the real Enrique.

But, as a spectator, one could take them for genuine memories.
Fine by me.

The decision to have Gael Garcia Bernal play the role of Zahara in Ignacio's La Visita, *as well as afterwards in the version filmed by Enrique make both fictions very close to each other.*
Yes, the two of them, Ignacio and Enrique, are friends once more – one writes, the other adapts what has been written. Except that Enrique changes one essential part of *La Visita*, a part which Ignacio couldn't change: the end. It highlights the fact that, for a director, the adaptation of a story

involves searching for a truth, resolving a mystery. Ignacio's story ends well: Zahara, now satisfied, comes out of the school in front of all the children and goes off to her date with the Enrique of *La Visita*. But by the time Enrique the film-maker comes to make his version of *La Visita*, he's already found out that Ignacio is dead – to him it seems more logical to have the character Zahara die. The film he plans to make he sees as a denunciation of priests, and in it he wants to have them finish off their initial attempt to destroy Ignacio by actually killing the person she became, Zahara. When Enrique tells Juan *La Visita* cannot have a happy ending, he explains that the Church can't simply let Zahara go: she would be a walking time-bomb that could go off at any moment. He adds that if the Church has to resort to violence to prevent Zahara from doing it harm, it will have no hesitation in doing so. But Enrique is also telling Juan, through all this, that it is their relationship that cannot have a happy end.

In Talk to Her, *you manage to tell the story of the rape committed by Benigno without it coming to dominate the rest of the story and condemn the character. You defuse that narrative bombshell in order to tell the story which interests you and nothing else. That's masterful.*
First of all, that's probably because I treat the character Benigno as I would a friend. I see him neither from the point of view of normality nor abnormality, only in terms of his near fanatical romanticism. He has his own logic, perfectly consistent with the world he lives in. In his world he is in control of everything, his own death even. I made a real effort not to judge the character, because I think that makes for a more interesting approach. Some might say that Benigno is a necrophiliac. That wouldn't necessarily be wrong. But I wanted to get away from all those sorts of categorisations. It was also my reason for including the film *The Shrinking Lover*: something is bound to happen with Benigno, I don't want to see it, nor do I want others to. It's like when a friend has done something terrible and you decide to turn a blind eye, just so as to keep them as a friend. I therefore came up with *The Shrinking Lover* in order to cover up what Benigno has done. As a narrator, it also appealed to me to, at a crucial point in the story, not reveal what was happening and to cut to something totally different: a silent film in black and white. My desire to hide the wrong that Benigno does is no doubt ambiguous, given that I place all the keys to unlock this secret inside the silent film, in which you can even guess how Benigno will end up. Deep down, I like Benigno's moral ambiguity. I think that he's one of my best male characters; and Javier Camara, one of my best actors. But in this film I am probably more present – in a really hidden way this time – in the hermetic nature and

silences of Marco, than in the garrulousness and imagination of Benigno, the character most frequently been likened to me.

You won the Oscar for Best Screenplay for Talk to Her. *Isn't that rather paradoxical, to the extent that the film's narrative complexity and very personal nature make it much more than a straightforward technical model of a screenplay?*

Ah, but you need a great deal of technique to write a screenplay like that. Apart from the fact that it's not the sort of technique you could learn at film school; it's what I've evolved in the course of my work. When you know Hollywood – and leaving aside for a moment that it's my film – it's quite easy to see why the Oscar for Best Screenplay went to *Talk to Her*. Firstly, eighty per cent of all American screenplays are adaptations of novels. Competition for the best original screenplay Oscar is therefore far less intense. But above all, what Americans like – moviegoers as well as industry practitioners – is the teeming, inventive side to my scripts. For them the fact that my scripts are packed with ideas and characters is a sign of riches. The *Times* journalist who wrote on *Talk to Her* said that, with a script like that, Hollywood could make ten films. Americans admire that kind of narrative fecundity. I think it has to do with their notion of what an original screenplay is i.e. one that not only is not an adaptation of a literary work, but also one that resembles no other. In any case, the last foreign film to get Oscar for Best Screenplay was Claude Lelouche's *A Man and A Woman* in 1964. So it's an incredible achievement to have won, particularly as *Talk to Her* is very different to the kind of script Hollywood produces, and to American scripts in general.

It's recognition of a richness that has always been there in your films but was often seen as a weakness . . .

There's certainly an element of that. Up until two years ago, my kind of inflated storyline was an argument that many critics used against me. Generally speaking, critics find the mixing of genres problematic. They appear to think it best avoided, whereas it's precisely what I've made my speciality. But now I have Hollywood's blessing.

For a long time now, what you've been doing goes beyond the mere mixing of genres – it's the mixing of stories and tones within a genre.

I have to say I'm very pleased with the process of distillation which has led me to these latest two films. It truly corresponds to my notion of what cinema is, but it's taken me a while to achieve. Anyway, I wouldn't want to

give the impression that I think I've now arrived where I wanted to get to. In fact, I continue to feel a certain frustration.

This allowing a story to mature over the years – is that now your working method, a part of the writing process?
It's becoming my way of working, you're right. But it's a process I'd like to be able to speed up. Luckily, as I'm constantly writing, I have a lot written which can be incorporated into what I'm writing today. I'm like Enrique, who takes cuttings of articles out of the newspapers: anything I read, anything I'm told, any aspect of the world around me can be of interest and help give meaning to the fictional material I have already. At the moment, I'm working on a story which I thought was entirely new and have now realised I wrote a chapter of it a few years ago. All film-makers have fictional reserves. Billy Wilder kept cardboard boxes stuffed with ideas for dialogues, situations and gags, which he then used in his films. I do the same. I even buy objects which I then put away in boxes thinking that one day they'll find a story, a film. The danger is that these objects end up being of no use, mere lifeless objects. That can happen. Not everything I write will necessarily become a film. Some ideas are superseded, others remain vibrant. What's certain is that I could never be one of those writers who write to commission. The only method I have is to stay close to the stories that accompany me over the years, in order to one day make them into a film.

You spoke of cinema being the art of resolving a mystery, of unravelling or creating secrets. It strikes me that for you today these secrets are of an almost philosophical nature.
Yes, they're secrets which go ever deeper. But to say that they go deep isn't to say that they're not simple. I'd hate to turn them into something pompous. It's more intimate than that.

When the lover who has shrunk goes through into the secret passage that is the vagina of his wife – now a gentle giantess – it's as though he were going to solve the mystery of all mysteries . . .
And end a cycle, finish back where he started.

There's something almost sacred about that. Did you add humour so that it wouldn't be, as you put it, 'pompous'?
The tone is comic, but there's an epic dimension to it too. It's a blend fully in keeping with the spirit of silent films. And it does make this sequence more light-hearted. It's not my habit to talk about spirituality, but I think there is a

spiritual side to both *Talk to Her* and *Bad Education*. As I was saying just now, *Talk to Her* tells the story of a miracle: how Benigno brings Alicia back from the shadows. It has to be pointed out, of course, that the miracle occurs – let this be said in a whisper – as the result of a rape. Nevertheless, the miracle retains its spiritual and religious overtones. In *Bad Education* spirituality is, of course, present through the Church, the official face of spirituality in our society – even if, for me, it represents many other things. In the film, the catholic liturgy is no longer directed at God, but at the characters in the film. What matters to them is their desire, their passion; more so even than life itself – all are aware that their lifestyle puts them at risk. I have no religious faith, yet I feel a deep fascination for religious rituals, which touch me, of course, for what they have of the theatrical. In *Bad Education* there are three masses, an act which, in the Church's view, unites man with God. However, I leave out God and steal these religious rituals in order to integrate them into the lives of my characters. When Zahara goes inside the church, Father Manolo is celebrating mass; it's an act of contrition, and she twists his words to express her own truth. He says, 'It is my fault, my most grievous fault', and she replies, 'It is your fault, your most grievous fault'. She appropriates the language of the church and makes it her own. It's what I was doing in *Women on the Verge* . . . with the extract from *Johnny Guitar*: I wasn't paying tribute to a film or a film-maker, I was stealing these images from him to give them to my heroine and twist their meaning for her benefit. That way, I could have her hear a declaration of love, which the man she loves will never make to her in her life-time, and which bowls her over.

As you do with the two ballets by Pina Bausch in Talk to Her. *They're not a cultural reference – they become part of the very language of your film.*
Absolutely. And in this case I felt it was a film which had a musical rhythm, a musical language even. I couldn't say why. So this opening and closing in music were perfect.

You are friends with Pina Bausch, as well as with Gaetano Veloso, who makes an appearance in Talk to Her *to sing* Cucurrucucú Paloma. *Does that indirectly merge your private life with the film?*
No. The fact that they're friends of mine simply made it easier to do what I wanted in the film. Had those three moments containing the work of Pina and Gaetano not been full of meaning for me, I wouldn't have used them. They had to be moments of great emotion, because Marco cries while watching Pina's ballet, just as he does while listening to Gaetano's song, and I think we can see why. The condition for me to include them

in the film was that I be the first to cry. And the opening to Café Müller really did make me cry, as I did the first time I heard Gaetano's version of *Cucurrucucú Paloma*. It's a song of such moving tenderness that it almost becomes violent; and it loses all relation to the version everybody knows.

Talk to Her *ends – with Pina Bausch's ballet* Mazurka Fogo, *set in a Garden of Eden -with the 'creation' of the first happy couple in the film, Alicia and Marco. The same Marco who had to kill a snake in the house of his ex-wife, Lydia. By including these elements, did you want to give the story a biblical dimension?*

No, but I like that interpretation. It's true that Pina Bausch's piece depicts a real paradise, and that there is something marvellous about the couple on stage, as well as the couple formed by Alicia and Marco. It's where you sense everything starting, in nature, as the film ends. My intention with the snake (a grass snake) was to create an emotion linked to a phobia, whilst at the same time shrouding Marco's character in mystery. A man who has just killed a snake and cries, neither out of pain nor fear – he'd been in no danger – now there's an interesting mystery. The entirely rational explanation for this is that Marco used to live with a woman who had a phobia of snakes, and that she is no longer with him. I thought that was a good way of evoking nostalgia, the absence of someone you miss. It's also what makes me feel close to Marco. I recognise the pain that a love affair can leave you with, how hard it is to get over. That pain can mark you for years. But in the scene where Marco attends the wedding of his ex-girlfriend, he doesn't cry. That means he no longer loves her. In that scene, it's Lydia who cries, thinking about the bull-fighter she is in love with. Running throughout the film is a sort of secret code: the person who talks is the one who loves, and the one who cries, also loves. Benigno tells Marco to talk to Lydia, but Marco finds it hard. When Marco sees Lydia at the hospital, he sees her as if she were already dead. Whereas when he sees Alicia, on the same day and in the same hospital, he sees her with very different eyes. And it is to Alicia that he will go and talk. In a way, it's a premonition of their love.

Café Müller, *the other Pina Bausch ballet, which opens* Talk to Her, *depicts a sombre world, a world of solitude and lost wanderings. Could it not also introduce* Bad Education?

For me that ballet is so tied in with *Talk to Her* that it would require a lot of mental gymnastics on my part to turn it into a key to understanding *Bad*

Education. The woman sleepwalking is such a perfect expression of the two women in the film who live in a state of limbo. And the man who comes to her aid, pulling chairs from out of her way so she doesn't fall over, perfectly represents the two men in the film who try to help the two women and make their lives more agreeable, even if the women themselves are in no position to say what an agreeable life is for them. Opening the film with this ballet was a very straightforward way of telling the story, for everything in it is linked to what follows. But, as with *The Shrinking Lover*, it's also a way of not showing other images.

There's perhaps a word which we could take away from that ballet and would be apt to describe both films: chaos. Life and death are interlinked, so too are past and present.
Yes, in abstract terms, that mix is present in both films, and to talk of chaos reflects both. *Café Müller* is, in any case, a ballet that is full of mystery.

Most striking about this disorder is probably the combination of gentleness and harshness which one senses are present in both films. It's expressed fairly emblematically in Bad Education *in the story of the woman who dies hugging the crocodiles which devour her. That image could refer to Benigno too, to his protective love that extends to rape. Gentleness and harshness – are these aspects of life which have struck you in recent years?*
They're hardly a revelation. It's more that this gentleness and harshness are constantly present in my life, in ways that are very evident, very apparent and that I am very conscious of. I try to maintain a balance between the two, and that creates a tension which no doubt ends up adding to the harsher aspects of my life. But I couldn't say when I first became aware of these two aspects of my existence. Maybe over time. In any case, I'd like to move on from there.

In Talk to Her, *there is at least a desire to go towards that earthly paradise depicted at the end of the film, and to show that reconciliation is possible. In* Bad Education, *however, beyond the reference to film noir, the vision of human relationships is a very bleak one. Weren't you struck by this?*
Yes, but not only when the film was finished. It had already struck me at the writing stage. Oddly enough, that was what most appealed to me: to create an atmosphere of unambiguous bleakness. As I've already said, there are other subjects I'd like to tackle, but in this case, it was this bleakness that interested me.

With regard to the sexual desire that you mentioned between Juan and Enrique, the carnal relations in the film seem to me fairly carnivorous.
That's a good way to describe them, as there is a real sense of voracity. In the scene where Enrique and Juan make love, Enrique is leaning over Juan, and yet in that instant, we get the curious impression that it's Juan who will devour Enrique, not vice-versa. But the film also contains a portrayal of a love that is different: Monsieur Berenguer's passion for Juan. It's the classic depiction of a love like Alida Vali's in *Senso*, or James Mason's in *Lolita*. The adult character is aware both of their desire and of the price they'll have to pay for that desire; yet they give themselves in all generosity, without heed to eventual manipulations or, worst of all, to what eventually happens, the absence of the loved one. Rather paradoxically, the person I make into the moral hero of the film, in a certain sense, is the priest I want to denounce as the abuser of a child – when he becomes Monsieur Berenguer, the person who loves with a genuine passion.

Many have drawn a link between Bad Education *and* Law of Desire.
Of course, there's that scene in *Law of Desire* when Carmen Maura enters the church where, as a boy, she'd been a chorister, and is chased out by the priest. It's like a premonition of the scene with Zahara in *Bad Education*. But the two films are quite distinct.

We also find again the homophobia of the Antonio Banderas character in Law of Desire, *who nevertheless falls in love with the director in the film. In* Bad Education, *Juan gets involved with Enrique, but there's a sense that his phobia of homosexual relations is even greater.*
In the case of the Antonio Banderas character, it was a young man who'd had a conservative, homophobic upbringing in an Andalusian family. But the moment he falls in love with the film director, it's his true sensibility that guides him and all that counts are his own feelings. There's the added problem that his feelings exclude everyone else's, to the point of madness. Nothing could be more tender, though, than Antonio's last scenes in *Law of Desire*. That tenderness is not present in the character Juan; nor, by the way, is it there in the actor who plays him, Gael García Bernal. I always have to allow for a certain margin of adaptation between the character in the script and the actor who will play the role. Antonio had about him a joy and tenderness which I used in his character, even if it was a young man with a marked psychotic side to him. Gael – perhaps for cultural reasons as he comes from Mexico – neither inspires nor provokes those playful and tender feelings which may yet have fitted the character Juan. When we came to

The power relationship between someone who creates and their lover
(Fele Martínez and Gaël Garcia Bernal)

shoot the scenes where he plays Juan, Gael did, however, convey very well the character's implacable selfishness. I tried to do it in such a way that the character had a little more humour and warmth, but that didn't work. So I adapted the character Juan to what Gael inspires, which isn't to say that I renounced a part of the character, only that I made full use of what Gael offered me at an unconscious level: a darker element, very interesting for the film. In any case, Juan is totally homophobic from the start. However, he has such burning ambition that he is capable of anything, even what comes hardest. In the erotic scenes, his character behaves in a very selfish way, he doesn't give of himself physically. In the end, for Juan to remain a real bad guy with a charming face, it's right that his character cannot be redeemed by tenderness and humour.

From Law of Desire *onwards, many of your films have told a fairly similar story: the love and power relationship between someone who creates, an artist, and the person who loves them, and who wants to make of their love something even stronger, more beautiful and more essential than the act of artistic creation itself. It's the emotional dynamic in* Tie Me Up! Tie Me Down! *between the actress and the young man who wants her to recognise the value of his love. It's also what happens in* High Heels *between the*

mother, a singer, and her daughter, who wants to offer a love more precious than her mother's career. In The Flower of My Secret, *this conflict is condensed into the single character of a woman writer who wants her personal life to be as emotionally fulfilling as the relationships described in her novels. Is the relationship between Benigno and Alicia in* Talk to Her *in keeping with this pattern? He wants to overwhelm this young woman with his love, a love worth more than her dancing career.*

Benigno isn't aware of that. To him, Alicia is fully alive, she answers him back. He may be strange, but he is not in competition with her. That said, it's an accurate reading of the other films. There's always a fruitful tension between a creator's life and his work. In my case, the two are completely intertwined. I couldn't say which is more important, the life or the work. At times, the life becomes the source of creative material.

In Bad Education *this sense of rivalry is again there in the relationship between the film-maker and his lover. Only now the lover no longer offers a love that is overwhelming: he's ready to do anything simply in order to make it as an actor.*

Yes. But both of them pay a high price. Juan surrenders his body and Enrique is prepared to surrender his film, which to him is what matters most. Before leaving him, Juan says: 'You didn't think I was the best actor for the part of Zahara'; and it's true that Enrique chose him even though he clearly didn't consider him to be the best for the role. He did so, as I mentioned, to see how far Juan would go. In the end, Enrique ends up not making the film he had wanted to make. But he will make others.

In Bad Education, *the children escape Father Manolo's clutches by going to the cinema and finding refuge there. It's also to a cinema – the Madrid Film Institute – that Benigno goes at a crucial moment in* Talk to Her.

In the case of Benigno, it's then that he sees on screen what he is going to do with Alicia. Cinema is not only a refuge, but also a mirror onto which his future is projected. It reminds me of *Taxi Driver*, when the de Niro character only allows himself breaks to go to the cinema. As it happens, he goes to see porn films but it's to the cinema that he goes, not someplace else. Partly, it's to kill time. The cinema is the refuge of loners and of killers.

Is that a personal statement? Is the cinema your refuge?

As regards loners, I'm sure it is a refuge. But I don't actually think that there are many film-going assassins. For me, seeing a good film is like meeting someone who is going to have an influence on me. It happens less and less

often, but it's something from which I derive greater and greater pleasure. I don't know whether that's because I'm more solitary than I used to be, but what's for sure is that, in my case, seeing a good film or reading a good book is like a love affair. It's what gives my life delight, hope.

When Ignacio and Enrique go to the cinema to see Mario Camus' That Woman, *starring Sara Montiel, you show an extract that is very reminiscent of* Dark Habits. *You also explained to me how at the time this scene in* Bad Education *takes place – the early 1960s – Sara Montiel was a real gay icon. Did you take all that into account when constructing this scene and selecting this extract?*

I hope that I did it in a way that wasn't too heavy-handed; I mostly did it to please myself. I watched a lot of Sara Montiel films before picking out this one. Whilst it clearly resembles a photo story, it's perfectly achieved and I'd have liked to use other extracts. I like the way Sara Montiel delivers her lines. She's created her own acting style without recourse to the classics; like Marlene Dietrich who used to say her lines almost incorrectly, yet with such enormous force and personality. Both are atypical actresses with their own unique style. Marlene Dietrich, however, was the creation of the lighting skills of Josef von Sternberg, whereas Sara Montiel invented herself alone. Though I'm one of her admirers, in Spain and America there are people who profess an absolute devotion to her. And yes, she does have a cult gay following. So, once again, for the two boys in *Bad Education* it's as though they were seeing their future on screen. One will become a transvestite singer and dancer, the other a film director, also homosexual. As for the relationship between that film and my own work, it's actually rather incidental, since *Dark Habits* is marked by the influence of numerous other films, both with and without Sara Montiel. What I like most about this extract is that it concerns a visit. Sara Montiel plays a woman returning to see the Mother Superior of the convent where she had once been a nun. So it's the visit in *La Visita.*

In putting those two children in front of that particular film, you allow people to think that it's purely and simply you seeing the cinema that influenced you. Do you think that you reveal more about yourself in this film than in another?

No. In that scene, I have only time to show one film that the children go to see. So the scene becomes: the children discover cinema. Of course, in my case that calls into play a whole host of other films, which I can't cite, as there's a limit to the number of scenes I can have with the children at the

cinema. I don't think conclusions can be drawn about me by simply assuming that the child watching Sara Montiel is me; the child who will be marked by this actress and who will make films. The path I've taken is far more complex than that. At the age the children are in *Bad Education*, it was films by Antonioni that were making an impression on me. I wonder now how I was even allowed inside the cinema. There were also American films, like *Cat On a Hot Tin Roof*, which spoke to me of the sexual repression we faced in Spain. In fact, Sara Montiel was a pleasure that I discovered later, after I moved to Madrid. As for the discovery of sensuality, the carnality within us – that came mostly through watching films starring Hercules and all those Italian epics.

Almodóvar with Gael Garcia Bernal

As with Talk to Her, *you therefore manage to tell only the story that you want to tell: you make use of your own personal memories, but without letting yourself fall into the trap of autobiography. You succeed in letting the characters exist beyond yourself.*

It's not a confessional film – which would be made to satisfy a strong inner urge: I've got to talk about myself, this is what I was, this is what I am now! I do use elements of my own story and I try to understand better the path I've followed, but I use myself as fictional material in order to create characters and scenes. In that sense, there could be room for a certain amount of confusion. It's not my life, though, even if it might look it. But I have no problem with people thinking that I'm Enrique or Ignacio. Laying myself bare in a film would not bother me. It is true, however, that I'm careful in what I say about myself. That does not mean that I control what I say in order to hide. What I most intimately am is precisely what has given rise to my two latest films. I have no desire either to hide or put myself on display.

It's more mysterious than that.

Exactly. These two films have taken me to a place where, if I look around me, I feel that I am surrounded by mysteries. Mysteries that I know I'll have to tackle.

Filmography

1980

Pepi, Luci, Bom (Pepi, Luci, Bom y otras chicas del montón)
Written and directed by Pedro Almodóvar
Director of photography: Paco Femenia
Sound: Miguel Polo
Editor: Pepe Salcedo
Production: Pepon Corominas/Figaro Films
Length: 1 hour 20 minutes
Cast: Carmen Maura (Pepi), Olvido Gara 'Alaska' (Bom), Eva Siva (Luci), Felix Rotaeta (the policeman), Kiti Manver (the singer), Julieta Serrano (the actress), Concha Gregori (Charito), Cecilia Roth (the presenter)

Pepi, a young independent girl living in Madrid, is caught by a policeman growing marijuana on her balcony. Pepi is ready to do anything to avoid a charge except lose her virginity. The policeman rapes her. Pepi seeks vengeance. She tracks him down and has him beaten up by a rock group whose lead singer is her friend Bom. But the next day, Pepi realizes they attacked not the policeman but his twin brother. Continuing her revenge, Pepi befriends the policeman's wife, Luci, who soon becomes the willing victim of Bom's sadistic fantasies. Pepi, Luci, who's left her husband, and Bom, who's now found the perfect partner, lead a demented nocturnal life going to parties, including one featuring an erection competition organized by Pedro Almodóvar. The three women live together. Luci launches into advertising to earn money. Her advertisement for Ponte underpants is an enormous success. At the same time, her husband, the policeman, is looking for her. He assaults her coming out of a disco and kidnaps her from her two friends. After several days' waiting, Pepi and Bom receive a telegram from Luci in hospital. She welcomes them with a smile, happily reunited with her sadistic and tyrannical husband. Hand in hand, Pepi and Bom leave alone and make plans for the future.

1982

Labyrinth of Passion (Laberinto de pasiones)
Written and directed by Pedro Almodóvar
Director of photography: Angel Luis Fernández
Sound: Martin Muller

Editor: José Salcedo
Design: Pedro Almodóvar
With the assistance of other painters and artists: Ouka Lele, Guillermo Pérez Villata, Costus, Pablo P. Minguez, Javier P. Grueso, Carlos Berlanga, Fabio de Miguel.
Songs: 'Suck it to me', 'Gran gagna' by Pedro Almodóvar
Production: Alphaville
Length: 1 hour 40 minutes
Cast: Cecilia Roth (Sexilia), Imanol Arias (Riza Niro), Helga Liné (Toraya), Marta Fernández Muro (Queti), Fernando Vivanco (the doctor), Fanny McNamara (Fabio), Antonio Banderas (Sadec), Angel Alcázar (Eusebio), Cristina Sanchez Pascual (Eusebio's friend), Agustín Almodóvar (Hassan)

Sexilia is undergoing a course of psychoanalysis in the hope of curing her nymphomania and her fear of the sun. But her psychoanalyst is far more interested in sleeping with Sexilia's father, a gynaecologist specializing in artificial insemination. One of the analyst's other patients is Princess Toraya, the ex-wife of the Emperor of Tiran, who, flicking through a magazine discovers that the Emperor's son, Riza Nero, is visiting Madrid. Riza, a homosexual, is living incognito but when he realizes that Sadec, one of his lovers, is also from Tiran, decides to change his hair and clothes in order to protect his anonymity. He becomes a rock singer, meets Sexilia and they fall in love. That night, they tell each other of their feelings but don't sleep together. Coming home, Sexilia bumps into Queti whose father, a dry cleaner, forces Queti to sleep with him because he confuses her with her mother who left him for another man. Sexilia asks Queti, who looks exactly like her, to take on her identity. In this way, Queti can free herself from her father and Sexilia can run away and live with Riza in Panama. Sexilia goes to Riza's hotel and finds Toraya and Riza in bed together. Horrified, Sexilia visits her analyst and discovers that Toraya was responsible both for her childhood traumas and her nymphomania. Sexilia decides to forgive Riza. Sadec, who has a highly developed sense of smell and has fallen head over heels in love with Riza, is looking for him everywhere. Sadec's flatmates, Islamic extremists, plan to kidnap Riza. Queti warns Sexilia and Riza of the danger and, when Toraya and the students arrive at the airport, Riza and Sexilia are already on the plane bound for Panama on which they make love for the first time.

1983
Dark Habits (Entre tinieblas)
Written and directed by Pedro Almodóvar
Director of photography: Angel Luis Fernández
Sound: Martin Muller, Armin Fausten
Editor: José Salcedo
Design: Pin Morales, Roman Arango

Songs: 'Sali porque sali', 'Dime', 'Encadenados' by Sol Pilas
Production: Tesauro S.A. and Luis Calvo
Length: 1 hour 55 minutes
Cast: Cristina Sanchez Pascual (Yolanda), Julieta Serrano (Mother Superior), Marisa Paredes (Sister Sordid), Carmen Maura (Sister Perdition), Chus Lampreave (Sister Illtreated), Lina Canajelas (Sister Viper), Mari Carillo (the Marquesa), Eva Siva (Antonia), Antonio Banderas (the postman)

Yolanda, a *bolero* singer, finds refuge in the convent of the Humiliated Redemptresses after her lover dies horribly of a heroine overdose. The Mother Superior, a fan of Yolanda's who had promised to provide help if required, lives with four other nuns: Sister Perdition who looks after the 'baby' (a tiger in the garden); Sister Viper who, with the help of a priest, designs clothes for the Virgin Mary; Sister Sordid, who cooks between hallucinations; and Sister Illtreated who gardens and secretly publishes pornographic novels under the pen-name Concha Torres. The Mother Superior is responsible for finding lost girls for the convent to save. But there's been a shortage of girls and a recently widowed Marquesa who's been subsidizing the convent is threatening to withdraw her support. Yolanda's arrival, therefore, is interpreted as a divine blessing. The Mother Superior soon falls passionately in love with her and together they inject themselves with heroin. But Yolanda doesn't love the Mother Superior and decides both to break with her and her past. Yolanda cold turkeys and the Mother Superior, faced both with Yolanda's rejection and the threat of closure, starts importing drugs from Thailand. In spite of these trials, the Sisters decide to celebrate the Mother Superior's birthday, during which Yolanda, accompanied by the Sisters, sings again watched by the Marquesa who has now befriended her. At the end of the party the Mother Superior announces the dissolution of the convent. Sister Perdition decides to return to her native village and leaves her tiger to Sister Viper and the priest who have fallen in love and want to found a family with the tiger as their son. Sister Illtreated and Yolanda go to live with the Marquesa who has discovered a long-lost grandson brought up by apes in Africa. Only Sister Sordid is left to console the Mother Superior from the terrible heartbreak Yolanda's desertion has caused.

1984
What Have I Done to Deserve This? (¿Que he hecho yo para merecer esto?)
Written and directed by Pedro Almodóvar
Director of photography: Angel Luis Fernández
Sound: Bernardo Menz
Editor: José Salcedo
Design: Pin Morales, Roman Arango
Costumes: Cecilia Roth

Music: Bernardo Bonezzi
Songs: 'La bien pagá' by Miguel Molina; 'Nur nicht aus Liebe Weinen' by Sarah Leander
Production: Tesauro S.A.
Length: 1 hour 42 minutes
Cast: Carmen Maura (Gloria), Angel del Andrés López (Antonio), Chus Lampreave (the grandmother), Veronica Forqué (Cristal), Kiti Manver (Juani), Juan Martinez (Toni), Gonzalo Suárez (Lucas), Amparo Soler Leal (Patricia), Jaime Chavarri (Cristal's client who strips), Katia Loritz (Ingrid Muller), Francisca Caballero (dentist's patient), Agustín Almodóvar (bank teller)

Gloria lives with her husband, mother-in-law and two sons in a tiny flat in a sordid tower block outside Madrid. To make ends meet, Gloria works eighteen hours a day and takes amphetamines to keep going. Her marriage to Antonio, a taxi-driver, is on the rocks. Fifteen years earlier, in Germany, Antonio worked as a chauffeur to Ingrid Muller, a singer with whom he had a brief affair. His only mementoes of their liaison are a signed photograph and a tape of her song 'Nur nicht aus Liebe Weinen' which he constantly plays and which Gloria detests. There is also a book of Ingrid's memoirs written by a friend which contains letters from Hitler which Antonio helped forge. Antonio is trying to teach the art of forgery to one of his sons, as this talent will be his only inheritance. The younger son, Miguel, who is twelve, sleeps with the fathers of his schoolmates; Toni, who is fourteen, wants to become a farmer and is saving up enough money to buy a farm by peddling heroin. Their miserly grandmother, who is addicted to soft drinks, shares the same dream of returning to her native village. Cristal and Juani, two women who live in the same block, are almost part of the family. Cristal is a prostitute with a heart of gold. As for Juani, a bitter woman obsessed with cleanliness and vulgar ornaments, she has a daughter with extra-sensory powers who uses them to destroy their flat. Gloria's life becomes unbearable. The chemist refuses to sell her her amphetamines without a prescription; she cannot afford to buy some shampoo; she is forced to work for a couple of bankrupt writers; she has to put up with a lizard Toni and his grandmother have brought home. Worst of all, she learns Ingrid Muller plans to visit her husband and ask him to forge Hitler's memoirs. Finally, Gloria snaps and accidentally kills Antonio with a leg of ham. The police cannot find the culprit. Toni and his grandmother leave Madrid. Abandoned, Gloria decides to commit suicide. But the unexpected return of her younger son gives her a glimmer of hope.

1985–6

Matador
Directed by Pedro Almodóvar
Original story: Pedro Almodóvar
Screenplay: Pedro Almodóvar, Jesus Ferrero

Director of photography: Angel Luis Fernández
Sound: Bernard Orthion, Tino Azores
Editor: José Salcedo
Design: Roman Arango, José Morales, Josep Rosell
Music: Bernardo Bonezzi
Song: 'Espérame en el cielo, corazón' by Mina
Production: Andrés Vicente Gómez, Cia Iberoamericana de TV S.A.
Length: 1 hour 36 minutes
Cast: Assumpta Serna (Maria Cardenal), Antonio Banderas (Angel), Nacho Martinez (Diego), Eva Cobo (Eva), Julieta Serrano (Berta), Chus Lampreave (Pilar), Carmen Maura (Julia), Eusebio Poncela (the commissioner), Bibi Andersen (the flower seller), Veronica Forqué (the journalist), Jaime Chavarri (the priest), Agustín Almodóvar (the policeman)

Diego Montes, a *torrero* who retired prematurely after being gored in the ring, runs a school of bullfighting. One of his pupils is Angel, a strange boy prone to dizzy spells and the victim of an authoritarian mother obsessed with Opus Dei. One day, in order to prove his virility to his teacher, Angel tries to rape his neighbour Eva, who also happens to be Diego's fiancée. Angel goes to the police to confess but Eva, who identifies him as her attacker, refuses to press charges because he didn't manage to rape her. Craving punishment, Angel confesses to four murders. His defence lawyer, Maria Cardenal, is a great admirer of Diego and loves above all to kill her lovers with a hairpin at the moment of orgasm. Diego sees Maria on television and decides to follow her. They meet for the first time in the lavatory of a cinema showing *Duel in the Sun*. Diego invites her home. She tries to kill him, but he prevents her and realizes he has found his soulmate. The police, meanwhile, are trying to verify Angel's confessions. Julia, the police psychiatrist, warns that Angel is about to enter a hypnotic trance. During these trances, Angel can see all the murders committed in the city. These trances become unbearable for Angel and finally he leads the police to Diego's garden where two of his supposed victims are buried. Seeing the graves, Maria realizes Diego is still a killer, a matador. They are indeed soulmates. Diego breaks off with Eva who denounces him to the police. On the day of a solar eclipse, Angel leads the police to Maria's secret villa. But it's too late: just as the moon eclipses the sun and just as Eva, Angel and the police arrive, two shots ring out. Having made passionate love, Maria and Diego have killed each other at the moment of ecstasy.

1986

Law of Desire (La Ley del deseo)
Written and directed by Pedro Almodóvar
Director of photography: Angel Luis Fernández
Sound: James Willis

Design: Javier Fernández
Editor: José Salcedo
Music: Tango (Stravinsky), Symphony No. 10 (Shostakovich).
Songs: 'Lo dudo' by Los Panchos; 'Ne me quitte pas' by Maisa Matarazzo; 'Guarda che luna' by Fred Bongusto; 'Dejame recordar' by Bola de Nieve; 'Susan get down', 'Santanasa' by Almodóvar and McNamara
Production: El Deseo S.A. and Lauren Films S.A.
Length: 1 hour 40 minutes
Cast: Eusebio Poncela (Pablo Quintero), Carmen Maura (Tina Quintero), Antonio Banderas (Antonio Benitez), Miguel Molina (Juan), Bibi Andersen (Ada's mother), Manuela Velasco (Ada), Fernando Guillen (the inspector), Nacho Martinez (the doctor), Helga Liné (Antonio's mother), German Cobos (the priest), Agustín Almodóvar (the lawyer)

Pablo Quintero is a fashionable film director. His brother Tino changed sex in order to become his father's lover, but his father left him. Tina now lives with his ten-year-old daughter Ada whose mother left them to travel the world. Tina is the perfect mother to Ada and is in love with Pablo who looks after them both. But Pablo is in love with Juan, a man who respects but doesn't love him. When Juan returns to his native village for the holidays, Pablo meets Antonio, the son of respectable Andalusians, who in the space of a few hours becomes a jealous and threatening lover in spite of never having had any previous homosexual experiences. Antonio comes across a love letter addressed to Pablo, signed by Juan but which Pablo in fact wrote himself, and falls into a jealous rage. Pablo escapes from Antonio's clutches and sends him a letter signed Laura P., the name of a character inspired by his sister in a script he's writing. In this letter, Pablo announces he loves Juan and intends to join him. But Antonio gets there first, kills Juan and disappears. Pablo is immediately suspected of the crime. Blinded by tears, Pablo has a car accident returning to Madrid and loses his memory. Antonio's mother shows the police the letters her son received signed Laura P. Laura P. becomes the prime suspect, but the police cannot find her. Antonio returns to Madrid and, in order to get closer to Pablo who's still in hospital, seduces Tina who believes his love to be genuine. Tina tells Pablo, who gradually begins to recover; he realizes later that Tina is in danger. He goes with the police to Tina's flat where she is being held hostage by Antonio. Antonio threatens a bloodbath unless he can have an hour alone with Pablo. Pablo joins him, they make love and Antonio then commits suicide.

1987

Women on the Verge of a Nervous Breakdown (Mujeres al borde de un ataque de nervios)
Written and directed by Pedro Almodóvar

Director of photography: José Luis Alcaine
Sound: Guilles Ortion
Editor: José Salcedo
Design: Félix Murcia
Music: Bernardo Bonezzi
Songs: 'Soy infeliz' by Lola Beltrán; 'Puro teatro' by La Lupe
Production: El Deseo S.A.
Length: 1 hour 35 minutes
Cast: Carmen Maura (Pepa), Fernando Guillen (Ivan), Julieta Serrano (Lucia), Antonio Banderas (Carlos), María Barranco (Candela), Rossy de Palma (Marisa), Kiti Manver (Paulina), Loles León (Cristina), Chus Lampreave (the concierge), Guillermo Montesinos (the taxi driver), Francisca Caballero (the TV presenter), Agustín Almodóvar (the estate agent)

Pepa and Ivan are dubbing artists. His profession allows Ivan to declare his love to the most beautiful women in cinema. Unfortunately, his love doesn't stop there. Ivan decides to dump Pepa and leaves a message on the answering machine asking her to pack her bags. Pepa realizes she can no longer stay in an apartment so full of memories and decides to rent it out. She desperately tries to get in touch with Ivan to tell him she's pregnant. Many people arrive in the flat while she waits for his call. A friend of hers, Candela, hunted by the police for having unwittingly harboured a group of Islamic terrorists, comes to hide there. Another woman, Lucia, also arrives. She is Ivan's ex-mistress and the mother of his son Carlos, a fact Pepa discovers when Carlos visits the apartment with Marisa, his fiancée. Mentally unstable, Lucia wants to kill Ivan, who was responsible for her going mad when he left her. She only recovered her sanity when she heard his voice in a TV film repeating the very same words of love he said to her twenty years earlier. Two policemen then arrive looking for Candela. Pepa solves the problem by giving them some gazpacho laced with sleeping pills. Lucia steals a revolver and runs to the airport where Ivan is about to board a plane along with his new mistress. Pepa manages to disarm Lucia and thereby saves Ivan's life. Ivan asks her for a drink in the airport cafeteria. He wants to make up with her, but Pepa refuses. All she wanted to say to him was goodbye.

1989
Tie Me Up! Tie Me Down! (Átame!)
Written and directed by Pedro Almodóvar
Director of photography: José Luis Alcaine
Sound: Goldstein and Steinberg S.A.
Editor: José Salcedo
Design: Ferran Sanchez
Music: Ennio Morricone

Songs: 'Resistire' by Carlos Toro Montero and Manuel de la Calva Diego; 'Canción del alma' by Los Coyotes, sung by Loles León; 'Celos' by Jacob Grade; 'Satanasa' by F. de Miguel, P. Almodóvar and B. Bonezzi.
Production: El Deseo S.A.
Length: 1 hour 41 minutes
Cast: Victoria Abril (Marina), Antonio Banderas (Ricki), Francisci Rabal (Maximo Espejo, the director), Loles León (Lola), Julieta Serrano (Alma), María Barranco (Berta), Rossy de Palma (the girl on the moped), Lola Cardona (hospital chief), Francisca Caballero (Marina's mother), Agustín Almodóvar (the chemist)

Ricki, an expert picker of locks, is released from the mental hospital where he led a tranquil life as the hospital director's lover. An orphan, free and alone, he dreams of a 'normal' future with a family and children. His choice falls on Marina, a girl who long ago slept with him for money and who, having once acted in porn films, has now become a 'serious' actress, although also a drug addict, as Ricky discovers from a film journal which announces the start of her next film. Ricky goes to the studios where Marina is working and finds her the subject of an unfulfilled passion on the part of a paraplegic director. He follows her to her apartment and forces his way in. She resists him but Ricky hits her, ties her to the bed and explains his intention: he wants a family – she will be his wife and bear his children. Ricky turns out to be gentle and submissive. He looks after Marina, feeds her and even scores her drugs for her. Gradually, their relationship becomes more intimate; soon it's Marina who tends to his wounds and makes passionate love to him. Her sister Lola frees her, but Marina soon realizes how much she misses Ricky. She finds him in the ruin of her family house in the country. Ricky, Marina and Lola leave together and, singing, imagine their future as a family.

1991

High Heels (Tacones lejanos)
Written and directed by Pedro Almodóvar
Director of photography: Alfredo Mayo
Sound: Jean-Paul Mugel
Editor: José Salcedo
Design: Pierre-Louis Thevenet
Music: Ryuichi Sakamoto
Additional music: 'Solea', 'Saeta' by Miles Davis; 'Beyond my control'; 'A final request' by George Fenton
Songs: 'Piensa en mi', 'Un año de amor' by Luz Casal; 'Pecadora' by Los Hermanos Rosario
Production: El Deseo S.A. and Ciby 2000
Length: 1 hour 53 minutes
Cast: Victoria Abril (Rebeca), Marisa Paredes (Becky del Paramo), Miguel Bosé

(the Judge/Hugo/Femme Letal), Pedro Diez del Corral (Alberto), Feodor Atkine (Manuel), Bibi Andersen (Chon), Miriam Diaz Aroca (Isabel), Nacho Martinez (Juan), Cristina Marcos (Paula), Ana Lizaran (Margarita), Rocio Muñoz (Rebeca as a child), Mairata O'Wisiedo (the judge's mother)

Becky del Paramo, a famous singer from the Sixties, returns to Madrid after many years' absence. She preferred to devote her time to her career rather than to her daughter, Rebeca, who hasn't seen her for fifteen years, but who, unknown to Becky, had helped her by eliminating her husband who had wanted to frustrate her ambitions. Rebeca has since become a newsreader for a private television station owned by her husband, Manuel. The reunion of mother and daughter is all the more tricky because Manuel turns out to be one of Becky's ex-lovers. The night of her return, Becky, Rebeca and Manuel have supper and then go out to see Femme Letal, a devoted imitator of Becky. For some time, Rebeca has been coming to see the show whenever she misses her mother. That night, Rebeca and Femme Letal make love. Becky realizes Rebeca's marriage is on the rocks, all the more so because Manuel wants to sleep with her again and divorce Rebeca. One night, Manuel is murdered in his villa. He had spent the evening first with his mistress Isabel, who is the sign language interpreter of Rebeca's words on the news, and then with Becky who, having become his lover again, has learnt he had another mistress and had come to announce it was over between them. Rebeca discovers the body. The investigating magistrate, Judge Dominguez, centres his investigation on the mother and daughter whose relationship he knows hasn't recovered since Rebeca discovered Becky was seeing Manuel. On the day of Manuel's funeral, Rebeca confesses to the murder live on television. In prison, she finds out she is pregnant with Femme Letal's child and hears her mother on the radio dedicating the first song of her concert to her. Sceptical of Rebeca's guilt, the Judge organizes an interview between her and Becky during which both mother and daughter confess to each other their lack of love, their jealousy, all their secrets. Rebeca is freed for lack of proof and accompanies her mother, who has fallen gravely ill, to hospital. To help her daughter, who confesses to having really killed Manuel, Becky accuses herself of the murder and leaves her fingerprints on the gun before dying. Rebeca is then free to go off with Judge Dominguez who turns out to be none other than Femme Letal, the father of her child.

1993
Kika
Written and directed by Pedro Almodóvar
Director of photography: Alfredo Mayo
Sound: Jean-Paul Mugel
Editor: José Salcedo
Design: Javier Fernández, Alain Baineé

Music: Spanish Dance No. 5 by Enrique Granados Campiña; Concierto para bongo by Pérez Prado; Fragments from 'Psycho' by Bernard Hermann; 'Youkalli Tango' by Kurt Weill; 'La Cumparsita' by Matos Rodriguez
Songs: 'Se nos rompio el amor' by Fernanda and Bernarda; 'Luz de luna' by Chavela Vargas
Production: El Deseo S.A. and Ciby 2000
Length: 1 hour 52 minutes
Cast: Veronica Forqué (Kika), Victoria Abril (Andrea), Peter Coyote (Nicholas), Alex Casanovas (Ramón), Rossy de Palma (Juana), Santiago Lajusticia (Paul Bazzo), Anabel Alonso (Amparo), Bibi Andersen (the beautiful stranger), Charo López (Ramón's mother), Francisca Caballero (Doña Paquita), Agustín Almodóvar (a workman repairing Kika's front door)

Kika, a make-up artist, a natural optimist in spite of the disasters around her, lives with Ramón, a photographer specializing in ladies' lingerie who also makes erotic collages full of naked women. They first met when Kika was employed to make up his face when he was presumed dead. They are in love, but don't understand each other. Like many men, Ramón is taciturn but he is also obsessed by his mother's suicide. Nicholas, a writer, both Ramón's ex-father-in-law and Kika's ex-lover, returns to Madrid after two years' absence and moves into Ramón's studio above their flat. Kika, whose sexual relationship with Ramón has broken down, becomes Nicholas's mistress again. Unknown to her, Ramón is sleeping with her best friend, Amparo. One day, Kika is raped by Paul Bazzo, a porn actor who's escaped from prison, who is also the brother of Juana, Kika's cleaning lady. The rape is filmed by Andrea, star of a garish reality show, who was once Ramón's mistress and has sworn revenge ever since he left her. Kika's rape provides her with a perfect weapon and Andrea broadcasts the tape on television. Deeply disturbed by the images, Kika leaves the apartment, having understood that Nicholas, who was working for Andrea, Ramón, who was watching from another flat, and Juana, who allowed Paul into the flat, have all betrayed her. Realizing that his mother didn't commit suicide but was in fact killed by Nicholas, Ramón goes to see him in his new house, a house Ramón's mother once owned. There he discovers the body of a dead woman and faints. Andrea also arrives, dressed in her reporting outfit with a camera on a helmet. She attempts to make Nicholas confess; having read his novel, she's realized he's a dangerous serial killer. But Nicholas refuses to talk. Furious, Andrea kills him. His last gesture is to shoot her in the heart. Kika arrives amid this carnage, finds the unconscious Ramón and for a second time brings him back to life. She then leaves to pursue her new life alone.

1996

The Flower of My Secret (La Flor de mi secreto)
Written and directed by Pedro Almodóvar

Executive producer: Agustín Almodóvar
Director of production: Esther Garcia
Director of photography: Affonso Beato
Editor: José Salcedo
Sound: Bernardo Menz
Design: Wolfgang Burmann
Costume: Hugo Mezcua
Make-up: Miguel Lopez Pelegrin
Hair: Antonio Panizza
Original score: Alberto Iglesias
Songs: 'Tonada de luna llena' by Caetano Veloso, 'En el último trago' by Chavela Vargas, 'Ay amor' by Bola de Nieve, 'Soleá' by Miles Davis
Cast: Marisa Paredes (Leo), Juan Echanove (Angel), Imanol Arias (Paco), Rossy de Palma (Rosa), Chus Lampreave (Jacinta), Carmen Elias (Betty), Joaquin Cortes (Antonio), Manuela Vargas (Blanca)

Under the pen-name Amanda Gris, Leo has become the queen of Spanish romantic fiction with a contract to write three books a year. But she is now miserable, incapable of writing a sentence, and spends her days waiting for her husband, Paco, to call from Brussels where he is working for NATO.

For several months now, their marriage has been on the rocks. Paco rarely calls and Leo refuses to face the truth. Neither Paco nor her friend Betty – a psychiatrist and habitual harbinger of doom, and, what's more, Paco's mistress – can tell her the obvious: he no longer loves her.

To cheer Leo up, Betty arranges an appointment with Angel, Arts Editor of *El Pais*. The amiable Angel, a great drinker and film-buff, is also Amanda Gris's number one fan. Unaware that the woman before him is his favourite author, he asks her to review a recently published Amanda Gris anthology. At first Leo refuses, saying she hates romantic fiction, Amanda Gris most of all. Finally, she accepts, deciding to commit artistic suicide by destroying her own work.

Meanwhile, Paco announces that he's coming to see her. Leo is overjoyed. Unfortunately, they only end up arguing again and Paco leaves, saying their marriage is over. Abandoned and alone, Leo swallows a bottle of sleeping pills. She is woken up, however, by her mother's voice on the answer-phone. Haggard and desperate, Leo goes out into the street and, caught up in the crowds, finds herself thrown into Angel's arms. The next morning she wakes up at his flat to the sound of him telling her: 'As Amanda Gris would say, last night you revealed to me the flower of your secret.' Her true identity is no longer a mystery to him.

Angel takes her home where she faces another difficult encounter, this time with Betty, who confesses her secret liaison with Paco. Drained and exhausted, Leo no longer has the strength even to scream or cry. Having heard again from her mother and agreed to accompany her to her native village, she faints into Angel's arms.

In the country, Leo regains her lust for life. A phone call from her publishers,

who have have been suing her for breach of contract, finally makes her face reality. It seems they have just received two fabulous novels by Amanda Gris; they are ecstatic. The problem is Leo hasn't written a sentence in months and has no idea who wrote these books. She soon finds out. For his own pleasure, and anxious to help her, Angel penned them himself. The two Amandas Grises – Leo and Angel – are reunited in Madrid where they drink and kiss before a roaring log fire.

1997
Live Flesh (Carne trémula)
Directed by Pedro Almodóvar
Script: Pedro Almodóvar, in collaboration with Ray Loriga and Jorge Guerricaechevarria; based on the novel by Ruth Rendell
Director of photography: Affonso Beato
Sound: Bernardo Menz
Editor: José Salcedo
Original score: Alberto Iglesias
Cast: Javier Bardem (David), Francesca Neri (Elena), Liberto Rabal (Victor), Angela Molina (Clara), José Sancho (Sancho), Penélope Cruz (Isabel), Pilar Bardem (Dona Centro), Alex Angulo (Bus driver)
Production: Ciby 2000, El Deseo S.A., France 3 CINEMA
Length: 1 hour 39 mins

Victor is born in Madrid, on the night Franco's regime declares a state of emergency. Twenty years later another night will mark his life, when he goes to join Elena – a girl he met in a club – at her apartment. But Elena doesn't remember him, and only opens the door expecting to find her dealer. After failing to chase Victor off, she threatens him with a gun. A shot goes off. No one is hurt, but the neighbours, alerted by the noise, call the police. Two police officers, David and Sancho, arrive at Elena's apartment: they assume Victor to be a dangerous assailant and, whereas David immediately falls for Elena's charms, Sancho lets the guns do the talking. A shot goes off, this time fired by Victor. David is hit, and crumples to the floor. Several years later Victor gets out of prison, where he never stopped thinking about Elena. By now, though, Elena lives with David, who as a result of the bullet fired by Victor has lost the use of his legs – he's also become a paraplegic basketball champion. At the cemetery where Victor comes to spend a few quiet moments at his mother's graveside, Victor meets Clara, Sancho's wife. Defeated by life at the side of a violent, alcoholic husband, Clara finds secret happiness with Victor. She helps him move into his home, teaches him the secrets of how to make love to a woman; but Victor remains intent on finding Elena. He manages to get himself taken on at the nursery where Elena works; then gets her to agree to a night of passion with him. Elena accepts on condition that afterwards he stays away from her for good.

But the night of passion turns out to be one she cannot forget. On hearing that Victor is back, David threatens him; he wants his revenge. Victor reveals to David that it was not him, but Sancho, who pulled the trigger on the night that left David paralysed. At the time, David had been Clara's lover – a fact for which Sancho made him pay. In an attempt to get rid of both Victor and Sancho, David tries to get them to kill each other by revealing to the hate-filled Sancho his wife Clara's affair with Victor. But in the duel that soon ensues, the two that die are Sancho and . . . Clara, who defended Victor to the end. One night in Madrid, some years later, Victor and Elena's baby is born.

1999

All About My Mother (Todo sobre mi madre)
Written and directed by Pedro Almodóvar
Director of photography: Affonso Beato
Sound: Miguel Rejas
Editor: José Salcedo
Original score: Alberto Iglesias
Cast: Cecilia Roth (Manuela), Marisa Paredes (Huma), Candela Peña, Penélope Cruz (Rosa), Antonia San Juan (Agrado), Rosa María Sarda
Production: El Deseo S.A., France 2, Canal +
Length: 1 hour 40 mins

Manuela lives alone with her adolescent son, Esteban. There is only an 18-year age gap between them, and mother and son are very close. Manuela works as coordinator of the National Transplant Centre at the Ramón y Cajal Hospital in Madrid. Esteban is passionate about literature and wants to become a writer; he's recently begun a short story whose title, *All About My Mother*, is inspired by Mankiewicz' *All About Eve*. On Esteban's seventeenth birthday, Manuela gives him Truman Capote's *Music For Chameleons* and takes him to the theatre to see *A Streetcar Named Desire*. Mother and son share the same admiration for Huma Rojo, the actress playing the part of Blanche Dubois. After the performance, Esteban remains eager to ask Huma for an autograph, despite the pouring rain. And so, as they wait in a doorway opposite the stage door for the lead actress to appear, Manuela and Esteban talk of the emotion and excitement they felt while watching the play. To Esteban's surprise, his mother tells him how, twenty years earlier, she'd played Stella opposite Esteban's father in the role of Kowalski.

Esteban is taken aback that Manuela is talking to him about his father at last: for ages now, he's wanted to know everything about this man he doesn't know. Manuela promises that she'll tell him everything when they get home. At which point Huma and Nina Cruz, her fellow actress and girlfriend, emerge from the theatre. They are having a violent argument, as they hail a taxi. When their taxi moves off, Esteban runs after it, only to get knocked over by another car. The car

speeds away, leaving Esteban lying motionless on the ground, deaf to his mother's screams. Desperate, out of her mind with grief, Manuela flees Madrid for Barcelona. She's decided to honour her son's last wish, and goes in search of his father, the man who she loved and left eighteen years earlier – the man who was also called Esteban, before he became Lola.

2002

Talk To Her (Hable con ella)
Written and directed by Pedro Almodóvar
Executive producer: Agustín Almodóvar
Director of production: Esther García
Director of photography: Javier Aguirresarobe
Editor: José Salcedo
Original score: Alberto Iglesias
Art direction: Antxón Gómez
Associate producer: Michel Ruben
Make-up: Karmele Soler
Hair: Francisco Rodríguez
Costume: Sonia Grande
Sound: Miguel Rejas
Sound mixer: José A. Bermúdez
Choreography: Pina Bausch (*Masurca Fogo* and *Café Muller*)
Cast: Javier Cámara (Benigno), Darío Grandinetti (Marco), Leonor Watling (Alicia), Rosiario Flores (Lydia), Mariola Fuentes (Rosa), Geraldine Chaplin (Katerina Bilova), and with Pina Bausch, Malou Airaudo, Caetano Veloso, Roberto Álvarez, Elena Anaya, Lola Duenas, Adolfo Fernández, Chus Lampreave, Loles León, Fele Martínez, Helio Pedregal, José Sancho, Paz Vega
Length: 1 hour 52 minutes

A curtain decorated with salmon-pink roses and gold trim rises on a performance of Pina Bausch's *Café Muller*. Sitting in adjacent seats in the audience are two men who have never met. The first is Benigno, a young male nurse; the other is Marco, a writer in his forties. Strewn about the stage are wooden chairs and tables, as two women, their eyes closed and arms outstretched, move about to the strains of Henry Purcell's *The Fairy Queen*. The performance moves Marco so much that he starts to cry. Benigno sees the tears of the man next to him in the darkness of the stalls; he'd like to tell him that he too is moved, but he doesn't dare.

Several months later the two men meet again, this time at El Bosque, the private clinic where Benigno is employed. Marco's girlfriend Lydia, a professional bull-fighter, is in a coma as result of an injury sustained during a *corrida*. Benigno, for his part, is at the bedside of another coma victim, Alicia, a young dancer. When Marco passes the door to Alicia's room, Benigno has no hesitation in beckoning

him in. It marks the start of a great friendship, one as smooth as a ride on a roller-coaster!

Time passes at the clinic. The four characters' lives follow their course, leading them on towards an unexpected fate.

Talk to Her is a story about a friendship between two men, about solitude, and about the long convalescence from the wounds of passion. It's also a film about the impossibility of real communication within a couple, as well as one in which cinema itself is the topic of conversation.

The film seeks to show 1. – that monologue in the face of silence can turn out to be a form of dialogue 2. – how silence can express the eloquence of the human body 3. – how cinema can come to be the perfect link in relations between people, and finally 4. – how cinema told in words can hold back time; take root not only in the life of the narrator but in the listener's too.

Talk to Her is a film about the pleasure of storytelling, as well as about the spoken word as arm against solitude, illness, death and madness. For it is equally a film about madness – a madness at times so gentle and full of common sense it becomes hard to tell apart from normality.

All About My Mother ended with a curtain going up on a stage plunged into darkness. *Talk to Her* begins in a similar way, with a curtain going up on a stage. In *All About My Mother* the characters were actresses, talkers, women able to act on as well as off stage. *Talk to Her* is the story of narrators who talk about themselves – men who talk to those will listen to them and, most of all, to those who cannot hear them.

2004

Bad Education (Mala educación)
Written and directed by Pedro Almodóvar
Producer: Agustín Almodóvar
Executive producer: Esther García
Director of photography: José Luis Alcaine A.E.C.
Editor: José Salcedo
Original score: Alberto Iglesias
Art direction: Antxón Gomez
Sound: Miguel Rejas
Sound mixer: José Antonio Bermúdez
Camera operator: Joaquín Manchado
Make-up: Ana Lozano
Hair: Pepe Juez
Costume: Paco Delgado, with the special collaboration of Jean-Paul Gaultier
Cast: Gael García Bernal (Angel, Juan, Sahara), Fele Martínez (Enrique Goded), Javier Cámara (Paquito), Daniel Jiménez Cacho (Father Manolo), Lluís Homar (Monsieur Berenguer), Francisco Boira (Ignacio), Francisco Maestre (Father José),

Juan Fernández (Martín), Ignacio Pérez (Ignacio, as a child), Raúl Forneiro (Enrique, as a child), Petra Martínez (Ignacio's mother), Sandra (Nancy Doll), Roberto Hoyas (Barman, Galicia)
Length: 1 hour 45 minutes

In a school run by priests in the early 1960s, two boys, Enrique and Ignacio, discover love, cinema and fear. Witness to, but also participant in these discoveries is Father Manolo, the school's principal and literature teacher. First at the end of the 1970s, then in 1980, the three characters will meet again. This second encounter will mark the life – and death – of one of the three.

Index

Page numbers in **bold** refer to illustrations.

PA refers to Pedro Almodóvar

Almodóvar on Almodóvar